BURLESQUE

POSTER DESIGN

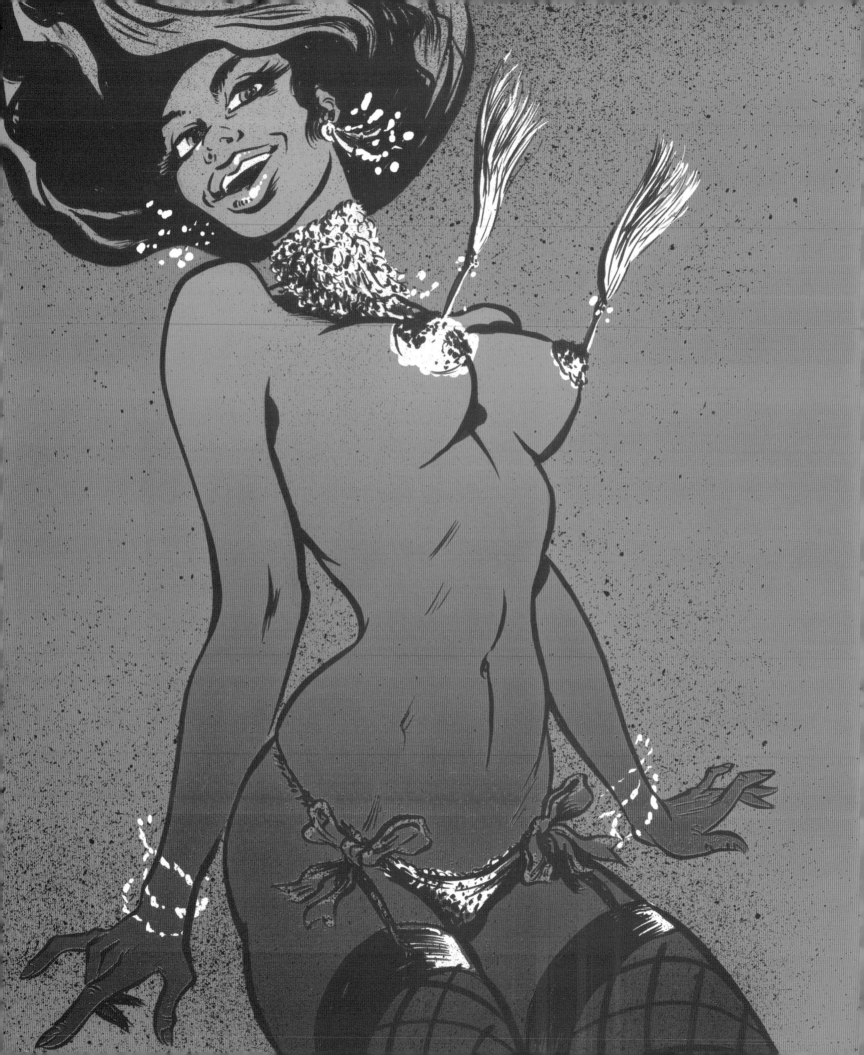

BURLESQUE

POSTER DESIGN

THE ART OF TEASE

Foreword by Chaz Royal

Written and compiled by
Yak El-Droubie and Ian C. Parliament

KORERO

Published in 2009 by Korero Books LLP,
32 Great Sutton Street, London, EC1V 0NB, UK
www.korerobooks.co.uk
contact@korerobooks.co.uk

© Korero Books LLP, 2009
ISBN 978-09553398-2-0

British Library cataloguing-in-publication data:
A catalogue record of this book is available at The British Library.

Printed in Portugal.

CONTENTS

Serigraph by Derek Yaniger, 2006.

FOREWORD
by Chaz Royal

WELCOME TO THE WILD AND wonderful world of burlesque poster imagery. What is burlesque you may ask? Some would say it is the lost art of the striptease, others would say it is a way of mocking popular culture through self-expression. But burlesque is a part of popular culture in many ways. Today's burlesque movement now spans the globe and having a unique and dedicated branding for your revue, company or solo performance is as important as what is being presented on stage. Decades ago, when burlesque was at its original peak, between the 1930s to 1960s, the style of artwork presented by burlesque theatre productions or dedicated burlesque houses was as broad as the styles of today's images, but certainly not as refined. The posters and images that were created then were often cut-and-paste screen prints, hand paintings, or very rough and borrowed images; these were used mainly for newsprint adverts and hand leaflets. The contrast with today's burlesque artwork couldn't be sharper, and the quality is that much better, with designs by several top lowbrow artists, and newcomers in the field wanting to get in on the action, and show their interpretation of what is hot, sexy and empowering about the current burlesque art scene.

My background in burlesque entertainment started when I first began seeing a resurgence popping up in various North American cities in the mid 1990s, primarily through news articles in national print. The world wide web was in its infancy, with only a handful of burlesque productions starting to pop up online. When researching who was who in this exciting neo scene, there were very few individuals who took the time to get it right from the start. Many of the new companies that emerged could barely get a slick and tasteful website together. The select few, who took the time to do so, proved that the artwork and imagery they presented was a major element in drawing others into their novel realm; their designs eventually

inspired dozens if not hundreds of new performers and producers to jump on the burlesque band wagon. You could almost say that pioneers like Fluffgirl Burlesque Society from Vancouver, Velvet Hammer from Los Angeles and Burlesque As It Was from Denver, were used as online templates for other hopefuls to follow.

By the new millennium, there was a second wave of the neo-burlesque craze, with many cookie cutter-style shows trying to emulate burlesque from its original golden age, but also a distinct new movement of troupes and solo divas creating original online web imagery. Many new producers attempted to take the short route by simply borrowing images of stars from yesteryear for their posters, or copying what the top names of the neo scene were creating. Often you would see similarities in graphic design on websites, colour concepts, photo shoots and poster designs. This tendancy of simply doing things the easy way, made some people wonder whether this neo movement would evaporate as quickly as it had started.

However, the true innovators of the time worked harder every year to stand out, with custom illustrations and graphic design that was nearly impossible to duplicate. It was a time when there were no touring productions and online video programs were a rarity. The main way the general public would become aware of the burlesque resurgence was by stumbling onto a website, or being lucky enough to see a poster in their city in time to catch a show. They say a photograph is worth a thousand words, and a poster and branding can make or break a show. Until recently, a dedicated website or poster was the only way to attract people to an event; this book seeks to capture the influential custom illustrations and graphic designs that were so critical in promoting 'The Art of Tease'.

Whether you call it a resurgence, a movement or a scene, it is amazing how contemporary burlesque has grown in leaps and bounds. In today's market, anyone and everyone can get involved. There are myriad work opportunities for entertainers, artists, graphic designers and freelance illustrators. Modern burlesque performers bring to life popular burlesque and pin-up imagery from the past; their poster artists are recreating, showcasing and developing these styles with the aim of reviving this niche market to its former glory. The designs in this book reflect the past, present and future direction of the art that is burlesque. Men love it, and women even more. I hope you enjoy 'The Art of Tease' as much as I have!

Chaz Royal
Burlesque Producer

RIGHT: Trouble in Mind, acrylic on masonite by Glenn Barr

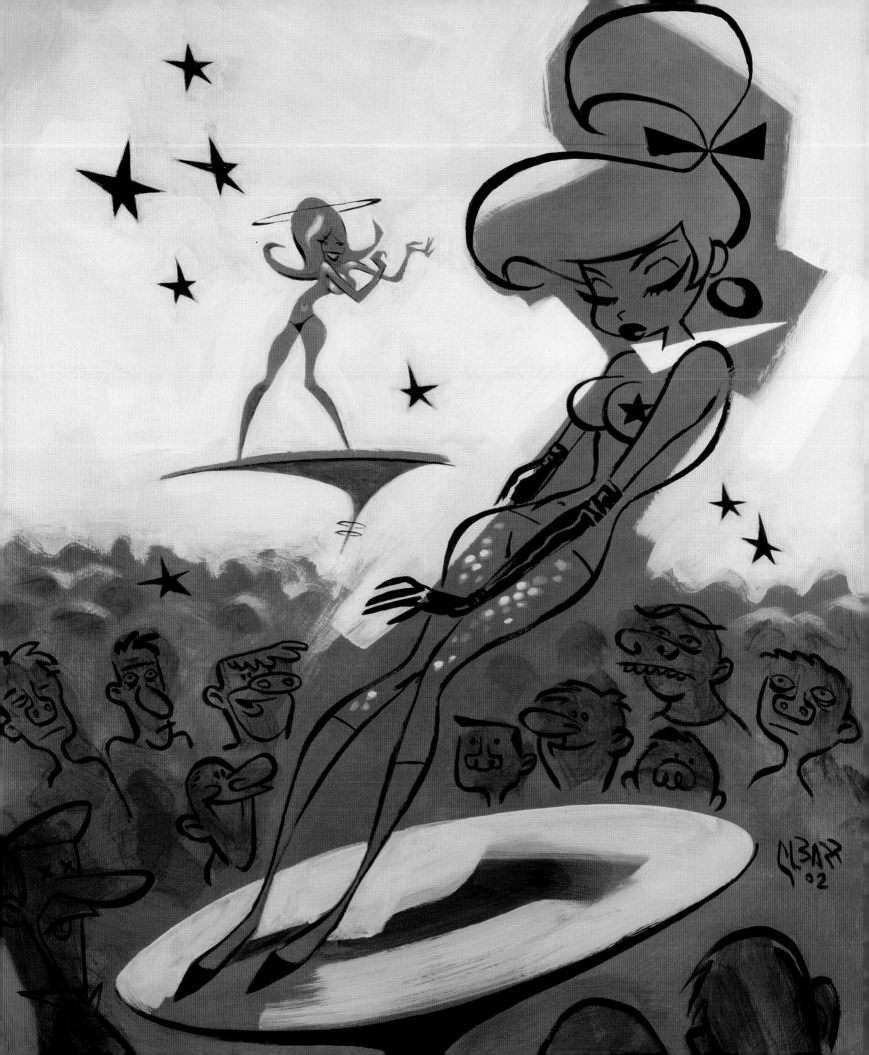

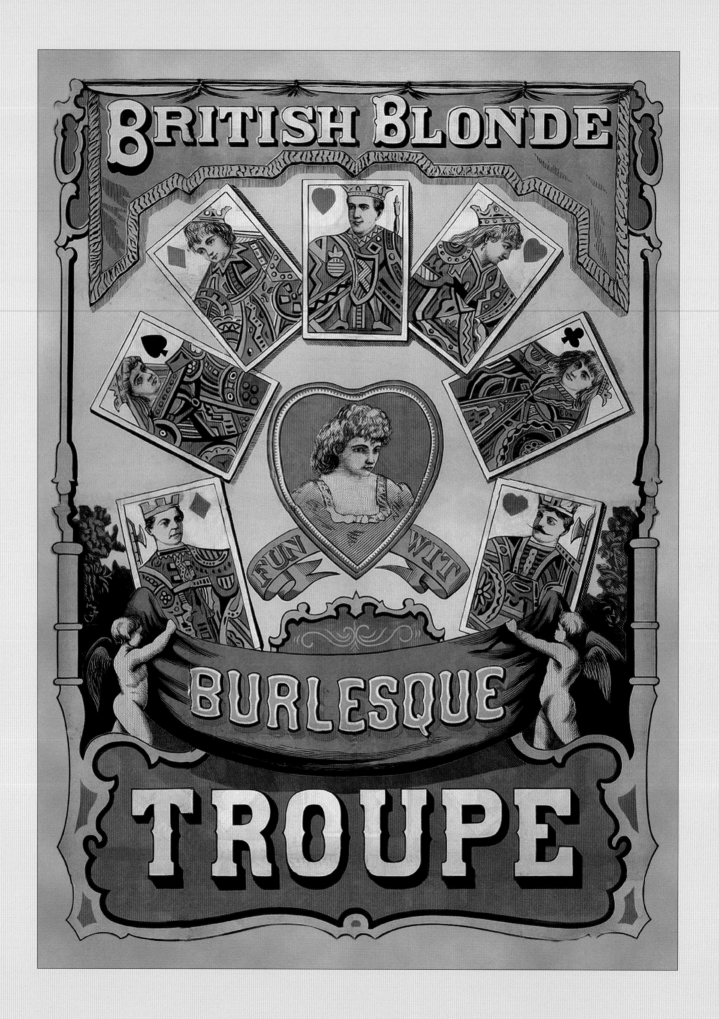

> *"The trouble with the burlesque show,*
> *from beginning to end, is either that it*
> *has been too dirty – or else that it*
> *hasn't been dirty enough."*

Irving Zeidman, *The American Burlesque Show*, 1967

SHIMMY AND SHAKE
A short history of taking it off

EVEN THOUGH "WHAT IS BURLESQUE?" is something that can be endlessly argued over, just about everyone has some idea of what to expect at a burlesque show. Burlesque is a descendant – not necessarily linear, not strictly legitimate – of John Hollingshead's comic operas at the Gaiety Theatre in 1860s London. Though the technique, and what the customers precisely demanded has changed, the theme, the focus, the main spring, and the staple diet remains the same. So long as the girls are on stage, risqué, and the audiences' eyes are fixed upwards, devouring, wide open, it's burlesque in one form or another.

Burlesque first hit the big time in America when Lydia Thompson and her troupe of "British Blondes" took New York by storm in 1868. Lydia is credited with shifting burlesque's emphasis away from comic sketches to displays of flagrant female sexuality. The success of the Blondes brought forth innumerable copy-cat shows.

At The Chicago World's Columbian Exposition in 1893, belly dancers from North Africa and the Middle East captured the American public's imagination. Their popular show at the Egyptian Theater both scandalized and delighted visitors. One dancer that stood out was Spyropoulos, who was billed as Fatima, but because of her size, was nicknamed "Little Egypt". She popularized the *danse du ventre* (belly dance) which came to be referred to as the "hoochee-coochee", or the "shimmy and shake"; exotic dancing had been born. As theatre promoters tried to cash in on Little Egypt's infamous dance, Vaudeville changed forever. She became front-page news in December 1896, after she apparently danced at a Fifth Avenue dinner party hosted by Herbert B. Seeley (the grandson of P. T. Barnum), that was raided by the vice squad. Broadway impresario Oscar Hammerstein later hired her to appear as herself, in a humorous parody of the 'Seeley Dinner'.

LEFT: 1868 tour poster of Lydia Thompson and her all female troupe of 'British Blondes', who used suggestive poses and mocking dialogue to send up the class and gender distinctions of Victorian England.

11

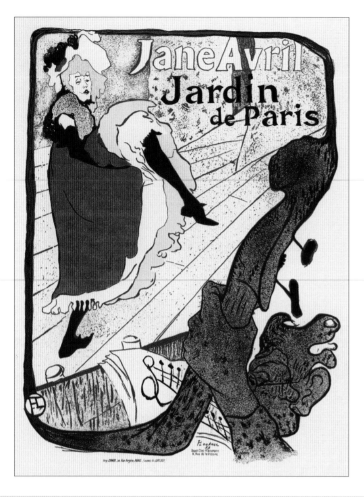

In Paris, meanwhile, *La Belle Époque* was in full swing. The Moulin Rouge, close to the red-light district of Paris, opened its doors in 1889, and introduced the world to the can-can. Initially the dance was performed individually by courtesans, flashing their panties and sometimes more to entice potential after-show clients. Oscar Wilde premiered the play *Salomé* in 1896, after which the dance of the seven veils became all the rage. That same year the Folies Bergère opened; dancing girls soon became a staple of Montmartre café society. It was a time of unprecedented artistic freedom and artists such as the aristocrat Henri de Toulouse-Lautrec, and Chéret, the renowned poster artist, mixed freely with the *demi-monde* of Parisian cabaret. Among the best-known works that Toulouse-Lautrec produced were depictions of the dancers Louise Weber and Jane Avril. Louise Weber, also known as La Goulue (The Glutton), got her nickname from her habit of dancing past a customer's table, picking up their drink, and downing it in one. She had a heart embroidered on her panties and would often do a high kick that would flip off a man's hat. Avril had been deemed insane as a child and committed; released at the age of 16, and knowing she had a talent for dance, she headed straight for the Latin Quarter. Within eight years she had become Paris's foremost club dancer, headlining at the Jardin de Paris on the Champs Elysées. She would eventually replace Weber as the principal dancer at The Moulin. It was a time when any girl could transcend the toughest background by lighting up the stage.

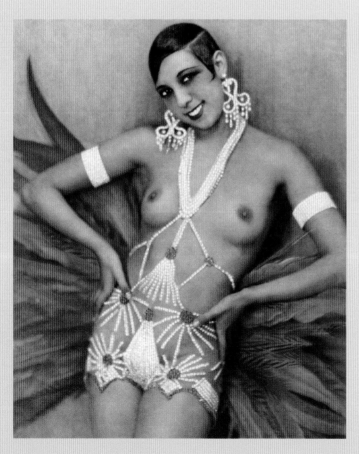

Joesphine Baker

In America Josephine Baker was no more than a moderately successful entertainer. Her career, however, really took off when she went to Paris in 1925 to become a dancer in *La Revue Nègre*. Dressed in nothing but a feather skirt, she became an overnight sensation. Her no-holds-barred dance routines and exotic beauty took the city by storm. She quickly became a Jazz age icon, and was nicknamed the 'Creole Goddess'. When *La Revue Nègre* closed, Josephine starred in *La Folie du Jour* at the Folies-Bergère, where she performed her now infamous banana dance, which cemented her legendary celebrity status. Her success was a manifestation of Negritude, the literary and political movement of Black consciousness that gained influence in 1930s France.

LEFT: Hand-tinted photograph of American-born singer and dancer, Josephine Baker, wearing a cabaret costume consisting of rhinestones and feathers.

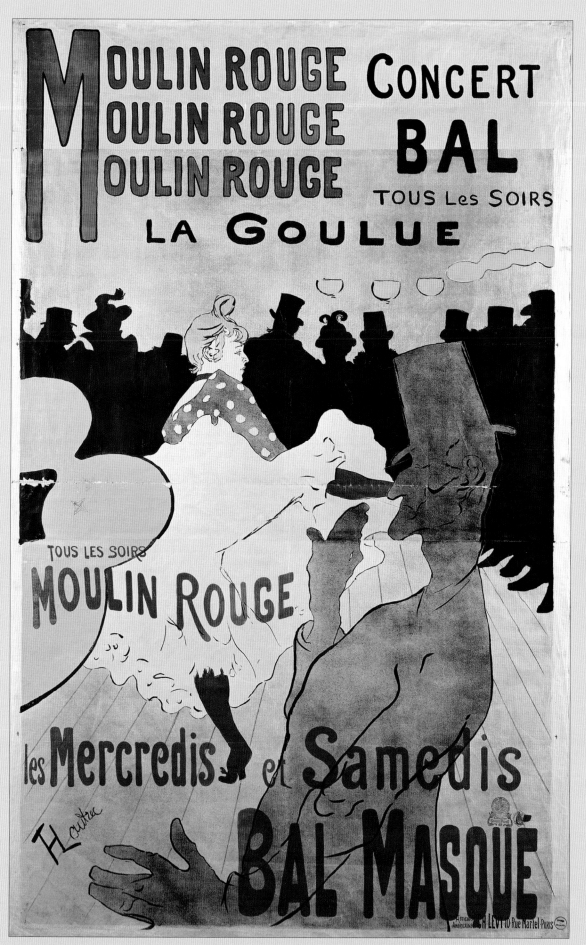

FAR LEFT: Poster for Jane Avril headlining at the Jardin de Paris by Toulouse-Lautrec, 1893. Lautrec was somewhat smitten by her, and she featured on four of his posters.

LEFT: Moulin Rouge poster by Toulouse-Lautrec, featuring La Goulue (Louise Weber), 1891.

ABOVE: Above: Fanny Brice in the 1937 film *The Great Ziegfeld*. Fanny Brice left school to become a burlesque dancer and ended up headlining the Ziegfeld Follies from 1910 into the 1930s. She is a posthumous recipient of a Grammy Hall of Fame Award for her 1921 recording of *My Man*, and was honoured with a star on the Hollywood Walk of Fame for her contribution to the motion picture industry.

MIDDLE: An exterior view of the Minsky's Burlesque Theater in Times Square, New York City, circa 1936. The theatre was one of many closed by New York mayor, Fiorello La Guardia.

In 1907, inspired by the Folies Bergère in Paris, Florenz Ziegfeld established the Ziegfeld Follies in New York, on Broadway. Ziegfeld's gift for publicity, and his devotion to "glorifying the American girl", earned him a reputation as one of the greatest American showmen. His lavish revues featured numerous chorus girls, wearing ornate costumes by designers such as Erté and Lucile (Lady Duff-Gordon). His particular genius lay in transforming popular dramatic forms into *art*, without losing their mass appeal. The subtle line between desire and lust, between good taste and vulgarity was always a concern. His shows were deliberately distanced from the more bawdy and intimate shows of his downtown counterparts, such as the Minsky Brothers, who relied on the personalities of their performers, rather than elaborate props and spectacle.

The theatre at the National Winter Garden on Manhattan's Lower East Side was taken over by the Minsky brothers in 1912. As the theatre was inconveniently located on the sixth floor, they needed something a little bit extra to pull in the public. Burlesque acts were relatively cheap and a new show could be supplied every week, complete with cast, costumes and scenery, by a travelling troupe called a wheel. There were several wheels of which the Columbia Wheel was the most celebrated. The Minskys soon decided to stage their own shows. They built a runway out into the audience and put on rather more risqué performances than their immediate competitors.

The Minskys were raided by the authorities in 1917, after dancer Mae Dix accidently began removing parts of her costume before she reached the wings of the stage. As the crowd cheered, she naturally returned to the stage to continue removing her clothing to wild applause. Thereafter, Billy Minsky ordered the so-called 'accident' to be repeated every night. He is often heralded as being the first to coin the term 'striptease'. Who the first striptease *artist* was, however, continues to be the subject of debate.

Burlesque thrived during Prohibition and the Great Depression, due to the mass migration of unemployed farm workers to the cities. People yearned for escapist entertainment, but few of them could afford to attend expensive shows on Broadway. There was also an unlimited supply of unemployed pretty girls. In 1924 the Minsky empire expanded, when they took over the Apollo Theater in Harlem. "Strippers and tossers, hip weavers and breast bouncers – this is burlesque." wrote Sime Silverman, the editor of *Variety*, in 1931. The times, however, were quickly changing. As burlesque thrived, competition became fierce and shows became increasingly bawdy, risking the wrath of the authorities.

By 1935, concerned citizens' groups, such as the New York Society for the Suppression of Vice, began calling for something to be done about a decline in public morality. Burlesque's combination of sexuality, social commentary and freedom were considered a potent and dangerous mix. The result was increased censorship and regulations from the New York City's mayor's office. Some were absurd: the word "burlesque" was even

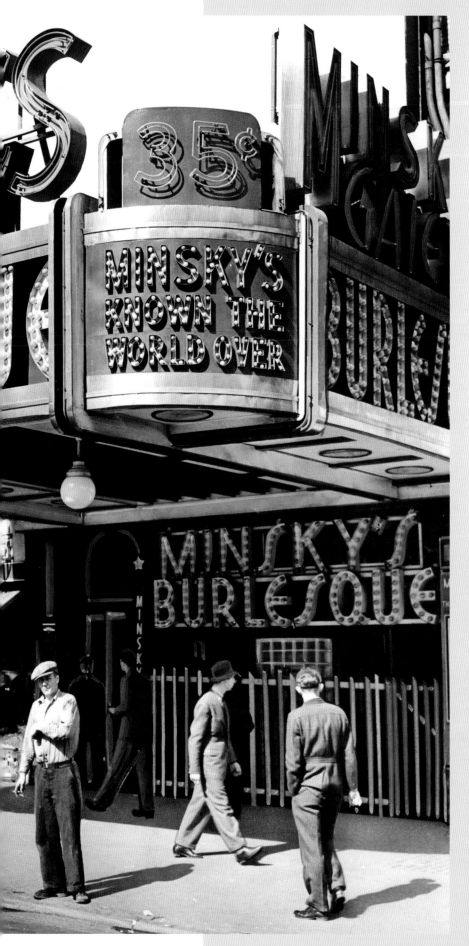

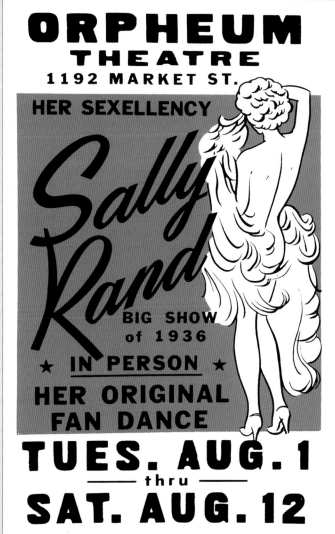

ABOVE: Poster for 'Her Sexellency' Sally Rand's 1936 shows at the famed Orpheum Theatre in San Francisco.

Sally Rand

Sally Rand, an entertainment industry icon, left home at an early age to join the carnival. She eventually ended up starring in several silent movies. Not being able to make the transfer to the talkies, she concentrated on dancing. With the right mixture of enticement, imagination and intricate feathery placement she became a huge success. Her "Lady Godiva" stunt, at the Chicago World's Fair in 1933, had her arrested on charges of lewdness, but she was eventually released. All the hulabaloo helped to spur her notoriety to the point where she packed theatres across the country. One of the highlights of the 1939 Golden Gate International Exposition in San Francisco was Sally Rand's Nude Ranch. It featured women wearing cowboy hats, gunbelts, boots, and little else. As an exotic burlesque performer, she not only winningly ignited male libidos, but found steady work well into her sixties.

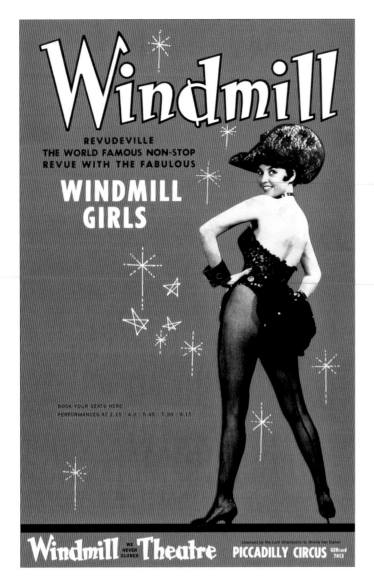

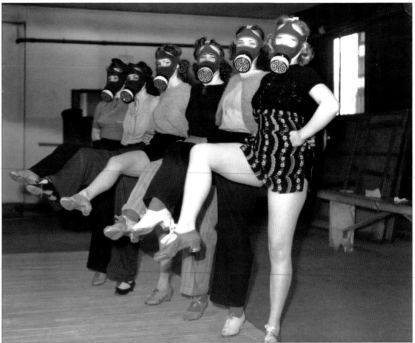

ABOVE: Windmill Theatre programme, 1941.

RIGHT: The showgirls of the Windmill Theatre rehearse with their gas masks firmly in place during the London Blitz in 1941.

banned, spawning the variant spelling "burlesk". Soon after, the Minsky name itself was banned, for by then it was synonymous with burlesque.

By 1938 it was almost impossible to renew a licence for a burlesque theatre in New York City. Syndicated columnist Robert Ruark reported at the time, "the burlesque show, as vital a slice of Americana as the covered wagon, seems just about ready for the boneyard." As the bright lights on Broadway were dimmed, the industry retreated into the shadows.

In London, England, however, the Windmill Theatre was having unprecedented success with Revudeville – a programme of continuous, nonstop variety that featured, besides the usual sketches and comics, glamorous nude girls on stage, albeit standing still as statues. The Lord Chamberlain's office was responsible for stage censorship in England. It ruled that actresses could only pose completely nude if the pose was motionless and expressionless. The pose had to be "artistic", and something rather more than a display of nakedness. Nudity was only deemed legitimate if it bore a likeness to art: then, and only then, was it worthy of contemplation. Essentially, "if it moves, it's rude". Rotating platforms, moving scenery, moving props, and wind machines, were creatively used to bend the rules. The Lord Chamberlain's ruling meant that *tableaux vivants* (the art of "living statues", which had been an erotic sensation in Paris in the 1890s) survived as a form of entertainment on the stage in Britain well into the middle of the 20th century.

During the Second World War the Windmill Theatre remained open, entertaining Londoners and allied troops continuously throughout the Blitz, earning the reputation "we're never closed" – often repeated as "we're never clothed". It's hard to imagine now what a national institution The Windmill had become, as central and significant an emblem of Britishness as a cup of tea, or the statue of Eros in Piccadilly Circus.

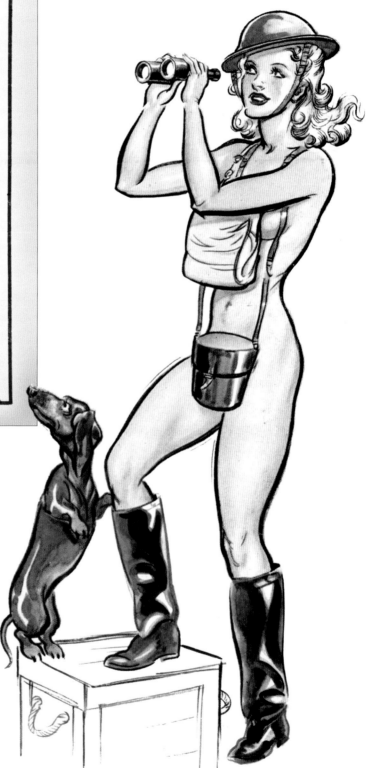

The poster reads:

PALACE OF VARIETIES

STRATFORD Telephone MARYLAND 1075

Lessees : THEATRE & MUSIC HALL (South Ltd.) WEDNESDAY IS CARNIVAL NIGHT. General Manager : HARRY LOSS

WEEK COMMENCING MONDAY, JANUARY 19TH 1953
MONDAY to FRIDAY CONTINUOUS from 6-25
SATURDAY TWO DISTINCT HOUSES 6-25 & 8-30

PAUL RAYMOND presents
THE NEW FRONT-PAGE STRIP SHOW
JANE COMES TO TOWN
FEATURING
JANE
THE MODEL FOR THE CREATOR
OF THE
DAILY MIRROR CARTOON
with Little FRITZI
and the PALM BEACH "BIKINI BEACH GIRLS"

THE ENVELOPE COMEDIAN
VIC LEONARD

DON NICHOLS YOUR JOVIAL COMPERE

DELMONICO DANCERS

DYNAMIC PERSONALITY SONGSTRESS
SHEILA STUART

RADIO'S NOVELTY PIANIST
CORELLI

MAGICAL VENT-ILLUSION
THE LYNDONS

"If Vera Lynn was the voice of World War II, then Jane was the body!". Jane was a comic strip created and drawn by Norman Pett for the *Daily Mirror* newspaper. The hapless heroine had a habit of frequently, and usually inadvertently, losing her clothes. Norman Pett's model and muse for the strip was Christabel Leighton-Porter. Christabel signed up with ENSA (Entertainments National Service Association, set up to provide entertainment for troops) at the outbreak of war, and as 'Britain's Perfect Girl', she trod the boards at the Wimbledon Theatre in an American-style revue. Throughout the war Christabel performed and developed her striptease act and "Loveliest of all Nude Presentations," increasingly using her Jane moniker, playing her part in maintaining the morale of Britain's fighting forces. Then Prime Minister, Winston Churchill, referred to Jane as "a secret weapon" – apparently worth two armoured divisions, three if she lost her bra or panties. That didn't, however, stop The Lord Chamberlain's concern over the amount of clothing she removed during her stage act. Christabel tried to persuade him that, in a bikini scene, she could remove

her top with her back to the audience and then cover herself with her hands before turning round; "I see," said The Lord Chamberlain, looking sceptically at her heaving bosom, "you must have very large hands." In 1945 King Features attempted to syndicate the Jane cartoon strip in the United States. The amount of nudity, however, was too much for American audiences, and the arrangement ended in 1946.

The first striptease show put on in the West End of London was in 1942, by Phyllis Dixey. After the popularity of her *Confessions of a Fan Dancer* act in 1939, she formed her own company of girls and rented the Whitehall Theatre in London to put on a revue. Thousands, among them many servicemen, flocked to see her topping the bill. Troops were certainly becoming used to a diet of full-fat 'cheesecake', as female pulchritude became patriotic. Phyllis Dixey stayed at the Whitehall for the next five years, producing such shows as Peek-a-boo, where she earned the title

BELOW: Striptease artist Phyllis Dixey (c.1914 - 1964), whose saucy revues at the Whitehall Theatre in London were legendary, circa 1940.

BELOW RIGHT: Poster for *The Phyllis Dixey Show*, presented by Paul Raymond in the mid '50's in Aldershot, home of the British Army.

FAR TOP RIGHT: Paul Raymond pictured standing outside his club, The Raymond Revue Bar, Soho, London, 1960.

FAR BOTTOM RIGHT: Programme for *Follies Strip-Tease* at the The Raymond Revue Bar, 1959.

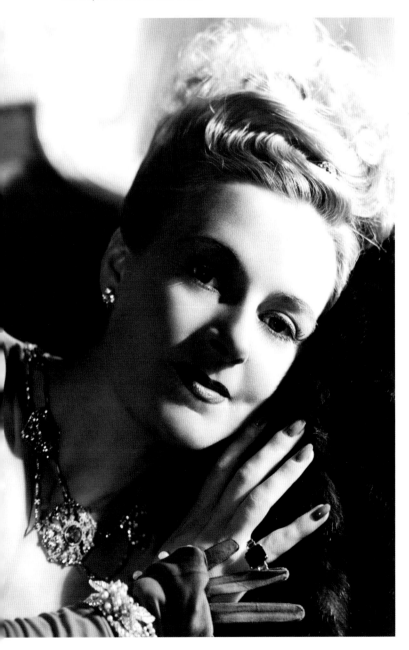

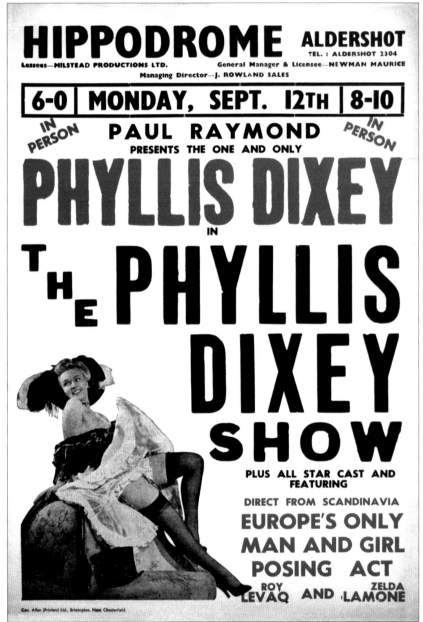

'Queen of Striptease'. In March 1940 in Sunderland she had to withdraw her act after it was banned by the Lord Chamberlain, just before she was due to appear again at Cardiff. Phyllis denied there was anything "naughty" in her performance, and said that an illusion was caused by lighting effects. After this incident she billed herself as 'the girl the Lord Chamberlain banned'. After the war she toured England and the Continent till the mid-'50s. Not willing to compete with the lewder and ruder shows that began to emerge, she was forced into bankruptcy in 1959.

In post-war England, local theatres and music halls struggled to keep their audiences, in the face of stiff competition from cinema and the relatively new medium of television. Variety shows, along with their increasingly all important 'girlie' shows and striptease acts, were used to attract audiences, but they still had to abide by the Lord Chamberlain's rulings. A young entrepreneur called Paul Raymond spotted a loophole in the law. When he opened his Revue Bar, offering full striptease, in the former Doric Ballroom in London's Soho in 1958, it was as a private club and not a theatre. A nominal membership fee entitled one and one's guests to enjoy the facilities of an elegant lounge bar, restaurant and theatre room. Following in the footsteps of the Revue Bar, similar clubs mushroomed throughout Soho, but the Revue Bar outlasted most of them and only closed its doors in 2004, after 46 years.

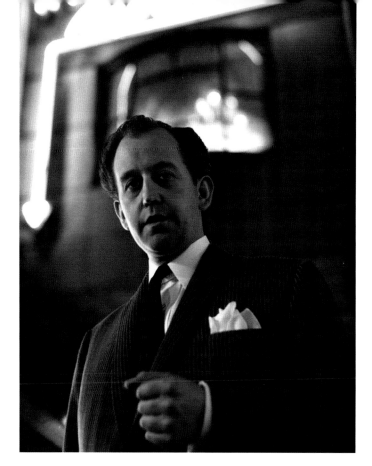

Even the Windmill Theatre with its famous shows that 'Hitler's bombs couldn't stop' had to close in 1964. It was taken over by Michael Klinger, who used to own the Nell Gwynn and Gargoyle striptease clubs in the heart of Soho, and Tony Tenser, the exploitation movie producer. They turned it into a cinema and casino, but they did film the last few performances which formed the basis for the film *Secrets of a Windmill Girl* (1966). The Theatres Act in 1968 eventually abolished censorship of the stage in the United Kingdom. However by then, as in the USA, traditional burlesque, with few exceptions, had moved away from theatres and into smaller clubs, where the emphasis was put on the strip rather than the show.

Burlesque in the USA followed a slightly different course after the war. The popularity of pinups amongst American GIs, considered "bad for morals but good for morale", had laid the foundations for a vigorous post-war market in men's magazines. The mainstay of these magazines were articles on burlesque stars and exotic dancers. The amount of press burlesque dancers like Tempest Storm, Blaze Starr and the "Anatomic Bomb" Lili St. Cyr received, turned them into genuine stars.

As burlesque theatres continued to decline the number of dancers, or so-called ecdysiasts, quadrupled, due largely to the introduction of exotic dancing to night clubs and supper-clubs. "The defunct burlesque theatre is a pretty lively corpse" proclaimed *Newsweek* in 1954.

According to Franklin L. Thistle, writing in the magazine *Sir Knight* in July, 1960: "Strippers packed their G-strings, vacated the big, musty

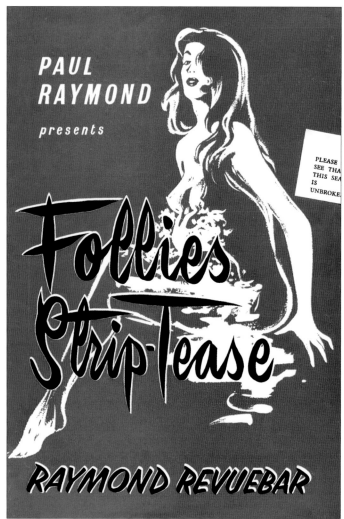

PAUL RAYMOND presents

Follies Strip-Tease

RAYMOND REVUEBAR

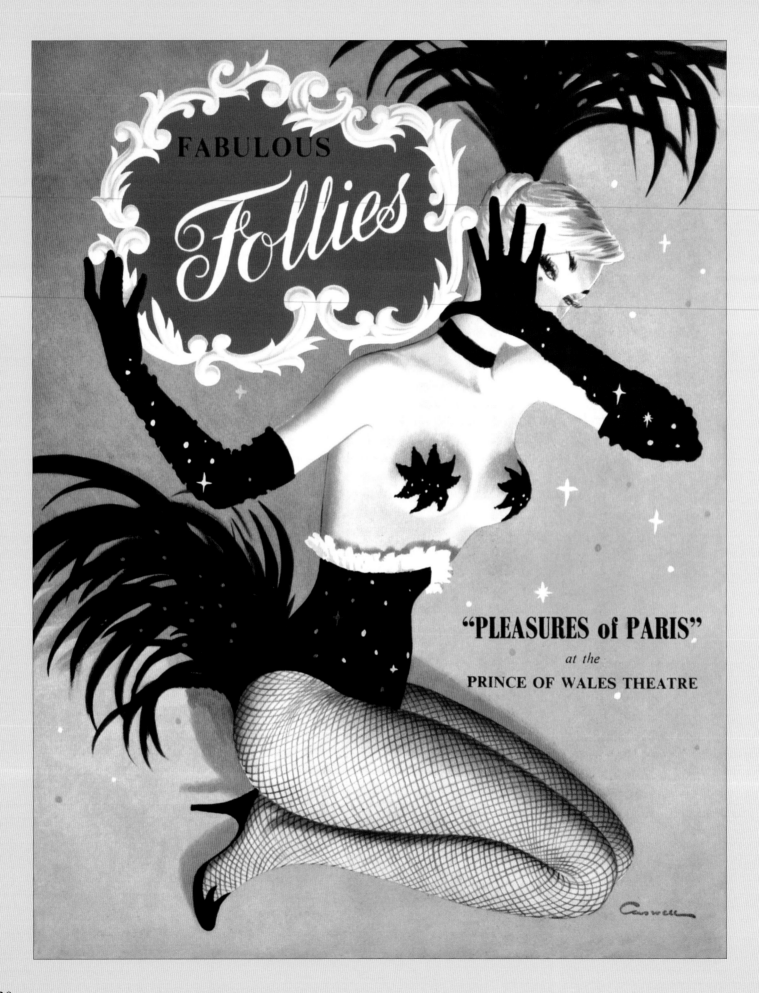

20

burlesque theatres, and moved into the night clubs... this move turned out for the best for striptease fans. No longer did they have to crane their necks or use binoculars from the balcony to get a good view." Striptease was by now considered the single most distinguishing feature of burlesque.

Throughout the late '40s and early '50s, the more elaborate and sophisticated a dancer's act, the wider was its appeal. Not everyone was blessed with the Tempest Storm figure (41" bosom and 24" waist), let alone her larger-than-life personality. So elaborate gimmicks came into vogue. Rosita Royce trained doves to disrobe her; Lili St. Cyr made good use of a see-through bath; and several artists learnt to strip underwater. As *Playboy* stated in August, 1954: "There was a time when a girl could count on an enthusiastic audience by simply peeling down to her birthday suit. Not so today."

During the summer months when the night club circuit tended to be slow, the carnival offered good money and regular work. The postwar boom in children created a need for more fairground rides; technology developed during the war was put to great use in developing new fairground

LEFT: Programme from Val Parnell and Bernard Delfont's Fabulous Follies revue, *The Pleasures of Paris* at the Prince of Wales Theatre in London, 1957 – "exhilarating entertainment with a continental background and streamlined production." Revue shows like the Follies and the Latin Quarter, that "Mr. and Mrs. Theatregoer would find worthy of their patronage", were popular in the '50s. By 1959 the Folies Bergère were even performing in America, at the Tropicana in Las Vegas.

BELOW: A group of fan dancers standing at top of stairs, in front of the entrance to a travelling show, circa 1930s.

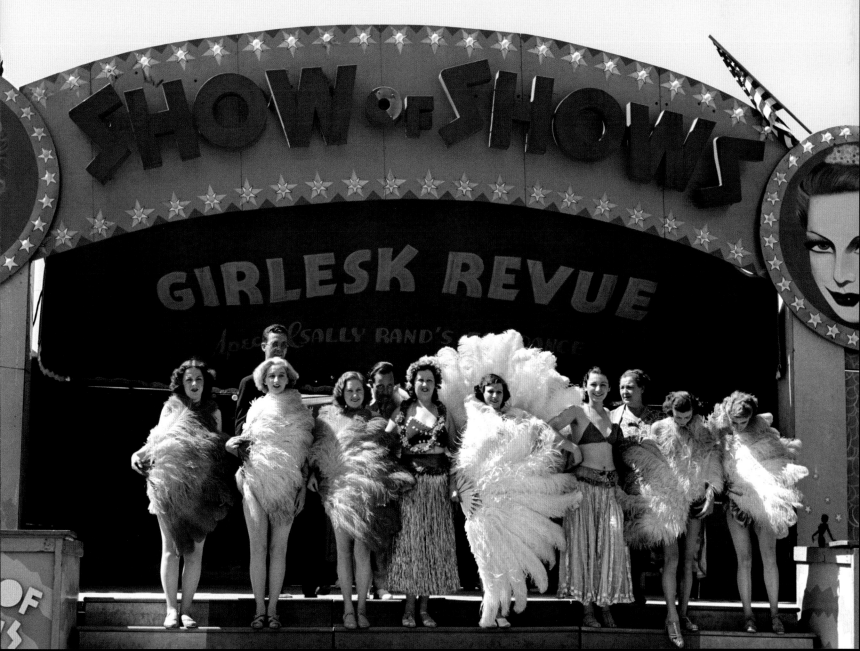

BELOW RIGHT: American stripper Tempest Storm poses under a theatre marquee in 1954.

BELOW: Hand-tinted display board of Evelyn West, a.k.a The Hubba-Hubba Girl, and her $50,000 treasure chest, as insured by Lloyd's of London. She was a fixture at the Stardust club on the old DeBaliviere Strip in St. Louis.

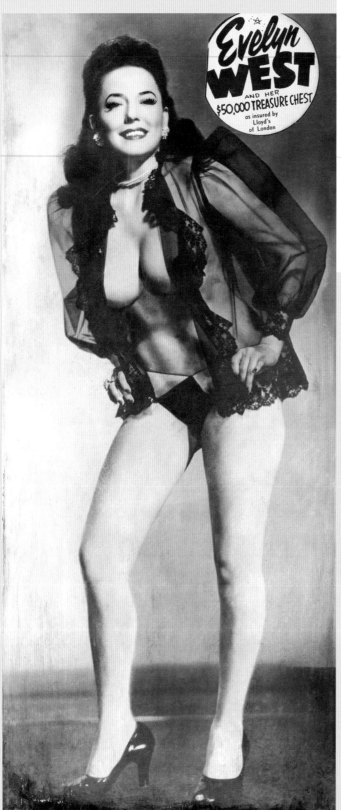

attractions. This level of investment required big names to draw in adult crowds, as well as families, and burlesque dancers fitted the bill perfectly. Sally Rand, Gypsy Rose Lee and Georgia Sothern all performed on the carnival circuit. The carnival shows became hugely popular, and, by the late '50s, cooch shows rarely disappointed.

'What the Butler Saw'-type devices, such as the mutoscope and kinetoscope, had for a while been showing burlesque and striptease short films at carnivals and fairs. Producers during World War II had seen a boom in business for peep show arcade machines and, by 1947, had upped their game and gone the theatrical route, first by producing shorts and then feature films.

The burlesque wheels, such as the Mutual and Columbia, tended to stage shows in the big cities. Burlesque films on the other hand played to small towns that didn't have a grind emporium. The films didn't cost much to make and were extremely versatile. Shorts could be cut up and re-edited with new material, over and over again. Additional income could be made by supplying the growing home market for 8mm and 16mm films. As the

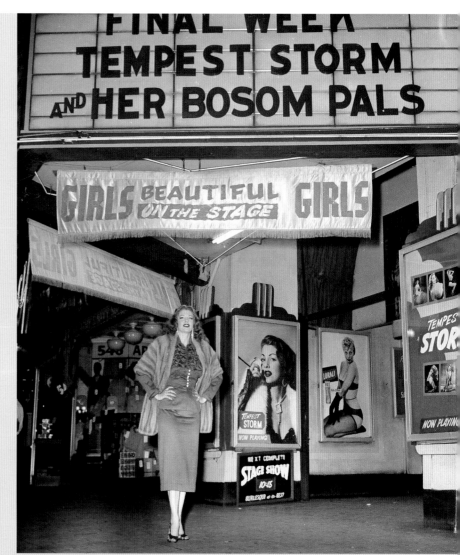

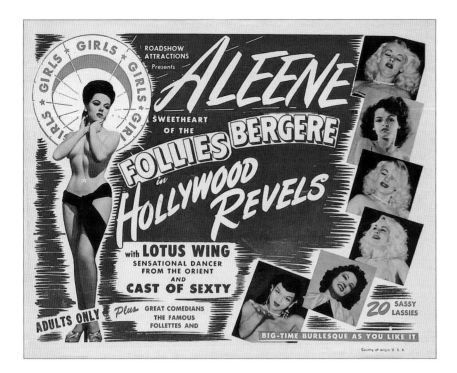

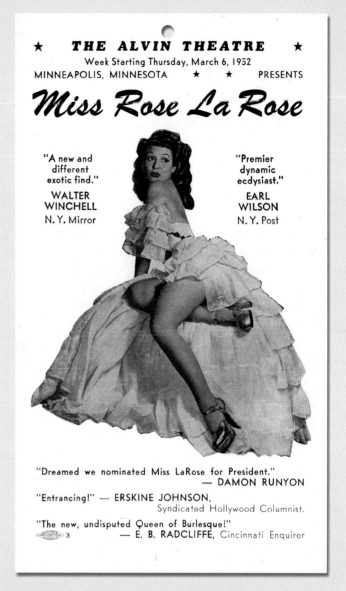

ABOVE: Showcard for Miss Rose La Rose at the Alvin Theatre, Minneapolis, 1952.

TOP LEFT: *Hollywood Revels* was one of the first burlesque feature films. It was filmed at the Follies Theatre in Los Angeles in 1946 and featured 20 sassy lassies and "baggy pants" comics. Top of the bill was raven-haired beauty Aleene Dupree.

theatres struggled to compete with the nightclubs, it became quite common for them to show compilation loops between live acts to save on costs.

Rose la Rose, a former performer at Minsky's, who owned several burlesque houses in Toledo, is reported to have been the first to totally switch to showing films. Not only was it much cheaper, one didn't have the hassle of dealing with the dancers themselves, who, with their larger-than-life personalities and petty rivalries, could prove to be a bit of a handful. By 1956 most of the old theatres had switched. Theatres had relied on advertising in the back of newspapers and decorated lobbies to pull in the crowds. The arrival of the burlesque feature film, however, heralded a new era of burlesque posters.

Hollywood Revels (1946), starring the exotic dancer Allene, was one of the first burlesque feature films. The production was staged in an actual theatre, resulting in much of the action being filmed in medium and long shots, which was the norm. In 1947 the film producer W. Merle Connell came up with the novel idea of re-staging the action in a studio. The new setup allowed for close-ups, better camera work, lighting and sound.

Girly-pix impresario Irving Klaw, best-known at the time for operating a mail-order business selling photographs, was surprised with the success of his movie venture *Strip-O-Rama* in 1953. The film stars the now notorious Bettie Page. He went on to produce and direct *Varietease* and *Teaserama* along the same formula, using a professional camera crew and richly-saturated Eastman color filmstock. Besides Bettie Page, the films featured Lili St. Cyr and Tempest Storm.

As the market for burlesque films continued to develop they ended up distinguishing themselves from other 'exploitation' films, by evoking nostalgia through a reminder of the good old days of burlesque – a trip down *mammary* lane. Burlesque increasingly was being regarded as a

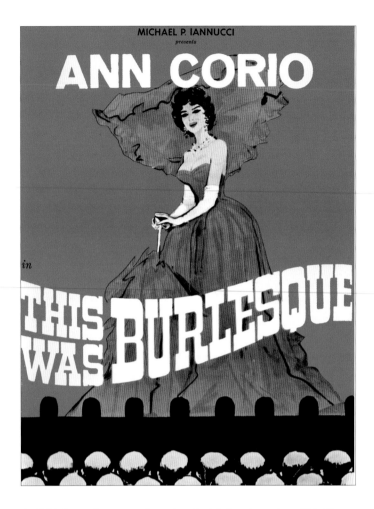

MICHAEL P. IANNUCCI
presents

ANN CORIO

in

THIS WAS BURLESQUE

ABOVE: Souvenir program from Ann Corio's Broadway show *This Was Burlesque* which she directed and performed. In 1968 she wrote a book using that same title. She also teamed up with record producer Sonny Lester and released the album *How to Strip for your Husband: Music to make Marriage Merrier*.

RIGHT: Selection of burlesque flyers from the turn of the 21st century.

BELOW: *Immodesty Blaize and Walter's Burlesque*, 2004, was Britain's first theatrical West End burlesque show in a Society Of London Theatre (S.O.L.T.). It played seven shows a week for an extended run of five months, and was seen by over 30,000 people. At the time, Prime Minister Tony Blair was running for his third election victory, and posters were defaced to read "vote Blaize for a more revealing Britain."

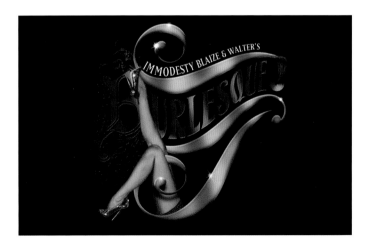

bygone form of entertainment. This was reinforced by shows like Ann Corio's autobiographical revue, *This was Burlesque*, in 1963, and the release of such major films as *Gypsy* starring Natalie Wood, in 1962, and *The Night They Raided Minsky's*, in 1968.

For the '60s generation, the ageing stars of burlesque, most of whom had been around since the '40s, held little appeal. *Playboy* publisher Hugh Hefner embraced cocktail culture with its love of nightclubs, jazz and exotica, but was disparaging about burlesque stars like Tempest Storm and Blaze Star. Instead he promoted and established the notion of the wholesome girl-next-door as the main sexual icon, not the exotic and overtly sexual girls of burlesque.

The '60s also heralded the go-go dancer, which arrived like a freshly laundered brassière in a bundle of dirty linen. Go-go dancers were nubile young things that were markedly slimmer than the exotic dancers that came before them. Essentially eye-candy with no act, they oozed spontaneity and accessibility. The Whisky a Go Go nightclub on the Sunset Strip, where the Doors were the house band till they got fired, pioneered go-go dancers in cages. Go-go dancers reflected the surge in youth culture and had an appeal burlesque dancers of yesteryear couldn't match.

Go-go dancing went topless in 1964, and, by 1969, bottomless as well. The increasing acceptability of nudity distanced striptease from its theatrical roots, leaving no place for burlesque in legitimate theatre. Striptease eventually evolved into lap and pole dancing, which in turn had very little of the strip or tease left. Burlesque was surely dead!

Things were to change however. In the late '80s the baby boomers of the '60s were still seeing bands and going to clubs, rather than turning into dull adults with their parents' middle-aged values. By the 1990s, the explosion of the world wide web was allowing individuals from Vancouver to London, Berlin to New York, and Paris to L.A., to share knowledge and resources to create new sub-cultures and re-energise old ones. The rise of kustom kulture; the growth of the rockabilly scene; the emergence of fetish clubs from the shadows; the iconic status reached by Bettie Page; the popularity of the film *Faster Pussycat Kill Kill*; the prominence of Dita Von Teese and the birth of such communities as Suicide Girls, all added up to a new zeitgeist. It was against this backdrop that burlesque made its comeback.

The burlesque revival, or neo-burlesque as some people like to call it, developed slowly at first. Little things like Something Weird Video re-releasing the movies *Strip-O-Rama* and *Teaserama* on video had a big impact, by significantly fuelling the Bettie Page revival and introducing Tempest Storm and Lili St. Cyr to a new generation. It wasn't long before the odd '60s garage band was being supported by a bevy of go-go dancers, or the occasional hot rod festival held a pinup competition. The Devil-ettes first big break was at the Las Vegas Grind (1999), a wild garage rock

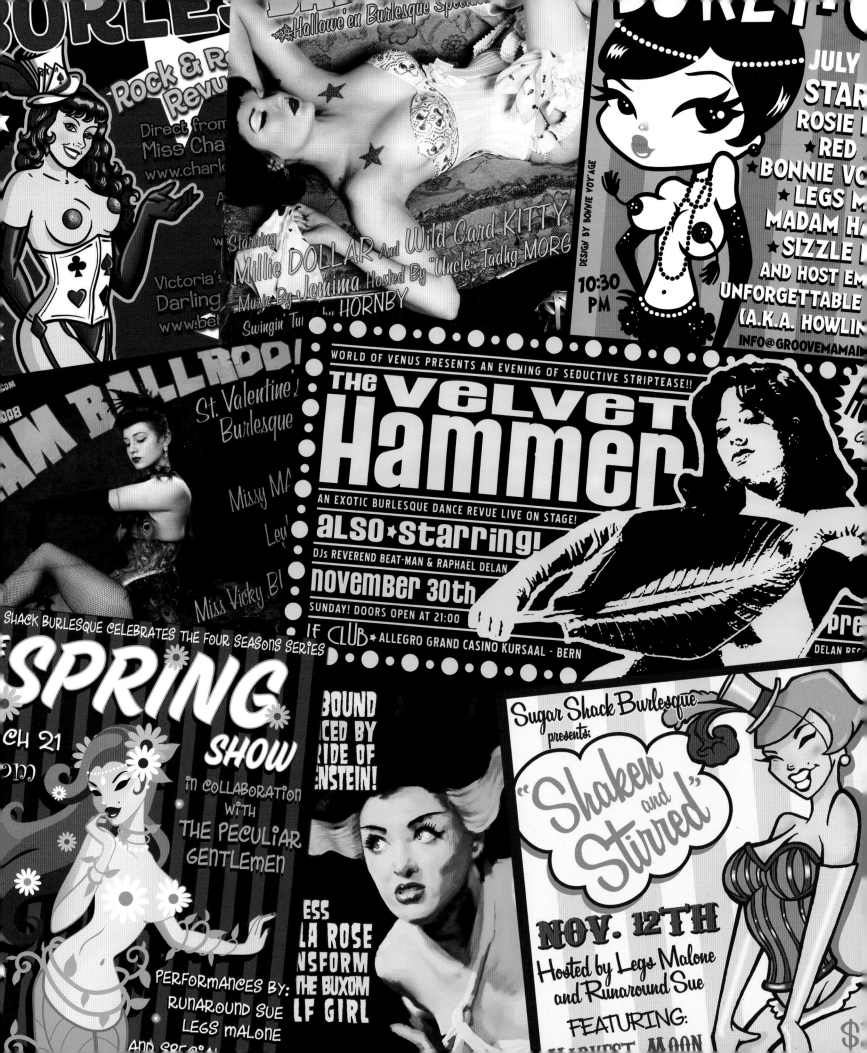

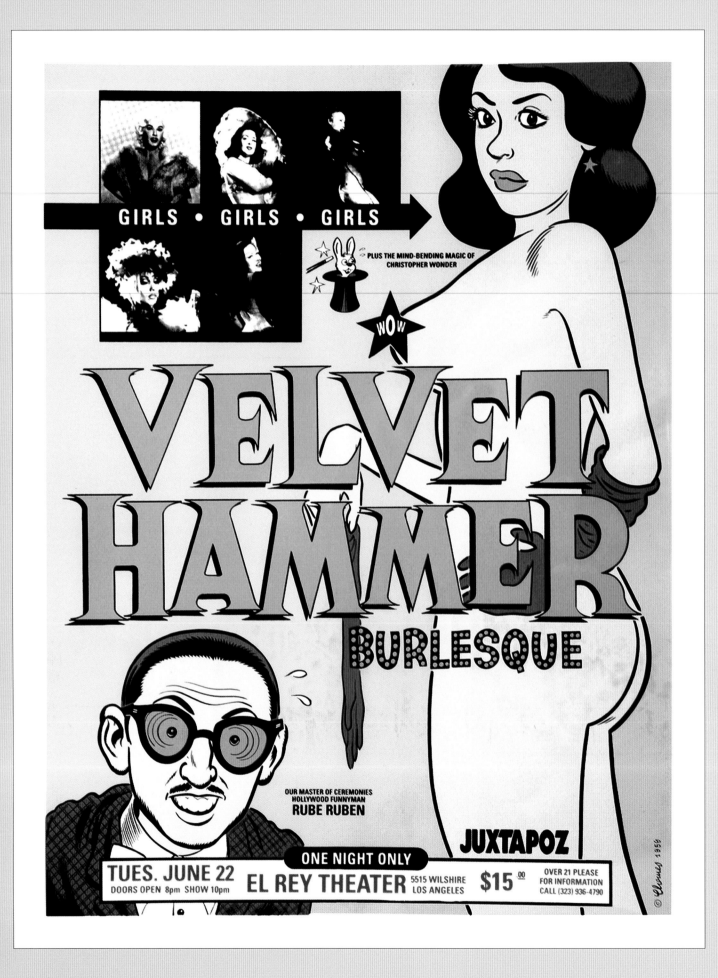

showcase put on by the notorious Josh Collins. According to Baby Doe the Artistic Director of the The Devil-ettes, "The Grind was all about the music, but we got an incredible response. No one had ever seen anything like us. We did a lot of guerilla performances (storming the casino floor in vintage nighties at midnight to do a Pajama Party routine and showing up poolside to do a Synchronized Swim Routine!). We knew we had stumbled upon something pretty magical."

By the mid 1990s The Shim-Shamettes started to shimmy in New Orleans; in 1995 Michelle Carr founded the now infamous burlesque troupe, Velvet Hammer, in Los Angeles; Tease-O-Rama had its first event in 2001; Whoopee started putting on shows in London in 2003 and the now celebrated Flash Monkey started presenting the Burlesque Bazaar in 2004, to be followed by Club Noir in Scotland. People were doing it for the fun of it and not the money. The audience was a mixed crowd of like-minded souls, the so-called in-crowd from the various subcultures that burlesque appealed to. Sometimes it was hard to tell the audience from the performers, as everybody was dressed up to the nines. There was very much a do-it-yourself punk attitude to a lot of these early shows. Performers spent far more money on their costumes than they ever made from the night. With a seductive blend of elegance, eroticism, show-stopping routines and infectious energy, burlesque now appealed to both men and women.

As the burlesque revival gained in popularity, it attracted more diverse audiences and performers. Though based on the traditional burlesque art of striptease, the new form now encompasses an ever-wider range of styles including circus, theatre, magic, cabaret, modern dance and comedy. As might be expected with a form of entertainment that claims to be both avant-garde and retro, the performers and producers of neo-burlesque differ sharply on what it is. This is compounded by the fact that even now, especially social commentators and the media, continue to struggle with the striptease element in burlesque, and attempt to justify its current legitimacy with over-wrought comments about body politics, cultural expectations, gender issues and empowerment. But, as history shows, the flash of a shoulder, or the bounce of a breast, has a timeless appeal, whatever the hang-ups of the day.

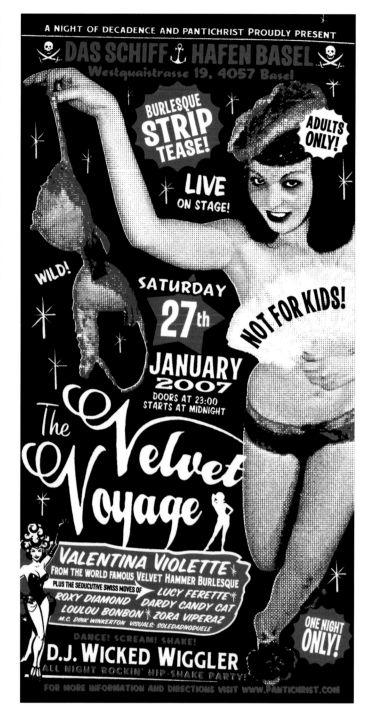

ABOVE: Burlesque poster by Swiss designer Panti-Christ, featuring Valentina Violette from Velvet Hammer Burlesque, 2007.

LEFT: Velvet Hammer poster by the renowned comic book artist and writer of Ghost World fame, Dan Clowes, 1999, from the collection of Don Spiro.

> *"...if you're not up there taking your clothes off and dancing around in pasties and a G-string, it's not burlesque. It can be cabaret...but it's not burlesque."*

Dita Von Teese, *Inked*, 2009

THE ART OF TEASE
From art to grindhouse and back again....

THE AMAZING UP AND DOWN NATURE of the burlesque scene is very much reflected in the evolution of burlesque poster art. Just as burlesque has gone from periods of being centre-stage to then being consigned to the seedier edges of rust-belt towns, so burlesque posters were at the forefront of the development of poster art, and in turn cheap and derivative in their design and production. Yet now, in the midst of the twenty-first century burlesque revival, even these simpler posters are a source of strange inspiration for a new crop of graphic artists; even at its most basic, the spirit of burlesque shines through.

The invention of colour lithography by Aloys Senefelder, an Austrian playwright, in 1798, eventually transformed the nature of poster production worldwide. It allowed high-speed printing and the production of delicate tones and colours. By 1860 the practice of producing larger lithographs was well established, and, rather like burlesque itself, graphic artists from Paris were influencing design in London and vice-versa. New York performers crossed the Atlantic to perform in Paris and thus became the subjects of French graphic designers.

Jules Chéret was a Frenchman working for circus, music-hall and opera companies and for the French perfume business, Rimmel. From London he moved back to Paris, where, financed by Eugene Rimmel, he began his prodigious output. His studio used the latest imported English chromolithographic presses, and in time he would earn the accolade "Maître de L'Affiche" (master of the poster) and, eventually, a Legion d'Honneur.

Chéret, the foremost poster designer of his day, was plugged into Paris's cabaret and circus worlds. Theatres such as the Folies-Bergère, needed the suggestion of excitement and semi-nudity to draw in the crowds, and the graphic skills of Chéret, and the effects achievable by lithographic

LEFT: Iconic 1893 poster by Jules Chéret, for American dancer Loïe Fuller. The poster was revolutionary in showing the artistic potential of the chromolithographic process mastered by Chéret.

29

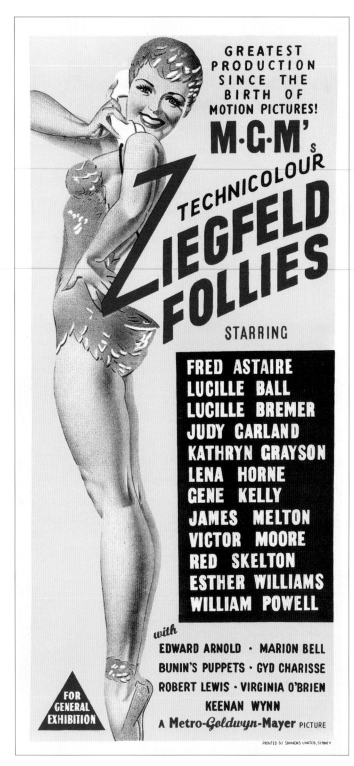

ABOVE: *Ziegfeld Follies* movie poster, 1946.

RIGHT: A musical comedy film *Glorifying the American Girl* was produced in 1929 by Florenz Ziegfeld in which most of the final half of the film is a revue given over to the re-creation of a Follies production. When shown on American TV in the 1950s a number of sequences were cut due to their pre-code content.

presses, were ideal. For the American dancer Loïe Fuller, Chéret produced a series of poster designs which perfectly captured the nature of her diaphanous costumes, and pulled in the punters thick and fast. For Loïe the posters were a revelation – sexier, racier, more theatrical than the photographic posters produced to advertise her in New York. Chéret's posters made their way to New York in 1894 and were an instant success amongst collectors.

Chéret's career coincided with that of the recognized genius of the genre, Toulouse-Lautrec, whose explorations of the demi-monde of Montmartre were to prove such an influence. In 1891 he was asked by Charles Zidler, boss of the Moulin Rouge, to design some posters, with the aim of reviving his audience and to publicise some new dancers the Moulin had recently taken on. Lautrec's career took off on the back of these designs – his design for the poster featuring Louise Webber "The Glutton", whose stage show would popularise the can-can, was an instant hit. The meeting of early burlesque, high society, bohemianism and high art was to prove the apogee of the burlesque poster for a century.

Back in the USA, Florenz Ziegfeld Jr. was sent by his dad, a Chicago music teacher who became the music director for the World's Fair Exhibition, to Europe in 1893, to seek out talent. In the process he found he had a taste for showmanship. On future trips to Europe he discovered the sexy singer Anna Held in Paris, and in 1907 founded the Ziegfeld Follies, intended to be an American equivalent of the Folies Bergère. The shows were a huge success. However, whilst Ziegfeld imported French dancers, he was not influenced by the free-flowing genius of Chéret-style designs. Ziegfeld posters were in the standard art-nouveau style, derivative of songbook covers of the time.

In effect the US trod its own stylistic path. Despite these early connections between New York and Parisian burlesque in particular, and despite the craze for collecting Parisian posters in the US, Paris did not really influence American burlesque posters, or those who commissioned them. Burlesque, notwithstanding Ziegfeld, was rather held in disdain in smarter design circles. The great American poster designers stuck to literary and commercial rather than racy theatrical work. Even Will Bradley, influenced in part by Aubrey Beardsley, and who may have brushed up against the dancers at the World's Fair in Chicago (he designed the covers for *The Columbian Ode*), did not deign to tread where Chéret and Toulouse-Lautrec didn't hesitate. Similarly, the greatest of the American designers, Maxfield Parrish, mostly stuck to book and magazine covers, or posters advertising both types of publications. By the time the Ziegfeld Follies were available on celluloid, there wasn't even much pretence at design – just a standard image with some roughly arranged type by a printer – completely in the manner of any other movie poster of the time.

Britain had seen a brief flurry of a distinct style, graphically strong, as in the early Windmill Theatre programmes. These evoked an almost abstract shape of a windmill, with no real reference to the nature of the

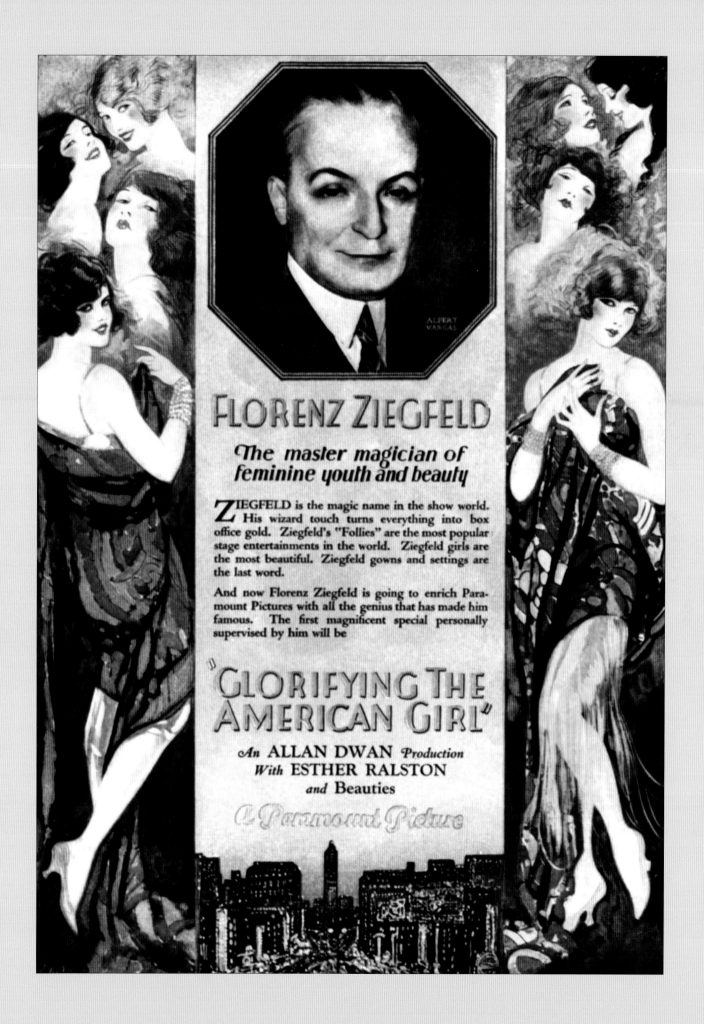

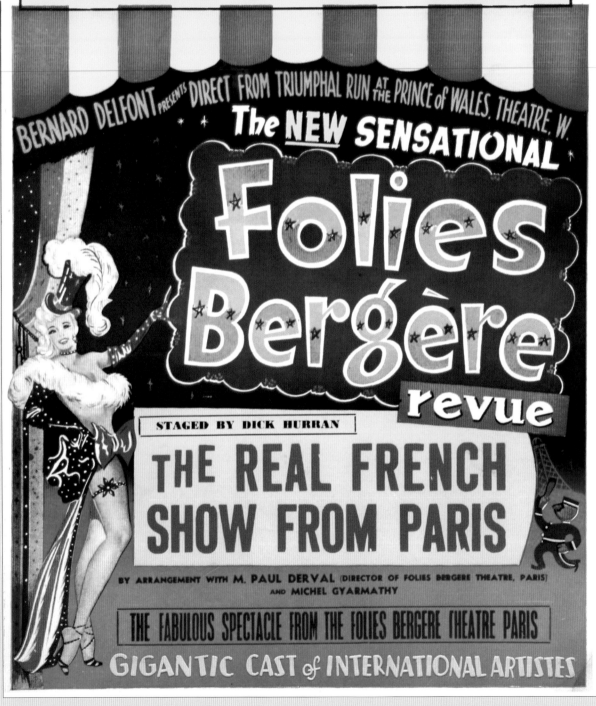

revue; the assumption was that the audience would know. However, with the onset of war, the default position was a return to the most basic playbill explaining in lots of type who was on. A famous early Jane poster did not bother with any imagery, not even a sketch of the celebrated Jane; austerity ruled, and the explanation that this was the *Daily Mirror* cartoon model was enough.

With the end of war, imagery crept back in Britain, albeit slowly and with barely any development in design. The draw was still a known artist on stage, and a photographic image, with some rough typography sufficed. Paul Raymond's Phyllis Dixey show posters, with the strikingly unoriginal title of "Phyllis Dixey in The Phyllis Dixey Show", show an image of Phyllis and the reassurance that she would indeed be appearing in her eponymous show – "In Person" – mentioned twice, are typical of the genre. Explanation rather than suggestion was everything. The poster for the imported Folies Bergère show is striking in its crudeness compared to the French original, explaining that this was "The Real French Show from Paris", repeating the same in a slightly different way, and adding that there was "a gigantic cast of international artistes". Hardly surprising that we know of none of these poster designers' names; they weren't designers but, at best lay artworkers at the printers.

Within a few years all this began to change, and more complex designs had to convey the extra dimension of burlesque on offer. Suddenly evoking the posters from Paris's Folies Bergère was in. Everything was focused on the image of, typically, an anonymous dancer – the smartness of the show was paramount. Text was back to a minimum, the image was a painted screenprint rather than a photographic reproduction, and models were anonymous, sometimes covering their faces with gloved hands, so that the focus was on pastie-covered breasts, legs and tail feathers.

In the British provinces little had changed since the immediate post-war posters, even by the mid-1950s. Paris was a by-word for naughtiness,

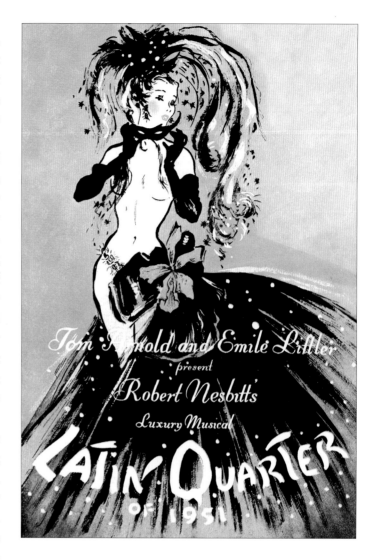

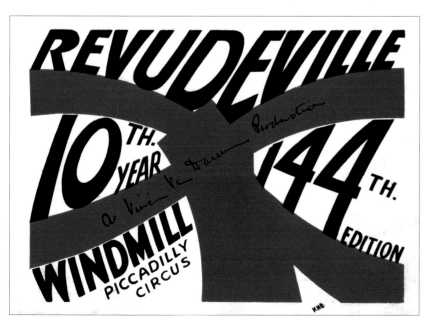

ABOVE: 1951 design for the Latin Quarter review, reflecting the move back to glamour in design, after post-war austerity.

FAR LEFT: Poster for the Folies Bergère revue. The show had been a smash hit in London, before going on tour.

LEFT: Unusually stylish design for the Windmill Theatre's massively succesful Revudeville.

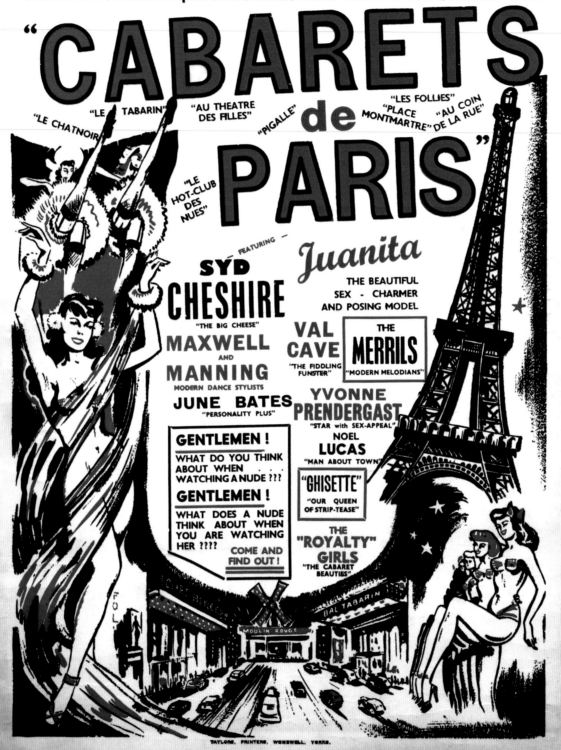

and the excessive amount of text used on posters also tended to be exceedingly cheesy. At once hilarious and pathetic puns abounded: "New Eye-Dears", "We Never Clothed", "She Strips To Conquer", "Nice Goings On, Nice Takings Off", were typical. Posters were liberally scattered with any and every reference to things Parisian. "Folies" was frequently misspelt "Follies" to avoid any legal action from the French revue; one poster, for the Hippodrome Aldershot, featured an unlikely image of a Champs Elysées-like grand avenue leading up to a Moulin-Rouge theatre, with the Eiffel Tower on the right, and scattered mentions of suggestive locations, some invented: Le Chat Noir, Le Tabarin, Au Theatre Des Filles, Le Hot-Club Des Nues, Les Follies, Place Montmartre, Au Coin de la Rue. Some theatre promoters tried to vary the diet for their British audience, and so American themes were introduced, including the completely invented idea of "The banned in America dance of the pound notes".

The contrast with what was going on in Paris could not be more striking. In 1950s and '60s Paris, the iconic status of the Folies Bergère gave the Parisian revues the ability to appeal to a 'sophisticated' and mixed audience, and tourists. The cultural legitimacy of the original French shows and, more significantly, their bigger budgets, allowed them to employ artists such as Aslan (Alain Gourdon) and René Gruau (who designed for Dior, Givenchy and Pierre Balmain) to design their posters. The connection between the burlesque and art worlds was revived.

Back in 1950s USA, the standard photographic movie poster provided the paradigm for almost all burlesque act posters. The fact that many burlesque starlets were also acting in movies, or modelling, meant a ready supply of stills was available. As a result American burlesque moved away from printers' tendencies to shower everything in standard type. Many designs emerged from show boards placed outside theatres, and relied on the sexiness of the image to do their work: Lady Godiva and her Strip-Tease Horse is a classic of this genre. She looks amazing, the picture conjures up all sorts of fantasy, but exactly what the show entails is not spelled out. In smaller theatres, the challenges faced from the censors meant that only the most basic bill-poster designs were used. Very few of these survive, not least as they were seen by collectors as having no merit.

As live burlesque shows went into decline, burlesque itself was finding some new life in the sexploitation movies of the late 1940s and early 1950s. Russ Meyer worked with Pete DeCenzie, the owner of the El Rey Burlesque Theatre in Oakland, California, filming the (now lost) 1950 production *The French Peep Show*. This featured legendary burlesque queen Tempest Storm and others performing their acts, although the poster does not survive. However, film-makers were using burlesque as a source of inspiration and censor bi-passing titillation; in effect movies began to consume the stage acts.

In the wake of this, a new self-consciously retro design style for some of the film posters emerged with, in some instances, an almost nostalgic nod to burlesque's stage past. The poster for *Naughty Dallas* looks at

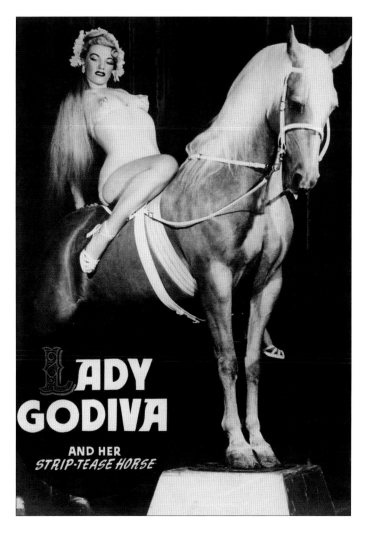

ABOVE: Show board for Lady Godiva and her Strip-tease Horse.

LEFT: Poster for the twice-nightly *Cabarets de Paris* at the Hippodrome, Aldershot, 1956.

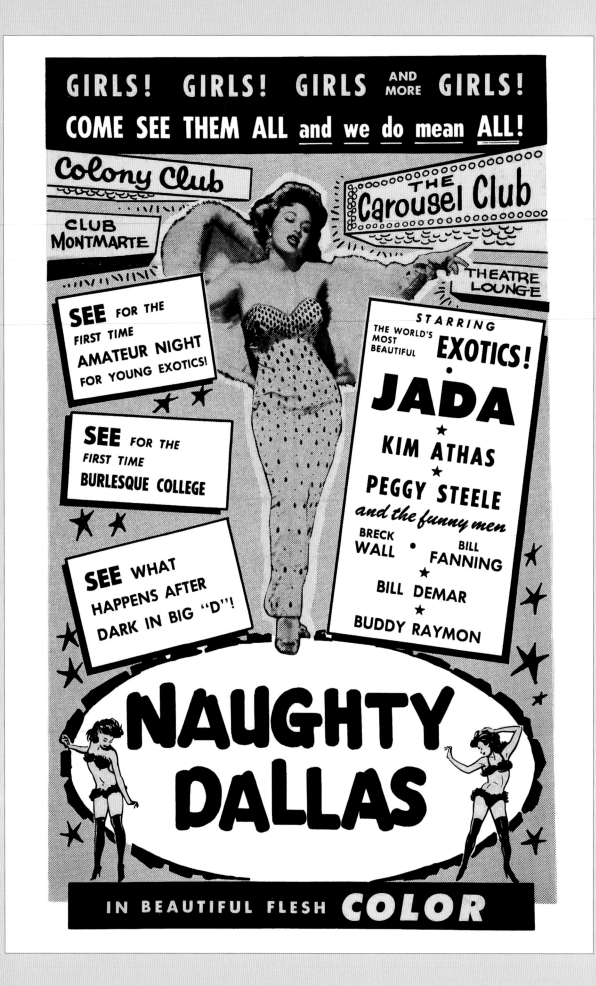

first sight like a classic 1940s standard, low production value, burlesque show poster; the only giveaway that this was for a movie rather than a live performance is the burlesquey faux-cheesy strapline "In Beautiful Flesh Color"; the poster even has the obligatory mis-spelling of French words, in this case "Club Montmarte". Designers were beginning to find retro inspiration. A new distinct burlesquey-style was emerging. A further development was the use of standard photographs of burlesque stars and old-fashioned bill-poster typography, which could have dated from the 1890s. This type almost became the US burlesque standard, suggesting nudity, titillation, and sauce, but with a faux-naïveté that somehow made it charming, with an almost girl-next-door quality. Usually the photographs were superimposed in a collage, but by the mid-1950s cutting-out became more common, with the result that designs appeared more integrated.

By the turn of the 1960s there was a move back to a more cartoony representation for movies with a burlesque inspiration, led by posters

LEFT: Featuring classic burlesque acts and comedy, *Naughty Dallas* was shot on location at Abe Weinstein's Colony Club as well as Jack Ruby's Carousel Club (Jack Ruby fatally shot Lee Harvey Oswald in 1963). The film is the story of a girl who comes to Dallas wanting to make it big in showbiz. She wins a stripping contest and lives happily ever after.

BELOW: Poster for the 1950 movie *International Burlesque*. Aimed at grind houses, and costing only $50,000 to make, it starred Betty Rowland and showed the hilarious backstage antics of dancers, strippers, comics and other performers as they prepared to stage the big show.

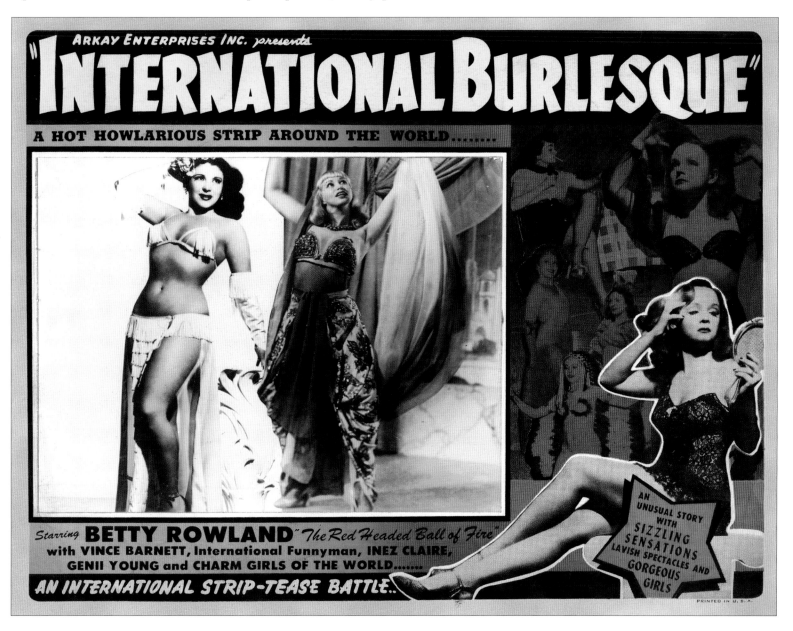

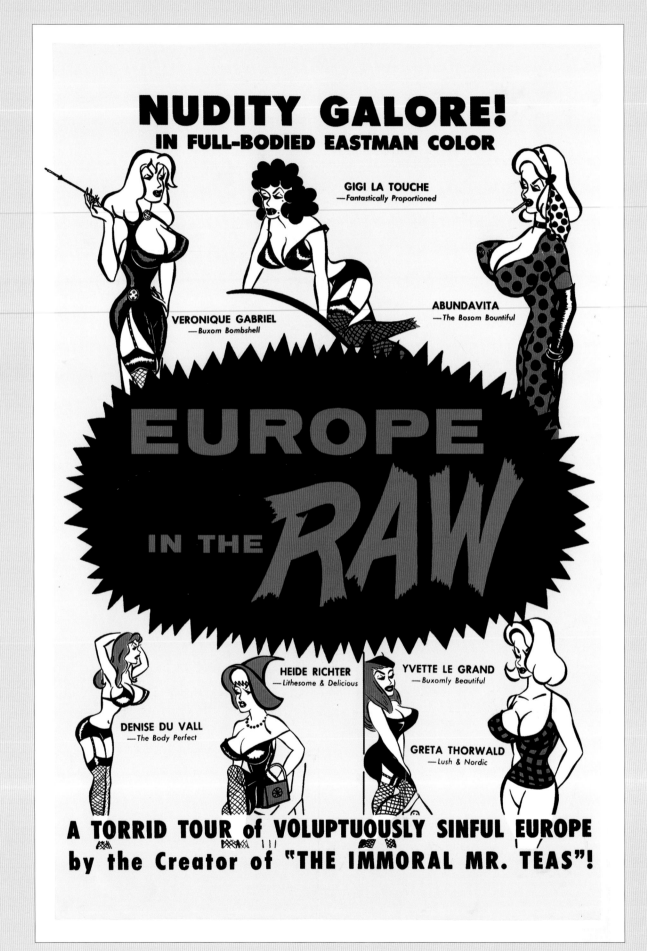

for Meyer's "nudie cutie" (his definition) movies. Meyer was completely uninterested in the standard voyeuristic, pseudo-documentary sexploitation movies being created as a way of showing nudity on screen whilst avoiding the censor. He turned down several offers to film naturist camps for instance. His movies had a more direct and honest purpose; sure he loved nudity, but he loved plot and wanted to explore the nature of female sexuality, male fantasy (not least his own), and the psyche of the viewing audience. And everything in his early movies had an undercurrent of humour. This had always been a staple of the live burlesque show: the in-house comic who would introduce the strippers, and might perform the odd skit with them, was, in effect, present in these Meyer movies as the voice of the narrator. In posters for his early movies, this translated into a cartoon treatment, with the humour rather than prurient titillation uppermost. *Europe in the Raw* illustrates the point. There was no wink wink about this, just fantastically cartoony depictions of leading ladies with vast breasts.

By about 1964 the "nudie cuties" were over for Meyer in particular, and for the market in general. Earthier, and bolder, movies were being imported from Europe and there was a shift in the sexual object of desire: *And God Created Woman* with Brigitte Bardot was showing the way forwards. The burlesque movie was gone, and with it the last vestiges of burlesque as a source of inspiration. It wasn't until the 1990s that a new sub-culture, connected subsequently by the internet, began to emerge, once more celebrating burlesque as a vibe and an art form. With this shift came an explosion in art and creativity which transformed the nature of the burlesque poster, the principle theme of this book.

Behind this movement were a number of hugely talented lowbrow artists, whose work had enormous energy and vibe. Working mostly in Southern California, many were plugged into the music scene and were major contributors to the boom in rock posters in the late '80s and early 90s. Artists like The Pizz, Coop, Robert Williams and Von Franco led the scene. Their work was featured in the newly formed magazine *Juxtapoz*, which itself became a catalyst for more artists to let creative juice flow. Traditional poster designers, such as Alan Forbes, also created influential designs and there was, in turn, crossover from comic books artists such as Dan Clowes.

There were also the early, but strong, shoots of a retro revival, in part a reaction to E-fuelled rave culture. The last thing you needed for a spaced-out weekend in a tent out in a field was any form of dressing-up attire; many missed the latter, and retro provided the answer. Dave Stevens's comic book *The Rocketeer*, set in 1938, featured a superhero inspired by the pulp heroes of the 1930s and 1940s. Appearing first in 1982, it also featured a character based on Betty Page. The growing fetish scene also adopted Betty Page as an icon. Page, a pin-up and bondage model of Irving Klaw's, appeared in the 1952 burlesque movie *Striporama*, and then in Irving Klaw's *Teaserama* and *Varietease*, which also featured classic burlesque acts

ABOVE: Tura Satana by Mitch O'Conell. Tura Santana played the iconic Varla in Meyer's 1965 cult classic movie *Faster Pussycat! Kill! Kill!* Born in Japan, Tura grew up in Chicago and became a dancer aged 13; "when I was dancing burlesque was an art - classy and elegant and requiring talent. I got out of it when it started to become raunchy and lost the art".

LEFT: In 1963, film director and auteur Russ Meyer made *Europe in the Raw*. Three years before *Mondo Topless*, this feature was shot in Amsterdam and Paris. Much of the filming was on location with the camera concealed in a briefcase. It's arguably not so much a burlesque film as more a mondo documentary on the night clubs of Europe.

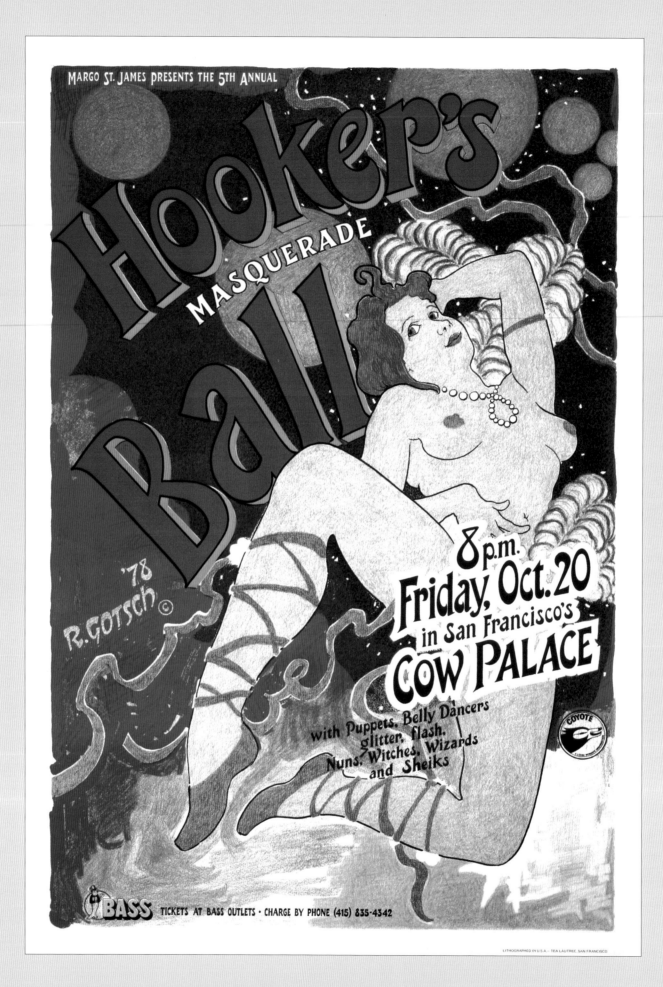

Tempest Storm and Lili St. Cyr. With go-go dancers becoming a frequent support act to many bands, the connections between music, retro, fetish, cartoon and the early burlesque revival were complete.

So when Velvet Hammer needed a poster for their events, it was the most straightforward thing to ask an artist such as The Pizz, already plugged into the rock and retro revival, to create a poster. The Pizz was one of a number of hugely talented artists on the scene. Velvet Hammer subsequently commissioned Von Franco, who worked with Ed "Big Daddy" Roth, rock poster artist Chris Martin and the brilliant Japanese Rockin' JellyBean, whose work was hugely influenced by the legendary artist Robert Williams.

Here was the critical difference between the original burlesque posters and the retro revival. Where the French designers had created a new form of poster art and the Americans and Brits had been pretty prosaic, the lowbrow scene had a massive fund of retro material to draw on, from rock, to fetish, to cartoons, to bondage. The internet had also allowed all these worlds to re-emerge as global sub-cultures, and the audiences were infinitely more culturally savvy than they had been in the 1950s. There was an echo of the poster collecting of almost a century earlier, when at the Miss Exotic World Pageant, a burlesque poster competition was held, with entries auctioned off to raise money for the Burlesque Hall of Fame.

As the number of burlesque troupes increased, so the sources of inspiration for their poster designers multiplied. Chaz Royal's London Burlesque Festival carved out a distinctive niche, with Colin Gordon's designs finding inspiration in classic British motifs, such as bowler hats, the Union Jack, elements from the Royal coat of arms and the symbol for the London Underground. Chaz's commissions drew on a number of other retro traditions, from wartime posters for his Burlesque not Bombs shows, to re-creations of original grindhouse posters for his Burlesque Social Club, the latter executed so authentically that it's almost impossible to tell them apart from the originals. Fluffgirl Burlesque went from art nouveau lettering, and designs evoking Aubrey Beardsley, to 1960s comic book type. Mark Reusch of Black Cat Burlesque created a look inspired by horror, monsters and zombies, working almost entirely in acrylics and fluorescent paint, before doing the final tweaks on a Mac. Hubba Hubba developed posters inspired by Mucha, striking a contrast with the burlesque stars depicted, as in Totally '80s, a classic nod to early 1980s porn, the star wearing just an open doctor's coat, panties, some cool shades and a come-hither look. As the looks got more diverse, so there was a return by some to the classic 1890s high-chic artistry. The Dirty Show commissioned interesting diverse work: Dirty Show No 9 is an elegant and sexy line drawing of a dancer, completely Parisian in essence. Not surprisingly it was by a Frenchman, André Dubeau.

Amidst all this inspiration, eclecticism and a crossover of influences, there was one strand of burlesque which retained a simplistic, raw, one-track approach. Lucha Libre, or Mexican wrestling, became popular in

ABOVE: Poster for the Burlesque Hall of Fame, 2009.

LEFT: Created to promote the fifth and largest, most outrageous of the annual *Hooker's Masquerade Balls* in San Francisco. Organized by Margot St. James as a fund raiser on behalf of the organization she created and led, C.O.Y.O.T.E. (Call Off Your Old Tired Ethics), which worked for the legalization of prostitution, this particular event was the high-water mark for C.O.Y.O.T.E., filling the Cow Palace. Poster designed by Robert Gotsch, 1978.

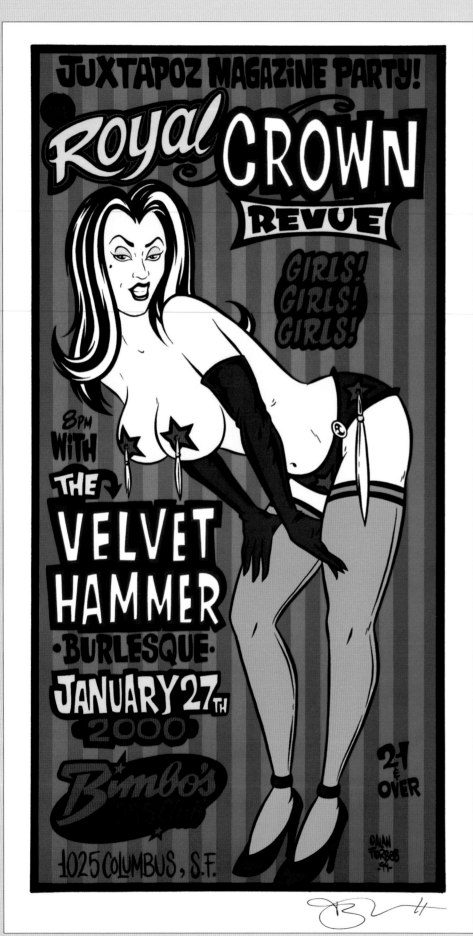

LEFT: *Juxtapoz* magazine party poster by Alan Forbes, who has made a name for himself doing posters and album covers for bands such as The Black Crows, Queens of the Stone Age, Electric Frankenstein and The Phantom Surfers.

RIGHT: *The Immodest Tease Show* (T.I.T.S), 2006, inspired by Paul Raymond's initially challenged production *This Is The Show* half a century earlier. Pathetically, in 2008, British magazine censors insisted that the acronym T.I.T.S. could not be used: the title had to be written out in full.

RIGHT: Hubba Hubba Revue: *Asylum!* May, 2009, by R. Black.

THE IMMODEST TEASE SHOW

WWW.T-I-T-S.BIZ

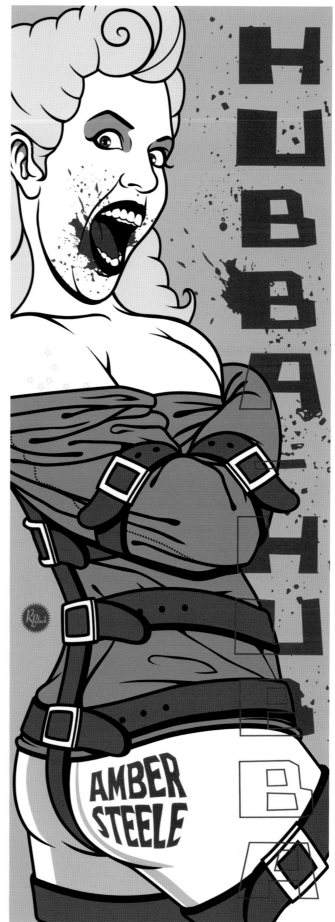

the US following its appearance on cable. Lucha masks, quite common in Mexico, became ubiquitous in the States as a way of characterising the wrestlers and distinguishing the rule-breaking "heels" (rudos) from the "good guys" (tecnicós). In a brilliant flash of inspiration, Lucha VaVoom mixed Lucha with burlesque, and a whole new phenomenon was born. There was enough energy in all this (and unlike more recent burlesque this was not retro but very *now*), that sophisticated design by individual artists was not necessary to get the vibe across. Lucha VaVoom's posters are completely in this vein, featuring masks, straight photos of fights and standard bill-poster lettering. There is a more than an echo here of the approach of grindhouse in the 1950s: the poster not as design object, but as a way of communicating direct information, as in "Three Big Nights of Sexo Y Violencia". Occasionally the backgrounds would change to reflect the theme of the evening, so a horror night poster might feature some images from Mexican sci-fi or B-movies, or skulls and bats would be used on a poster for a Halloween evening, but the formula is always essentially the same.

The decade and a half since the mid-'90s has been an amazing time for burlesque poster design. It was at its best when the revival was underground – a subculture connected with the world of bands, kustom, lowbrow, cartoons and all things retro. The risk now, as burlesque goes mainstream, is that the whole movement will become too self-conscious to retain this level of energy and invention. Where shows might have been held in small, edgy venues, many are now big business and being staged in major theatres, not least in Vegas. The role of the poster artist in projecting the spirit of burlesque is now more critical than ever. They have to keep pushing boundaries. If R. Black's latest, brilliant, raucous designs for Hubba Hubba are anything to go by, perhaps we don't have to worry after all.

NUDE REVUES

Bombshells over Britain

ALMA THEATRE
LUTON

TELEPHONE 1901 TELEPHONE 1901

6.15 ★ WEEK COMMENCING MONDAY, FEB. 26th ★ 8.30

GASTON & ANDREE PRESENT

FRENCH FOLLIES

THE SENSATIONAL AND SPECTACULAR FRENCH REVUE

CARL & ROGER DUDLEY THREE
YALE ★ DALE ★ HICKS
AND HIS SINGERS

FREDDIE
KOTCHINSKY & GRETYNA ★ HARRISON

PAULETTE D'ORSAY ★ BETTY BROUGHTON

THE ANDREE PARIS MODELS

FLORENCE WHITELEY PRESENTS
THE DE LELO BALLET

TRIBE BROS., Ltd., London & St. Albans.

FAR LEFT: 1955 poster for the *French Tit-Bits* show, with characteristic feeble pun.

LEFT: Poster for *French Follies*, a deliberate echo of the Folies Bergère.

47

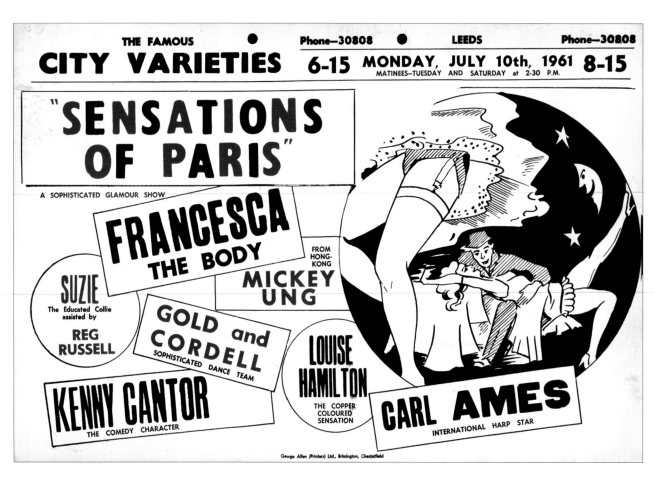

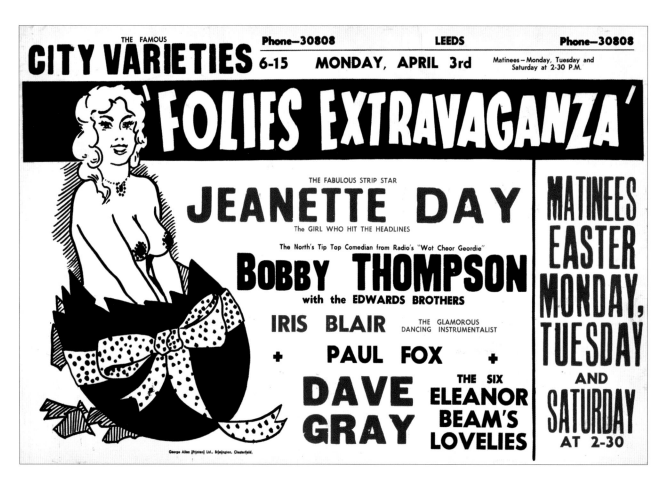

LEFT: Poster for another Parisian-inspired show, *Sensations of Paris*.

BELOW LEFT: Easter-egg themed poster for *Folies Extravaganza* in Leeds. Unusually for an English poster, "Folies" is spelt French-fashion.

RIGHT: Poster for *Oo! La La! Cherie*, interesting for including the vital statistics of its principal dancers.

HIPPODROME THEATRE
ALDERSHOT

LESSEES : MILSTEAD PRODUCTIONS LTD. GEN. MAN. & LICENSEE : NEWMAN MAURICE TELEPHONE 2304 MAN. DIR. : J. ROWLAND SALES, F.V.I.

MONDAY, 24th SEPT. ■ **6-0** Twice Nightly **8-10**

DICK RAY PRODUCTIONS present
THE YEARS FASTEST SHOW

THIS IS IT!
THE HIT of the CENTURY

"OO! LA LA! CHERIE"

A SLICK, SPICY & HOT REVUE!

JIMMY MALBORN
BRITAIN'S GREAT COMEDIAN

THE RAMONI BROTHERS
Britain's Ace Dancers

PAT WARD YOURS IN HARMONY **& SYD RAYMOND**

INTERNATIONAL POSING MODELS

RAYMOND RAY
THE LITTLE BRIGHT SPARK

BUDDY SMART

LOOK at the NUDES MEASUREMENTS
THE BLONDE 37½, 25, 37
The BRUNETTE 38, 21, 37

THE COMEDIANS FOIL
LILLIANE PEARSON

 THE GLAMOROUS LOVELIES
LARRY GORDON SHOW GIRLS

SHOW PUBLICITY SERVICE, LONDON W.1.

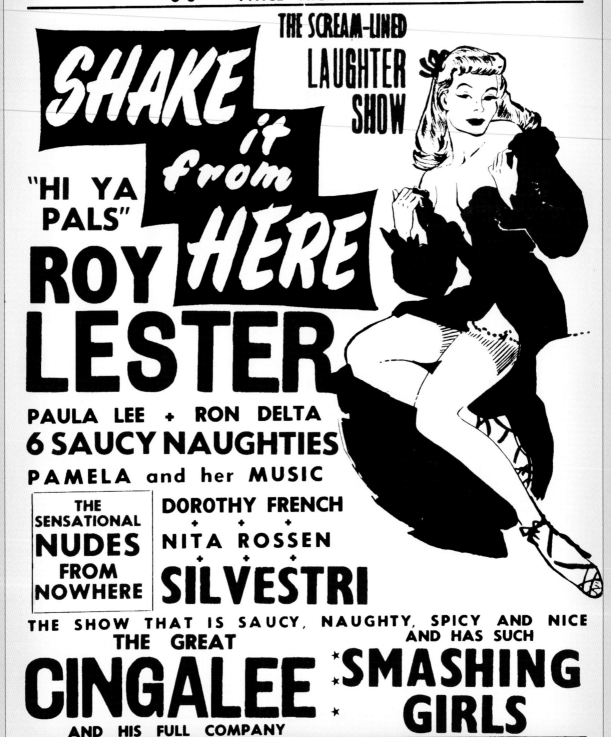

HIPPODROME

Lessees—Milstead Productions Ltd.

ALDERSHOT

Managing Director—Rowland Sales

Manager and Licensee—Newman Maurice

WEEK COMMENCING MONDAY, APRIL 30th, 1956
6-0 — TWICE NIGHTLY — 8-10

THE SCREAM-LINED LAUGHTER SHOW

SHAKE *it from* **HERE**

"HI YA PALS"

ROY LESTER

PAULA LEE + RON DELTA

6 SAUCY NAUGHTIES

PAMELA and her MUSIC

THE SENSATIONAL **NUDES** FROM NOWHERE

DOROTHY FRENCH

+ + +

NITA ROSSEN

+ + +

SILVESTRI

THE SHOW THAT IS SAUCY, NAUGHTY, SPICY AND NICE AND HAS SUCH

THE GREAT

CINGALEE

AND HIS FULL COMPANY

★ **SMASHING GIRLS**

George Allen (Printers) Ltd., Brimington, Chesterfield

ALMA THEATRE
LUTON
RESIDENT DIRECTOR & LICENSEE: H. G. CAREY Phone: 5780-1
GENERAL MANAGER: NEWMAN MAURICE

WEEK COMMENCING MONDAY, FEBRUARY 11th, 1952
6-15 — TWICE NIGHTLY — 8-30

DON ROSS'S
LOAD OF MISCHIEF
HERE COME THE GIRLS
— FEATURING —
JACK ANTON
AND THOSE
20 GORGEOUS GALS

TAYLORS, PRINTERS, WOMBWELL, YORKS.

FAR LEFT: 1956 poster for the *Shake It From Here* show. The poster is interesting for its ironic reference to the normal tag lines over-inflating the pedigree of their dancers: here it's "the nudes from nowhere".

LEFT: 1952 poster for *Here Come The Girls* show. The message is simple and, unusually, there is no attempt to suggest that this is a naughty Parisian import.

51

ARTHUR FOX brings you...

STRIP TEASE PEEP-SHOW

THE NAUGHTIEST GIRL OF ALL

PAULINE PENNY

SHE STRIPS TO CONQUER

PEEP SHOW POSERS

THE STRIP STARLETS TAKING A LESSON IN STRIP TEESE

FEY JOVER

THE PEEP SHOW GIRLS CLARK STEVENS

JOHNNY NOBLE
MARION JOHNNY TRIXIE
WILDE RAGOLDI KENT

KELTY & DELLA

BARRY PIDDOCK

A NEW COMEDY STAR
JIMMY EDMUNDSON

ELECTRIC (Modern) PRINTING CO. LTD., MANCHESTER 8

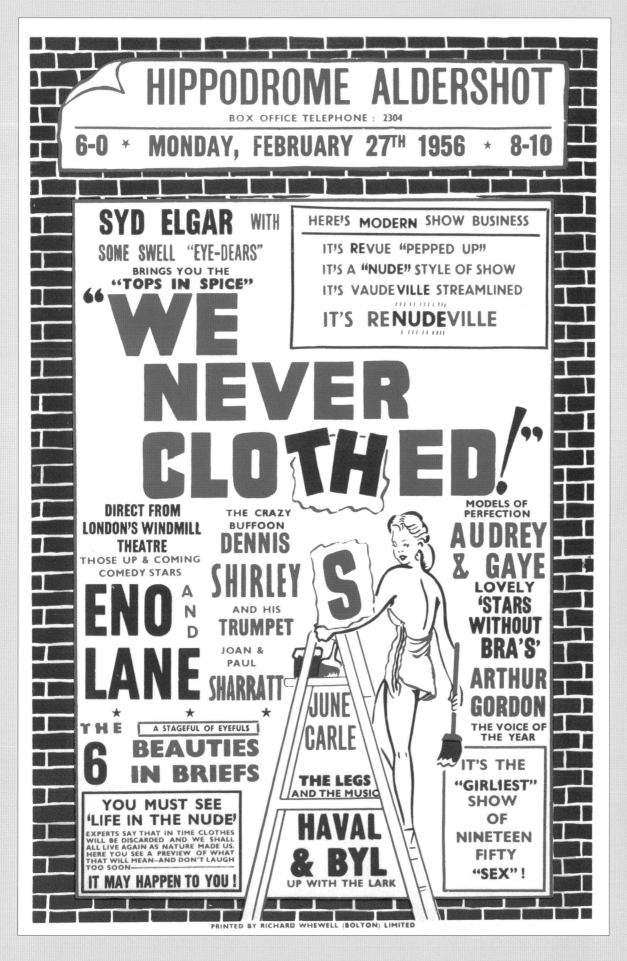

FAR LEFT: *Strip Tease Show* show with the regular weak puns. "She Strips to Conquer" is a reference to the Oliver Goldsmith play *She Stoops to Conquer* about a high-class girl who has to pretend to be a barmaid to pull her man.

LEFT: *We Never Clothed* poster for the 1956 show in Aldershot. Here the RevuedeVille strapline for the Windsmill Theatre in London is adapted into the name of the show, a rare case of London being the inspiration rather than Paris.

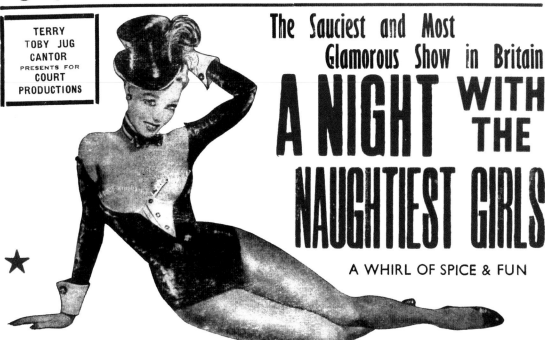

HIPPODROME
ALDERSHOT

Lessees : Milstead Productions Ltd.
Managing Director : J. Rowland Sales

Resident Director & Licensee : Newman Maurice
Telephone BOX OFFICE, ALDERSHOT 2304

6-0 Monday, 22nd October **8-10**
TWICE NIGHTLY

TERRY TOBY JUG CANTOR PRESENTS FOR COURT PRODUCTIONS

The Sauciest and Most Glamorous Show in Britain

A NIGHT WITH THE NAUGHTIEST GIRLS

A WHIRL OF SPICE & FUN

At Last ! She's Here ! In Person !

THE WORLD'S MOST BEAUTIFUL NUDES

PAULINE 'TAKE 'EM OFF' PENNY

A STAGE FULL OF GLORIOUS LOVELIES

THE SIX SAUCY SYRENS

TERRY 'TOBY JUG' CANTOR

LOTUS AND TOIYA KEE THE LOVELY
CHINESE NUDES

JACKIE FOY

GABRIELLE

'RED' PRESTON ★ SUSAN SCOTT

HAL SWAIN & his SWINGSTERS

JIMMY NOON

THE BIG SHOW OF THE YEAR

DALE WARREN

THE REVUE WITH SEX APPEAL

KENNY CANTOR

SHOW PUBLICITY SERVICE, LONDON

54

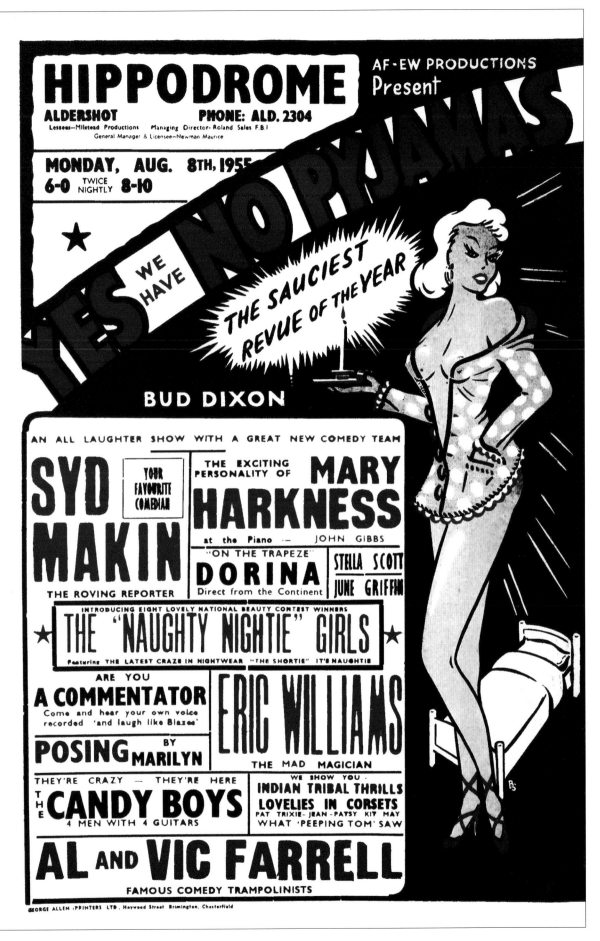

FAR LEFT: *A Night With The Naughtiest Girls* poster for the Aldershot Theatre.
The show promised "The world's most beautiful nudes" and added spice in the form of Chinese nudes.

LEFT: 1955 poster for the hilariously-titled
Yes We Have No Pyjamas show.
The poster emphasized the comic side of the evening, promising "an all laughter show".

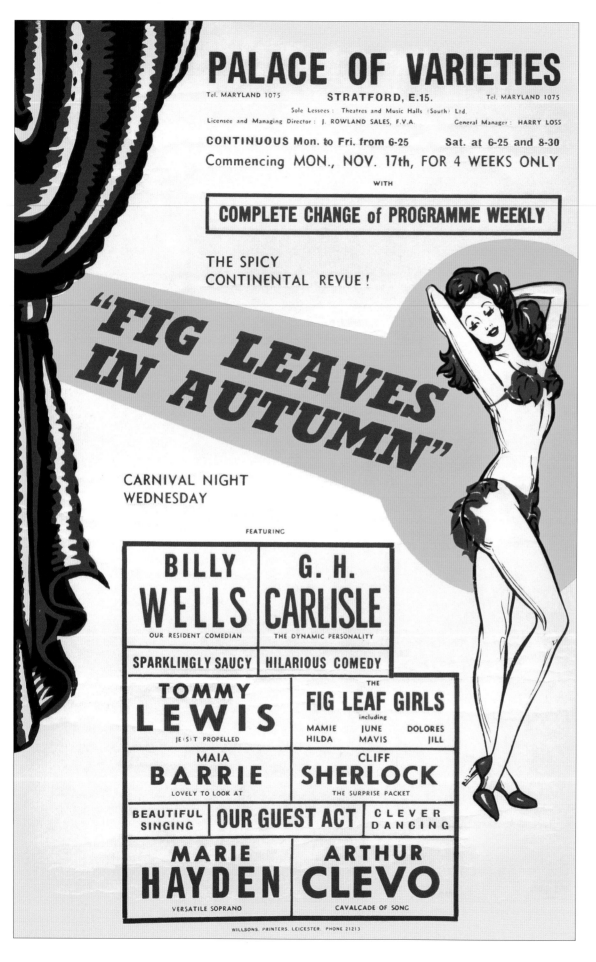

LEFT: Poster for the *Fig Leaves in Autumn* show at Stratford, East London. A "spicy continental revue" is promised. "Continental" to the English meant across the Channel, in other words, France and, by extension, Paris.

RIGHT: 1955 poster for the *Nice Goings On* show at Aldershot. The poster is a classic of cheesy puns, promising "nice takings off" and "a show for "broad"-minded people".

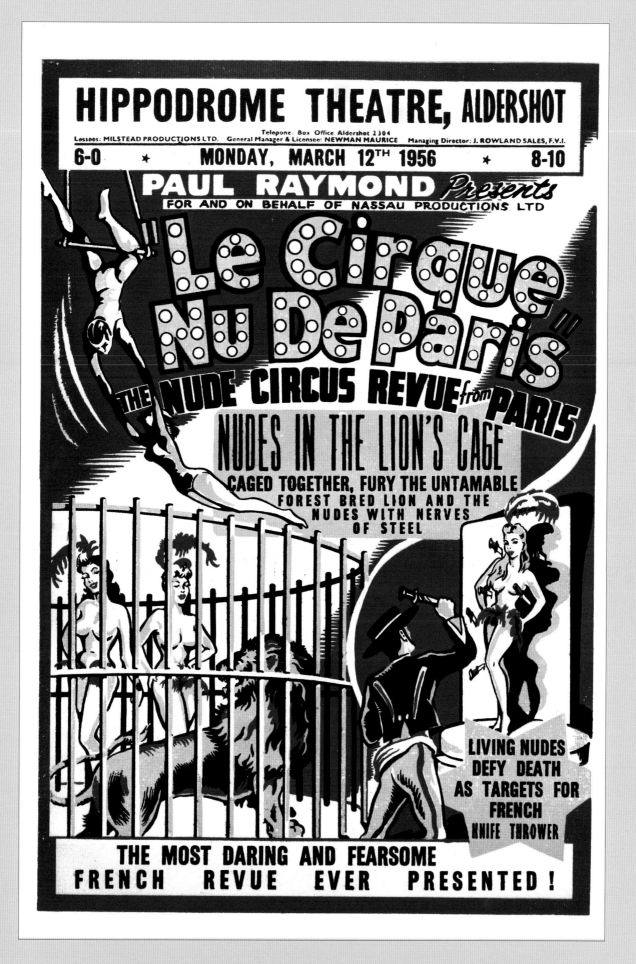

GRINDHOUSE USA

The classiest act in town

LEFT: *Dreamland Capers*, (1958), from roadshow producer Willis Kent. Directed by Harry Wald and starring Justa Dream.

HARRY WALD
Presents
THE GIRL FROM
OUT OF THIS WORLD

JUSTA DREAM
in
"DREAMLAND
CAPERS"

Snappy
Adult Entertainment

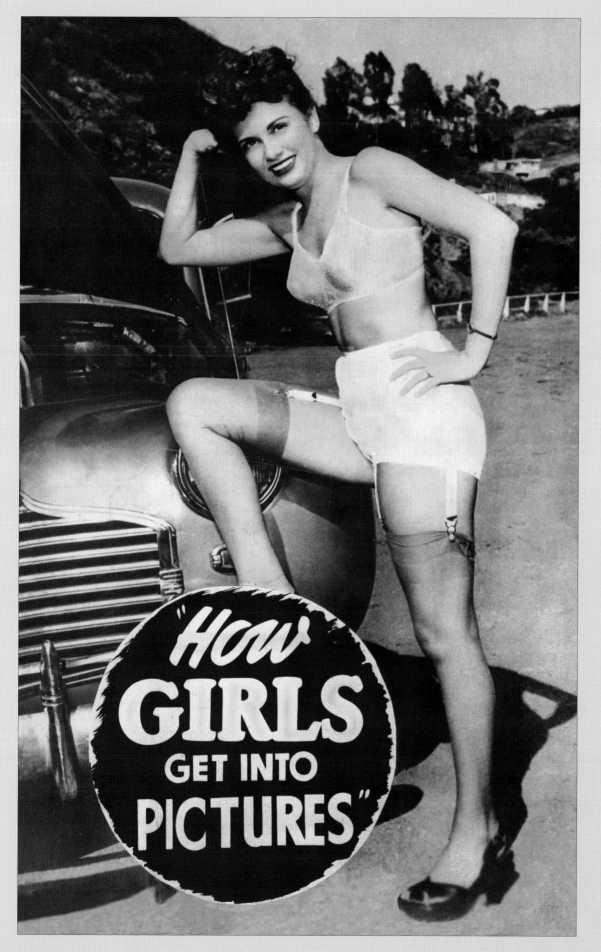

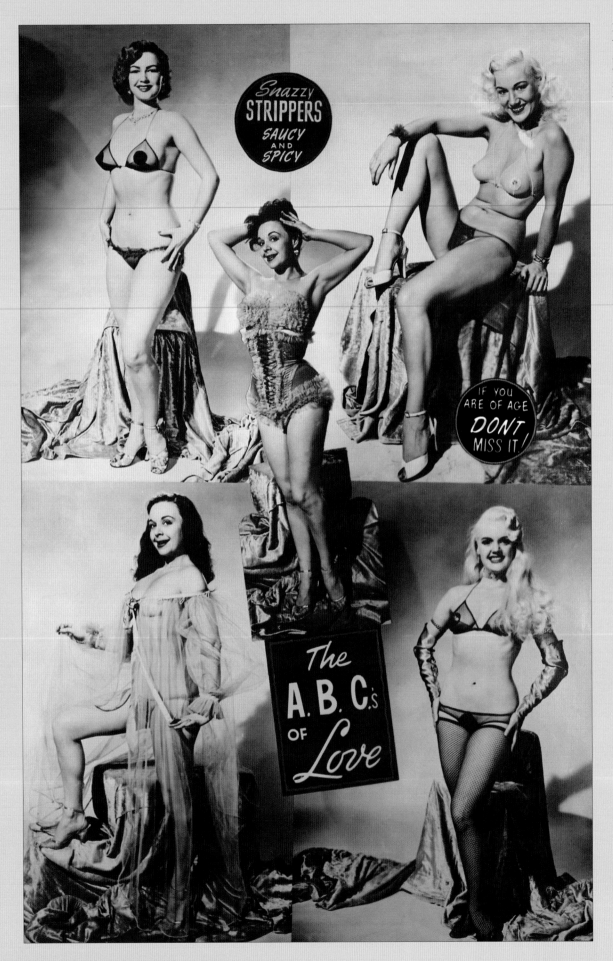

LEFT: As "the maddest, merriest whirly-girly show", *The ABC's of Love* (1954), starring Gilda "The Golden Girl", is one of the most renowned burlesque feature films, a treasure trove of titillating Americana.

Snazzy **STRIPPERS** *SAUCY AND SPICY*

IF YOU ARE OF AGE *DON'T* MISS IT!

The A.B.C.'s OF *Love*

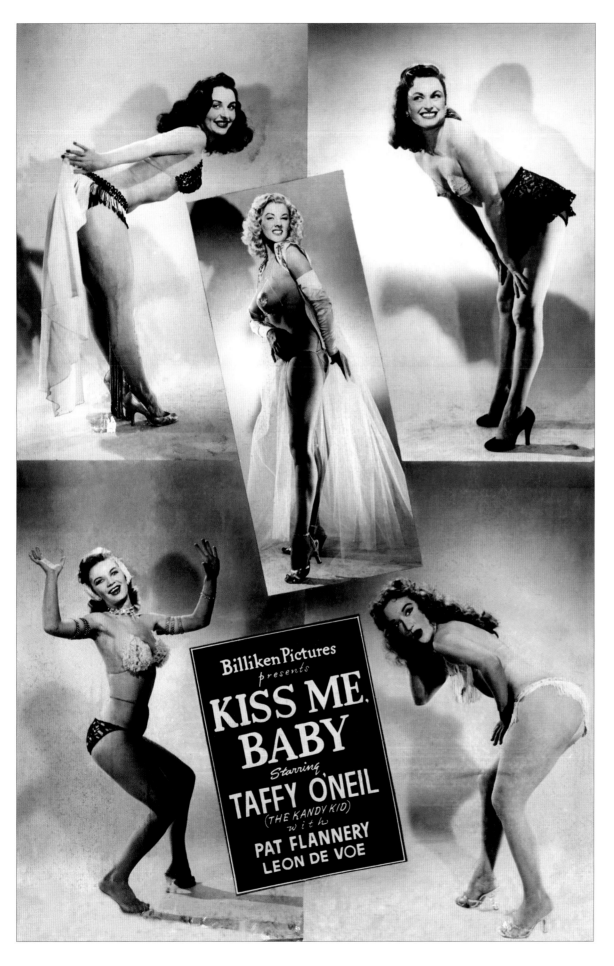

LEFT: *Kiss me, Baby* (1957), directed by Lillian Hunt and featuring the bosomy headliner Taffy O'Neil, "The Kandy Kid of Burlesque".

Billiken Pictures
presents

KISS ME, BABY

Starring

TAFFY O'NEIL
(THE KANDY KID)
with

PAT FLANNERY
LEON DE VOE

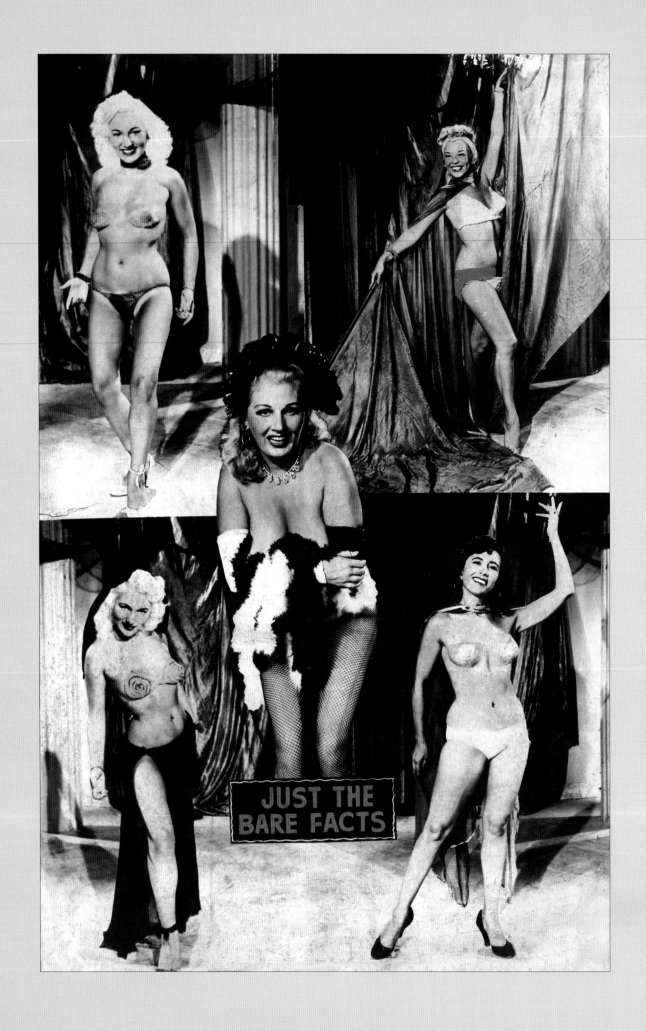

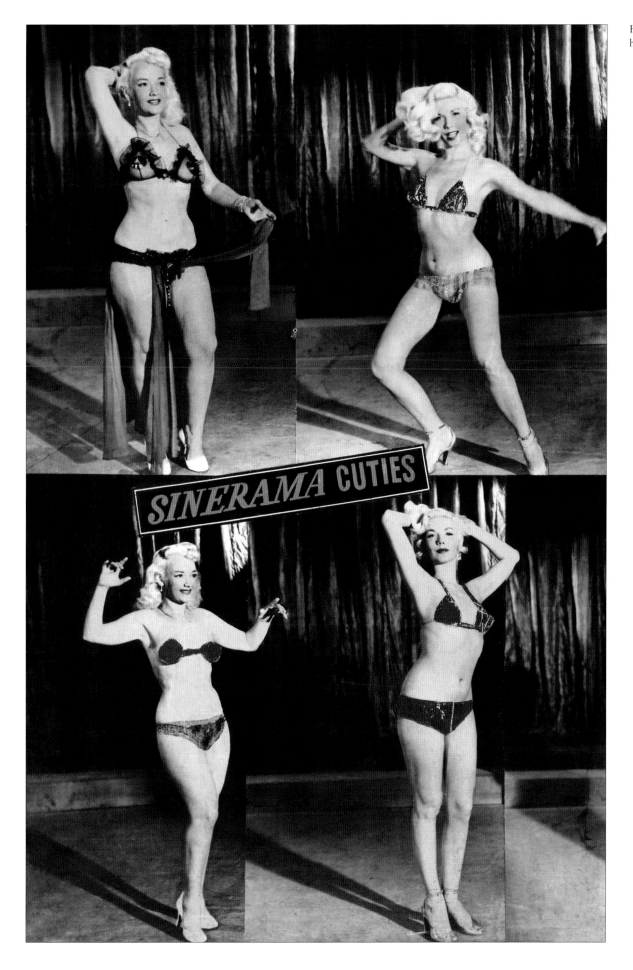

SINERAMA CUTIES

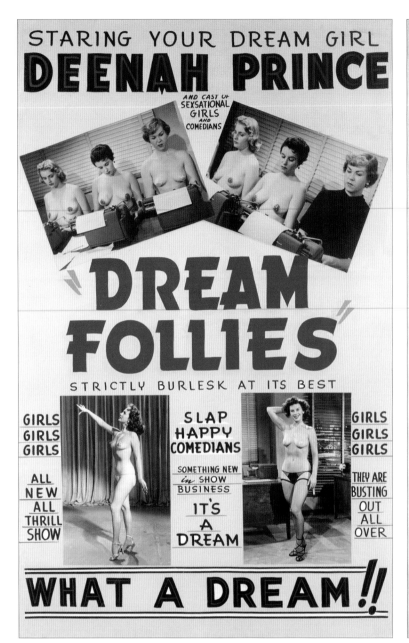

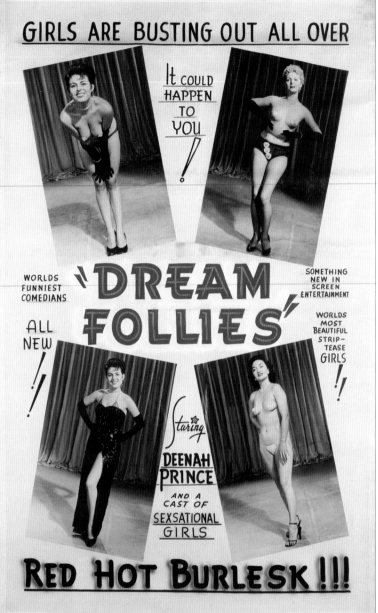

ABOVE AND RIGHT: *Dream Follies* (1954) was written and features an uncredited early performance by Lenny Bruce, the stand-up comic and social critic, who gets to dump a bowl of spaghetti on the head of his real-life mother, while playing Hitler, playing a waiter. The film was directed by Phil Tucker who directed his first six feature films in the span of two years while still in his mid-twenties. He is best known for his first film, the science fiction B-movie *Robot Monster*, and for the Lenny Bruce movie *Dance Hall Racket*.

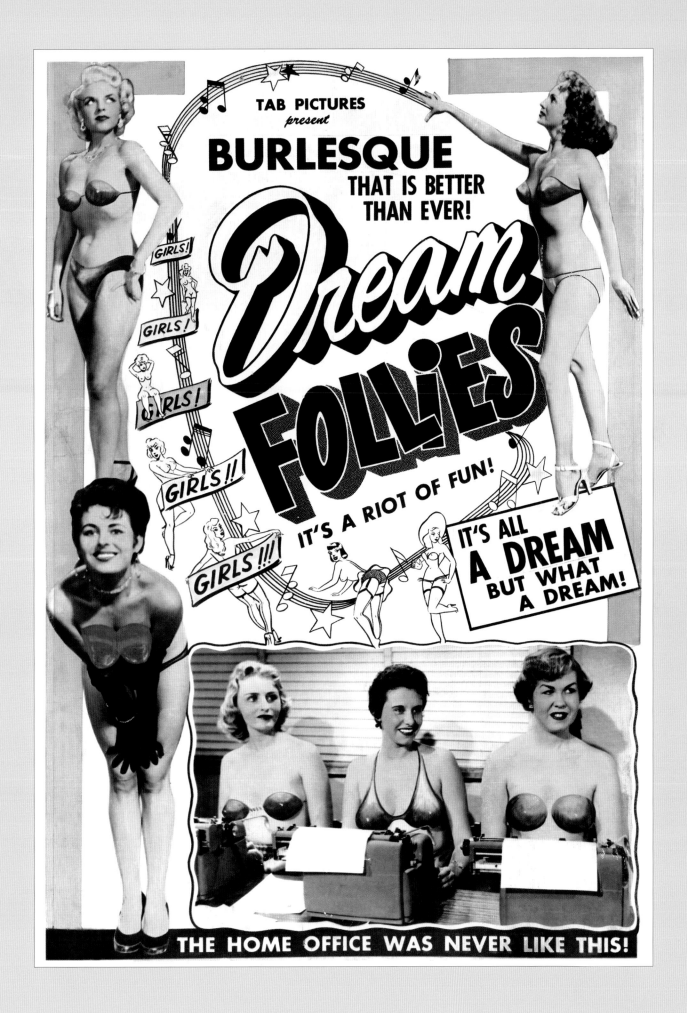

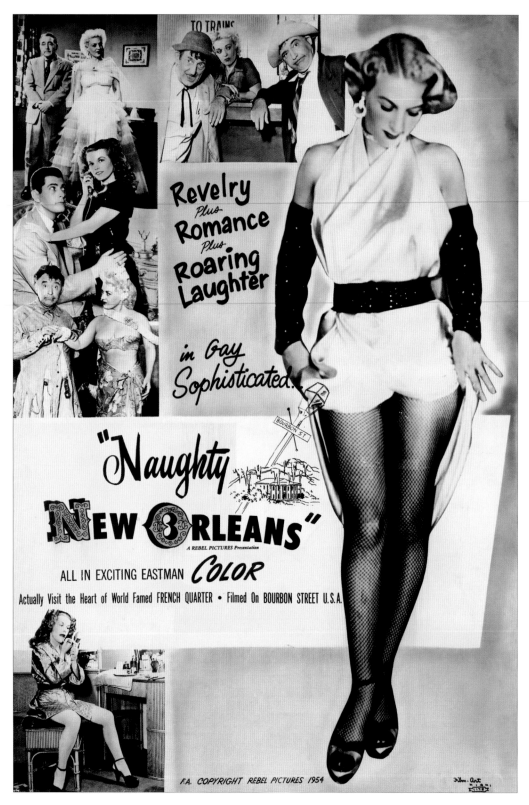

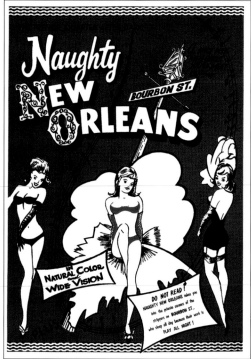

THIS PAGE: *Naughty New Orleans* (1954), "a spicy treat with the girls you'll meet on Bourbon Street!", starts off as a travelogue, but soon we meet a gal in a New Orleans nightclub where strippers sensuously strut their stuff, giving new meaning to the phrase "The Big Easy." Directed by Sidney Baldwin.

RIGHT: *Strippers Parade* featured the big burlesque stars Tempest Storm and Lili St. Cyr, and the then up-and-coming Betty Page, who would eclipse them both.

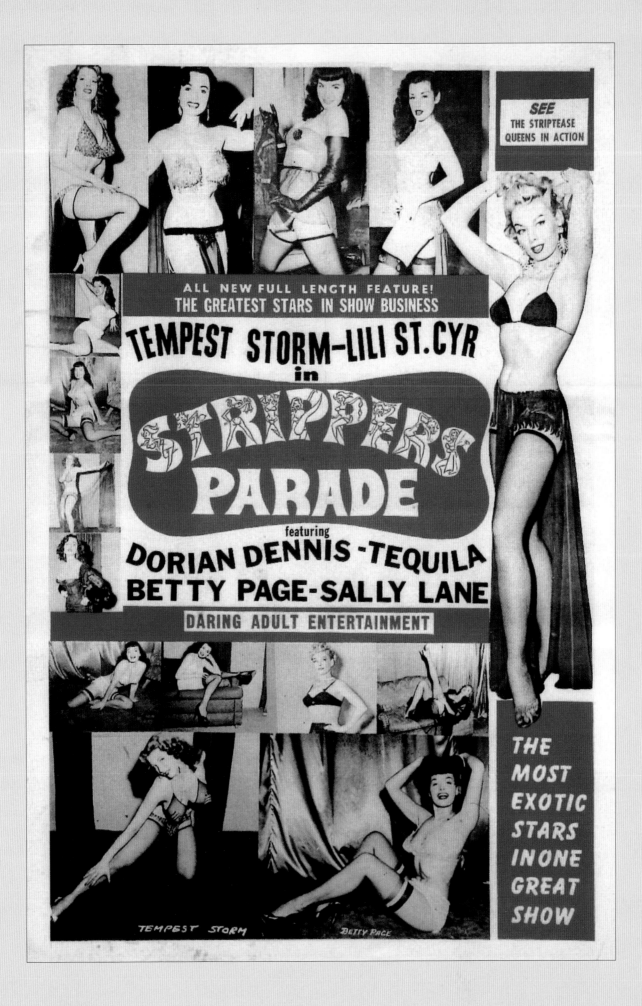

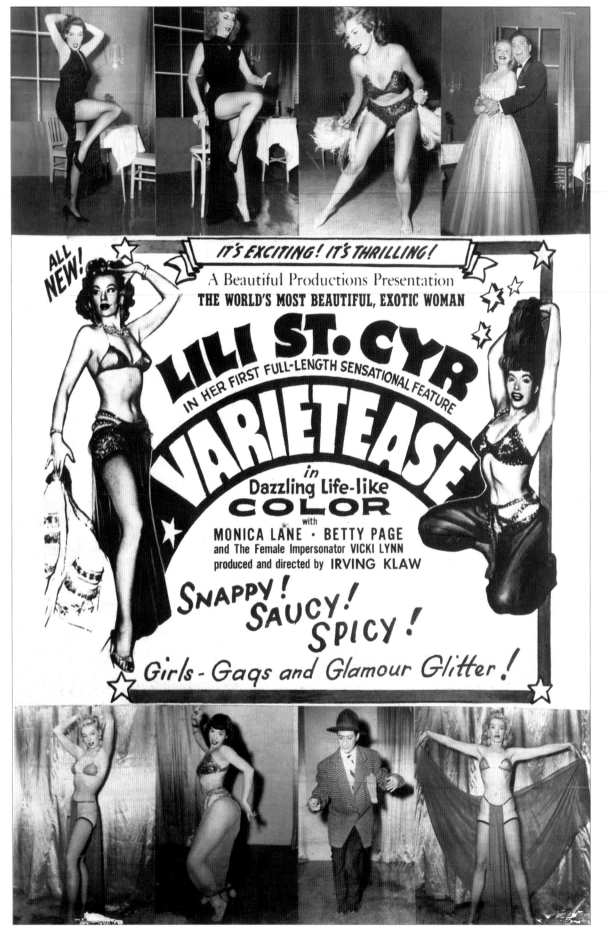

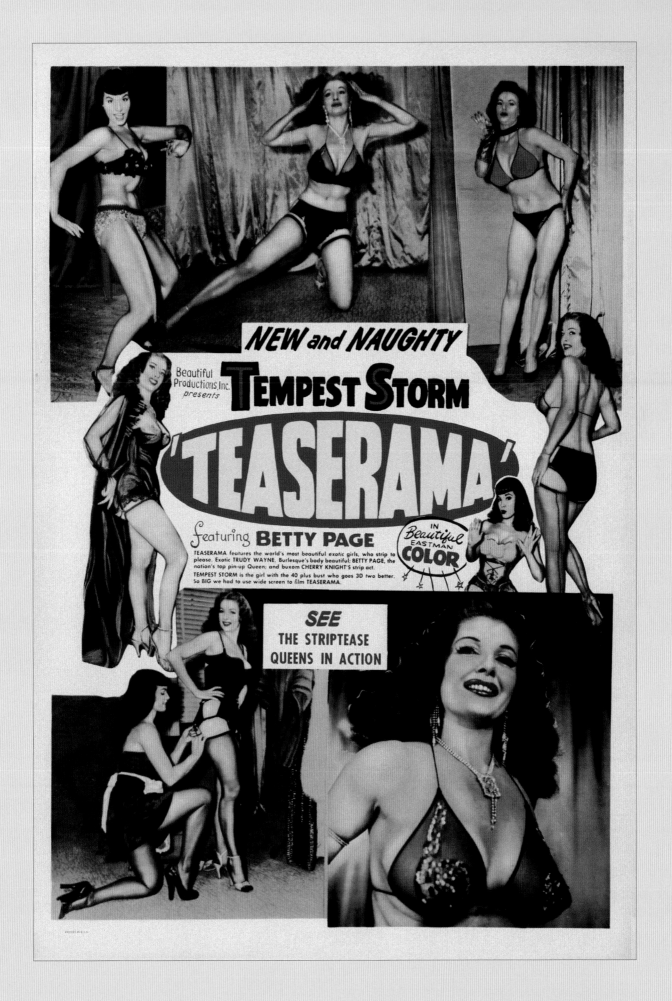

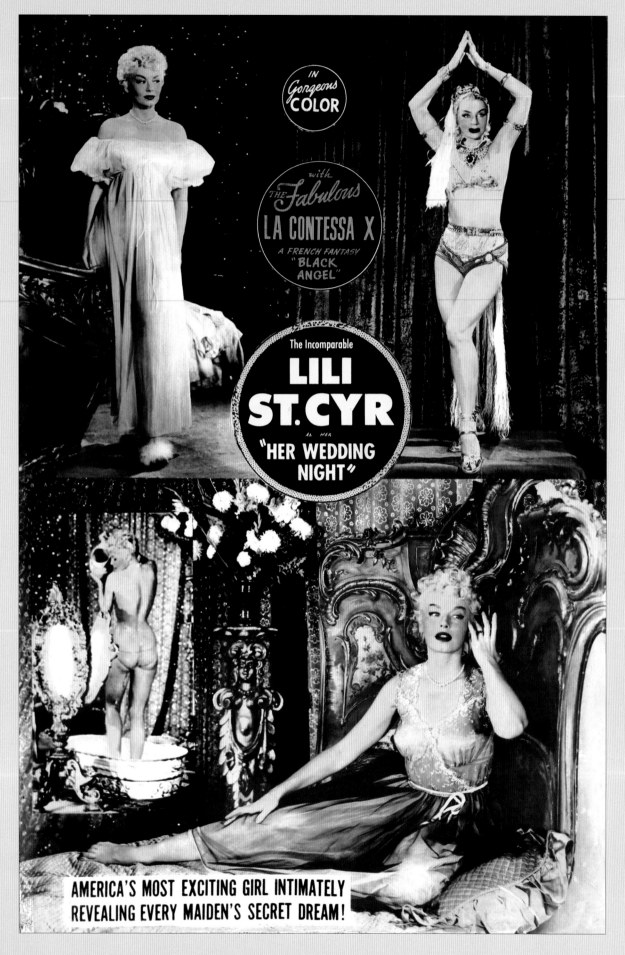

LEFT: *Lili's Wedding Night* (1952) in which the incomparable Lili St. Cyr, "America's Most Fabulous Entertainer", prepares for that most momentous occasion in every girl's life, her wedding night. Lili ends up peeling out of her wedding gown, to takes a sudsy bath. The film also features the "International Favourite", Contessa Vera Richkova, the blonde tiger from the Ukraine, half Mongol, half Russian.

RIGHT: *Love Moods* (1952) in which Lili St. Cyr takes a bubble bath (again). She was a favourite of the photographer Bernard of Hollywood. She was the girl that *Newsweek* called "The greatest of them all." When St. Cyr retired from the stage she started her own lingerie business. Renowned cartoonist and pin-up artist Bill Ward illustrated a number of lingerie catalogues for her.

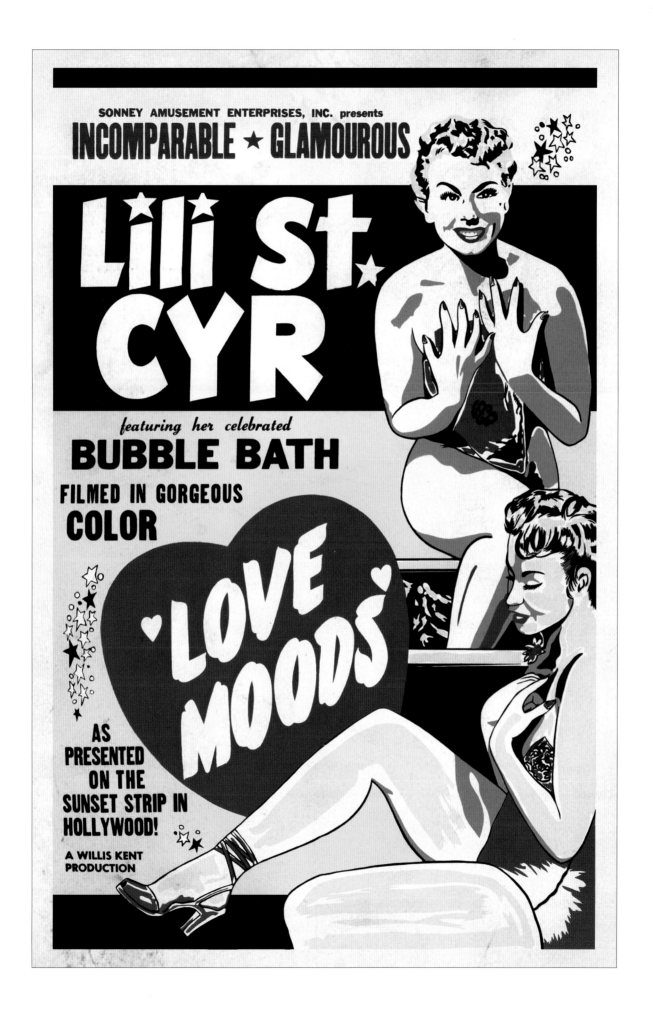

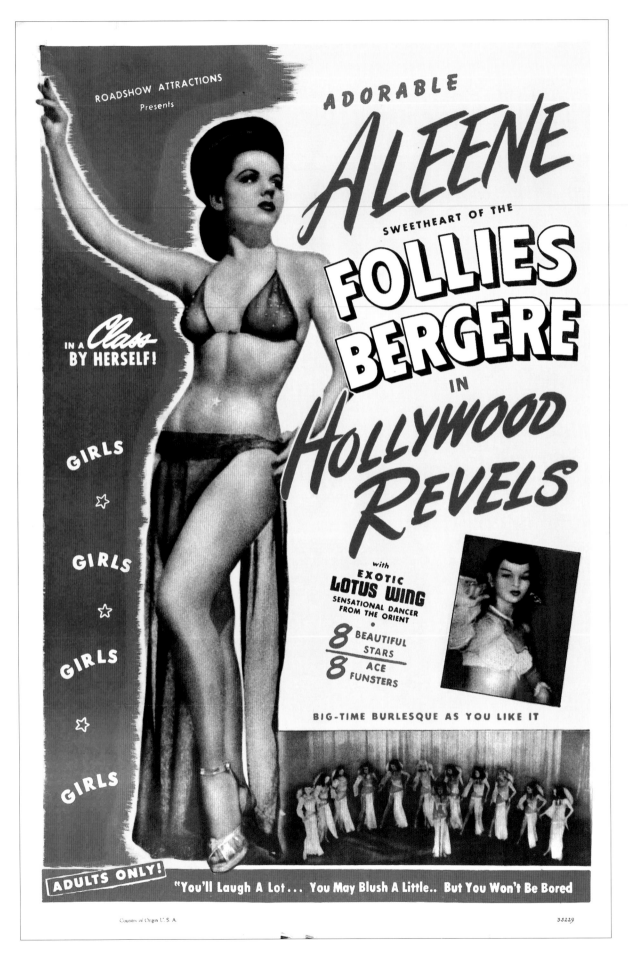

LEFT: *Hollywood Revels*, released in 1946 and directed and edited by Duke Goldstone, was a 58-minute filmed burlesque show from The Follies Theatre in L.A.. Aleene Dupree went on to appear in *Midnight Frolics* (1949) and as Kalantan in *Son of Sinbad* (1955).

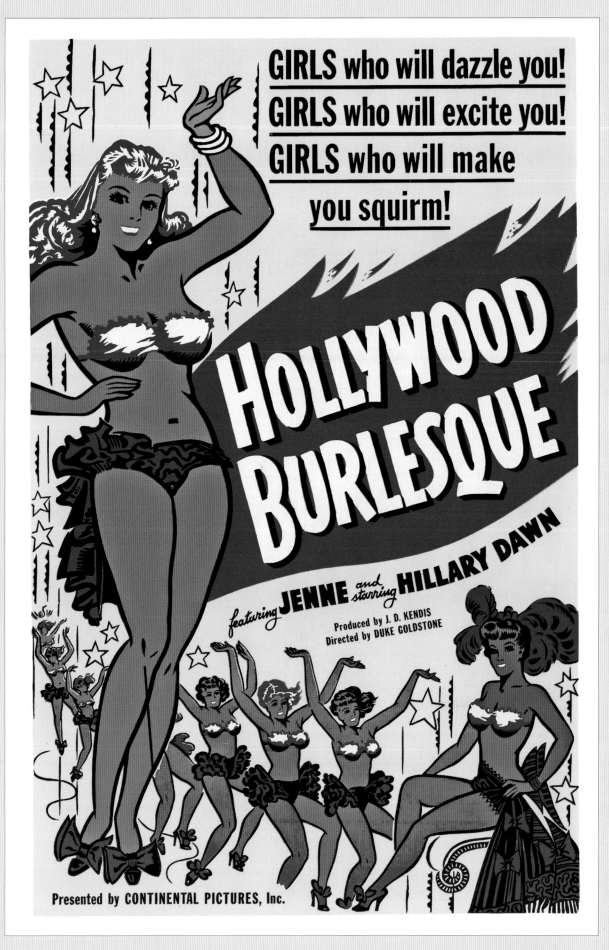

LEFT: *Hollywood Burlesque* (1952), a.k.a. *Famous Hollywood Burlesque*, gives you a front-row seat at San Diego's famed Hollywood Theatre. With appearances by Joy Damon, Honey Hayes and Hilary Dawn. Produced by roadshow king J. D. Kendis. Soon after making this film, director Duke Goldstone edited George Pal's *Destination Moon*, the first major science fiction film of the 1950s.

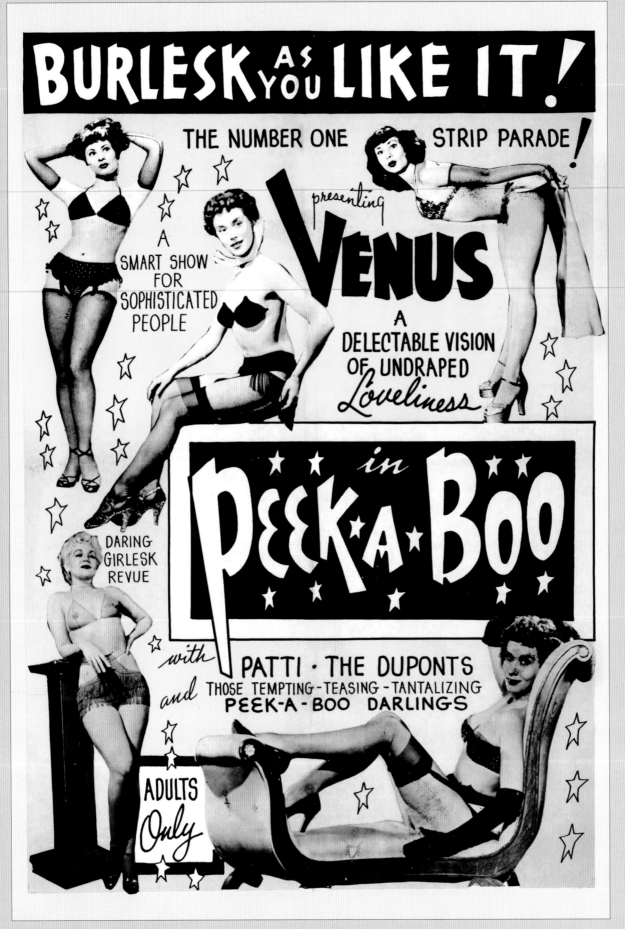

LEFT: *Peek-a-boo* (1953), "The most gorgeous girl show you've ever seen, with adorable Aleene, sweetheart of the Follies Bergere." Plus rib-tickling comedians and the Exotic Lotus Wing. "A daring girlesk revue". Directed by Lillian Hunt who shot many more burlesque films before the era fizzled out, including *Kiss Me Baby* (1957), arguably the last real burlesque feature before nudie-cuties took over. Cinematographer William C. Thompson is best known for his work on the films of Ed Wood.

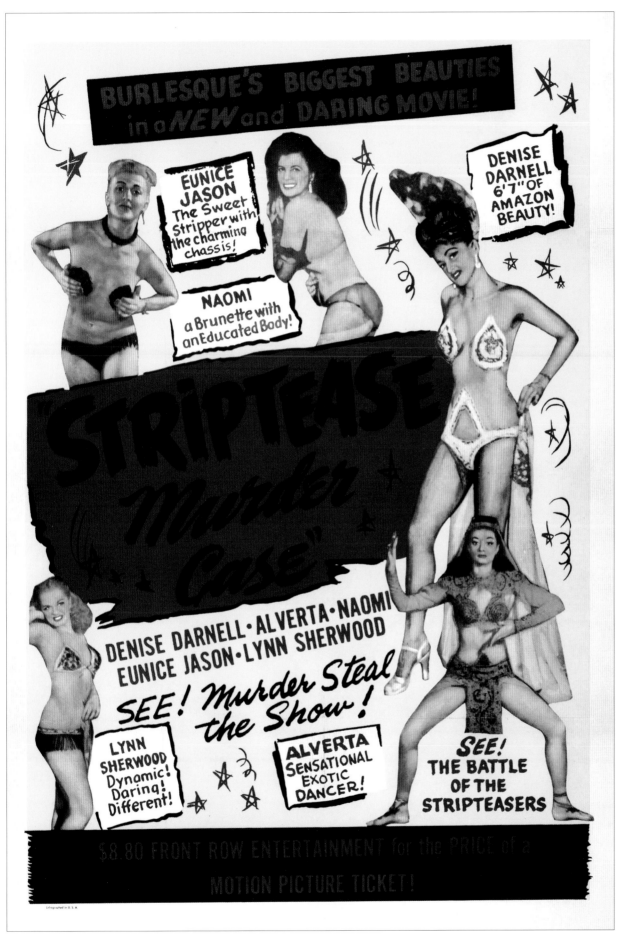

LEFT: *Striptease Murder Case* (1950). In New York's Runaway Theater, danger lurks behind the klieg lights. Two singers are being rough-housed, and the hood responsible is killed. Who did him in? If only the tassels could talk! Starring Eunice Jason and Denise Darnell. Directed by Hugh Prince.

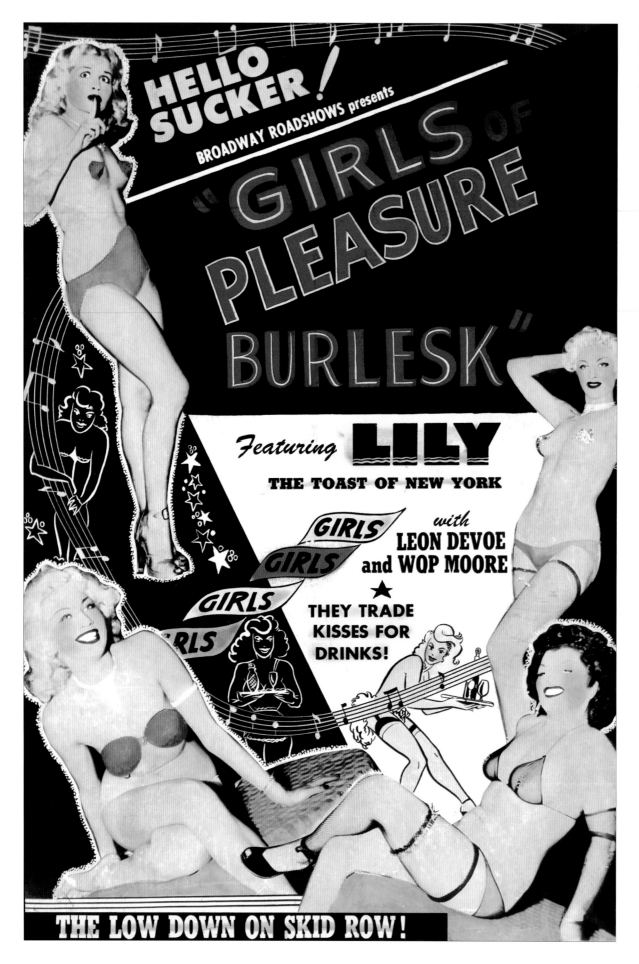

LEFT: *Girls of Pleasure* (1952) (a.k.a. *B-Girl Rhapsody*). Burlesque films were versatile and were often re-packaged with a change of title to extend their life on the grindhouse circuit.

BROADWAY ROADSHOWS PRESENTS

"B-GIRL RHAPSODY"

FEATURING **LILY**

THE TOAST OF NEW YORK

The Low Down On Skid Row...!
GIRLS · GIRLS · GIRLS

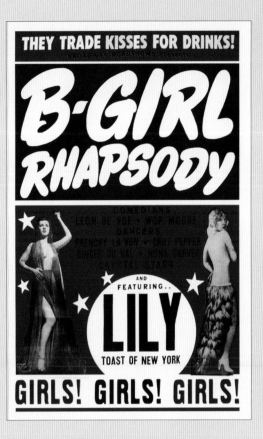

THEY TRADE KISSES FOR DRINKS!

BROADWAY ROADSHOWS PRESENTS

B-GIRL RHAPSODY

COMEDIANS
LEON DE VOE y WOP MOORE
DANCERS
FRENCHY LA VON y CHILI PEPPER
GINGER DU VAL y MONA DANVER
CRYSTAL STARR
AND
FEATURING..
LILY
TOAST OF NEW YORK

GIRLS! GIRLS! GIRLS!

LEFT AND ABOVE: More posters for *B-Girl Rhapsody* (1952) (a.k.a. *Girls of Pleasure*), a Broadway Roadshow production that was filmed at L.A.'s New Follies Theater. The main act is the incomparable tempestuous, Lily, princess of primitive passion, in her own dazzling creation, Dance of the B-Girl. The film purports to give us the low-down on skid row, where slinky sirens snare suckers, trading kisses for drinks. Some things never change.

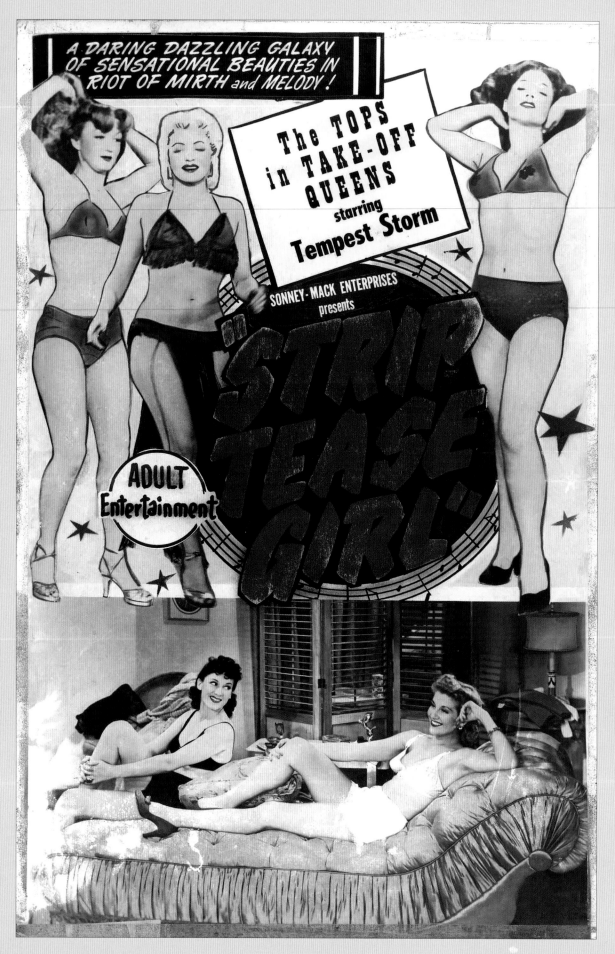

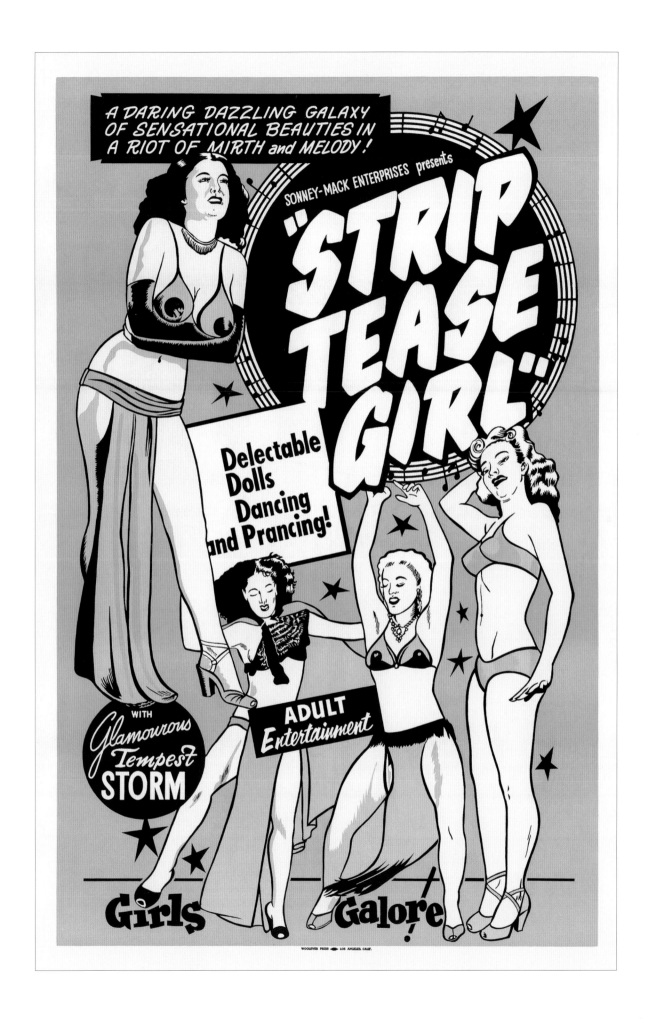

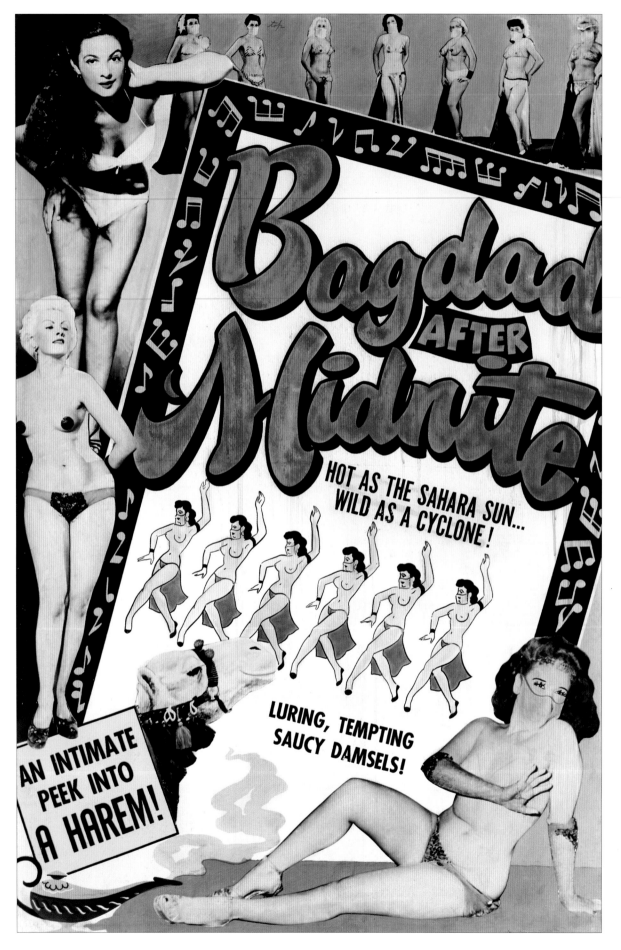

LEFT: Hot as the Sahara Sun, *Bagdad After Midnite's* (1954) delightfully flimsy premise is one long gag featuring comic Wally Blair, who is sent by a travel agency to visit the Passionate Pasha of Pomonia and his accommodating harem. Produced by George Weiss, who made several *After Midnite* films, and lensed by Phil Tucker, who made Lenny Bruce's *Dance Hall Racket* in 1953.

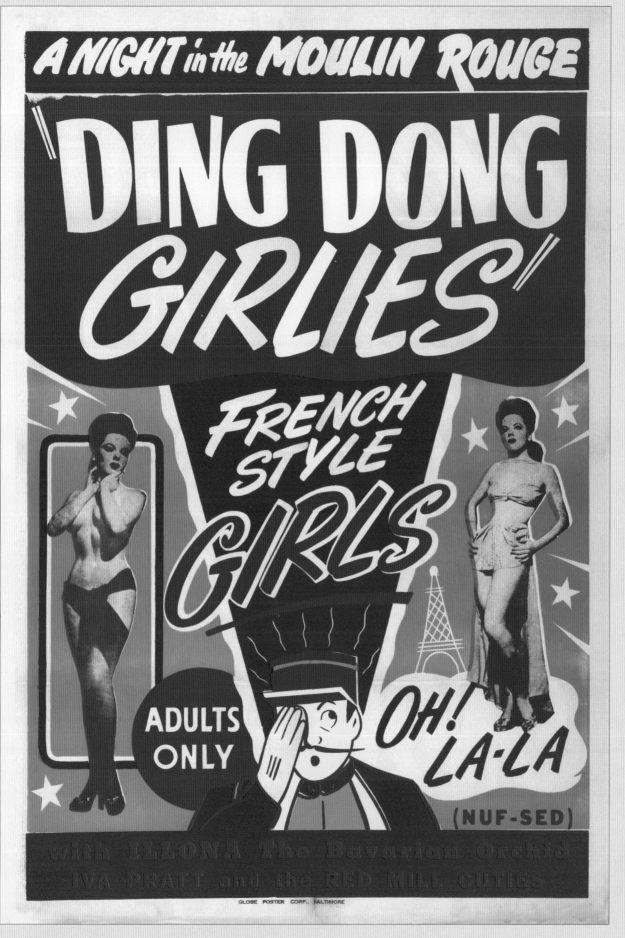

LEFT: Ding-Dong, *A Night in the Moulin Rouge* (1951). That is the Moulin Rouge in Oakland, California. Directed by W. Merle Connell and featuring Illona, "the Bavarian Orchid", Iva Pratt and the Red Mill Cuties, and a bunch of baggy-pants comedians. Legs and laffs at "the Gay Moulin Rouge at its Gayest".

NEO-BURLESQUE

Return of the tassel twirlers

Velvet Hammer Burlesque

Credited with kick-starting the neo-burlesque movement, Michelle Carr founded The Velvet Hammer Burlesque in L.A. way back in 1995. At the time her club, Jaberjaw, co-founded with Gary Dent, was at the height of its success, launching several influential underground bands, and hosting acts such as Sonic Youth, The Beastie Boys, Beck and Nirvana. Through Jaberjaw Carr commissioned major artists of the rock poster revival, who would subsequently create posters for the Velvet Hammer, including Coop, Lindsey Kuhn, Kozik and the Pizz. Carr had always had an obsession with "high" kitsch and burlesque culture. Little did she know the impact she would have when she brought it to life in the first Velvet Hammer shows. Inspired by vaudeville, the traditional American burlesque revues of the 1940s and '50s and a "post-feminist punk attitude", a Velvet Hammer show was a fabulous assault on the senses. Intricate choreography, elaborate costumes, an ever-changing crew of performers, acrobats, comedians and musicians proved a potent cocktail, earning the troupe a regular engagement at the iconic El Rey Theater in L.A. and soon leading to sellout shows in both the US and Europe.

BELOW: Poster by The Pizz, 2005, capturing the vibe backstage. The Pizz had worked with Michelle Carr on posters for her L.A. club, Jabberjaw.

RIGHT: *Illuminata* by Velvet Hammer Burlesque. Art Direction and Design: Steven R. Gilmore. Photography: Austin Young.

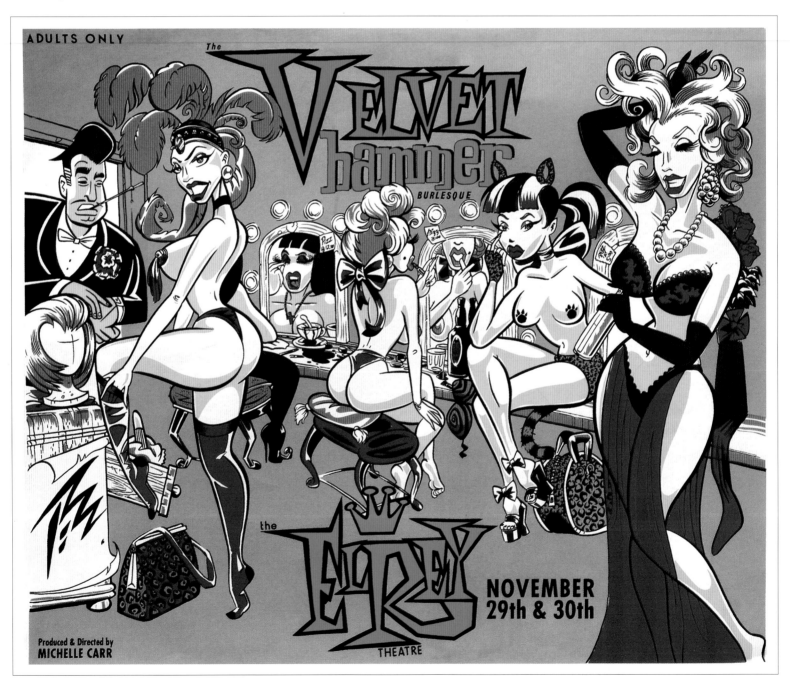

THE *Velvet Hammer* BURLESQUE

PRESENTS *Illuminata*

DIRECTED BY MICHELLE CARR

APRIL 8TH, 2004 8 P.M.
THE AVALON THEATER
1739 N. VINE STREET, HOLLYWOOD, CA

FOR DETAILED INFO. PLEASE VISIT : WWW.VELVETHAMMERBURLESQUE.COM

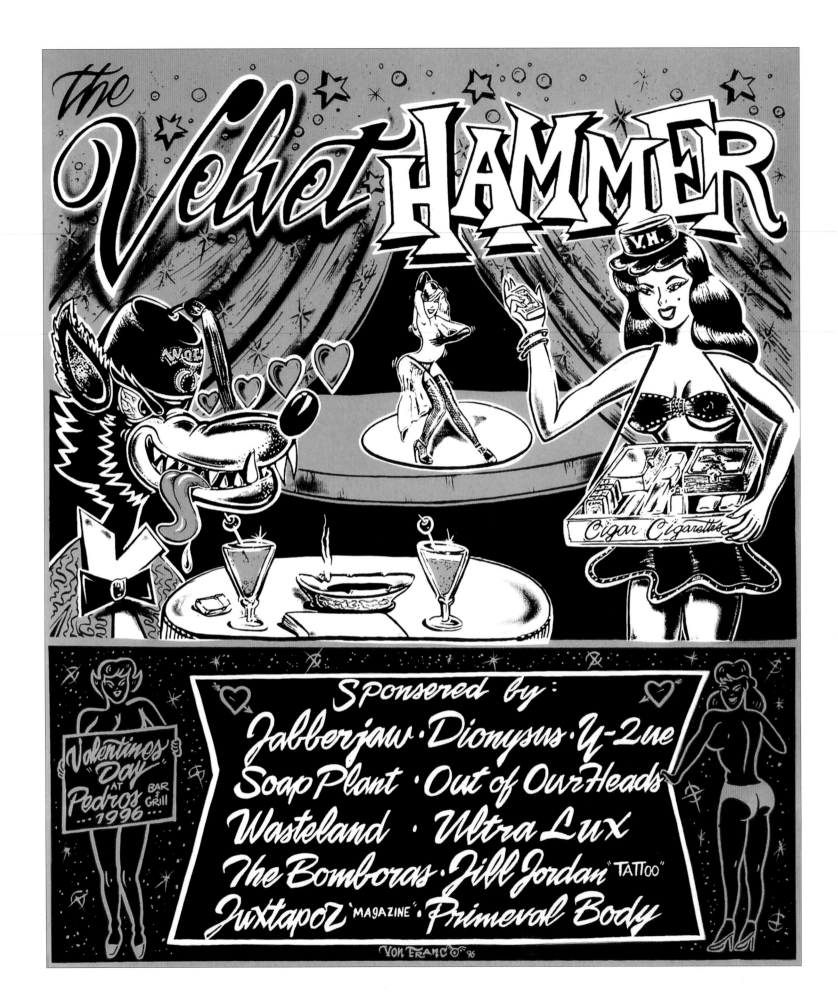

FAR LEFT: Early Velvet Hammer poster by lowbrow legend Von Franco, 1996.

LEFT: Poster by Chris Martin, 2001.

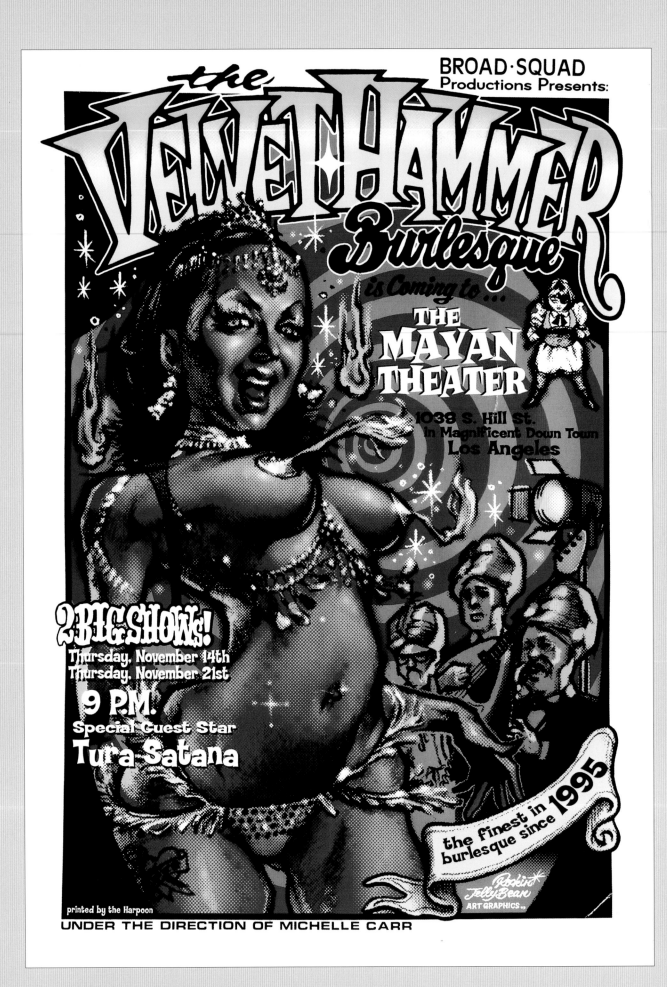

UNDER THE DIRECTION OF MICHELLE CARR

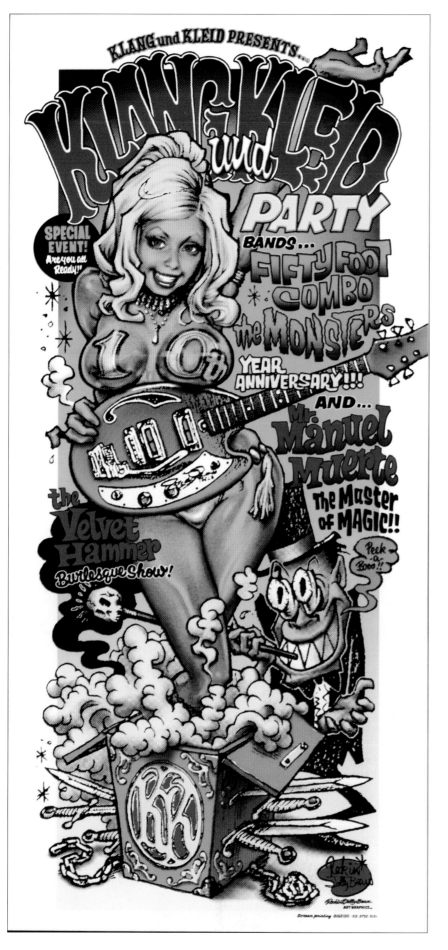

PAGE OPPOSITE: Silkscreened poster by Tokyo-based Rockin' Jelly Bean, 2002.

LEFT: Zurich and Munich-based Klang und Kleid – "the source of weird and cool stuff" – commissioned Rockin' Jelly Bean to design this poster to celebrate their 10th anniversary in 2004, involving four parties in Zurich, St. Gallen, Berlin and Munich. The 10 on the girl's breasts refers to the anniversary; the girl represents burlesque in general and The Velvet Hammer in particular; the guitar in her hand represents rock 'n' roll; the magic box with the "KK", Klang und Kleid. Lurker Grand commissioned the poster, having bumped into Rockin' Jelly Bean and his band Jackie and The Cedrics on one of his Tokyo trips. Klang und Kleid were pioneers of neo-burlesque in Europe, organizing one of the very first full burlesque nights, which featured the Voodoo Girls from Canada and the three leading ladies from Russ Meyer's *Faster Pussycat! Kill! Kill!*.

Tease-O-Rama

Created by then freelance journalist and go-go dancer Alison Fensterstock and San Francisco promoter and artistic director of The Devil-ettes Baby Doe, Tease-O-Rama kicked off with a bang in May 2001. Their first show was in New Orleans, and featured Dita von Teese, Catherine D'Lish and the Pontani Sisters and their go-go robics class; in all there were three action-packed days and nights devoted to the saucy art of striptease.

One of the earliest of the neo-burlesque festivals, they hugely raised the profile of the art in 2002, with a move to San Francisco, where they were joined by Alan Parowski of Liftoff! Productions. The festival was a sell-out and featured on the front page of the *San Francisco Chronicle*. In 2003 Tease-O-Rama moved to L.A., to the 1000+ capacity Henry Fonda Music Box Theater, and featured over 60 acts; Russ Meyer vixen and legend, Kitten Natividad, turned up to watch. The festival now takes place every fall, lasts four days and nights, is always a sell-out, and features classes, movies (Tease-

O-Rama has revived many burlesque classics), presentations on burlesque history and a burlesque shopping bazaar. Alison is now a fulltime music journalist in New Orleans but Baby Doe and Alan continue as producers.

BELOW: Tease-O-Rama Roadshow ad by Josh Ellingson, 2008.

RIGHT: Image of Dita Von Teese for the 2005 Tease-O-Rama in San Francisco. Dita had appeared at the first Tease-O-Rama show in 2001.

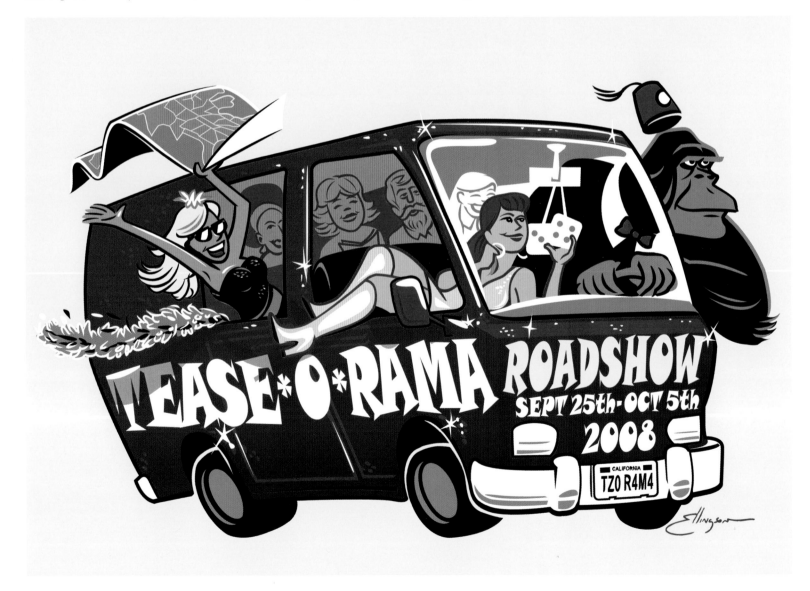

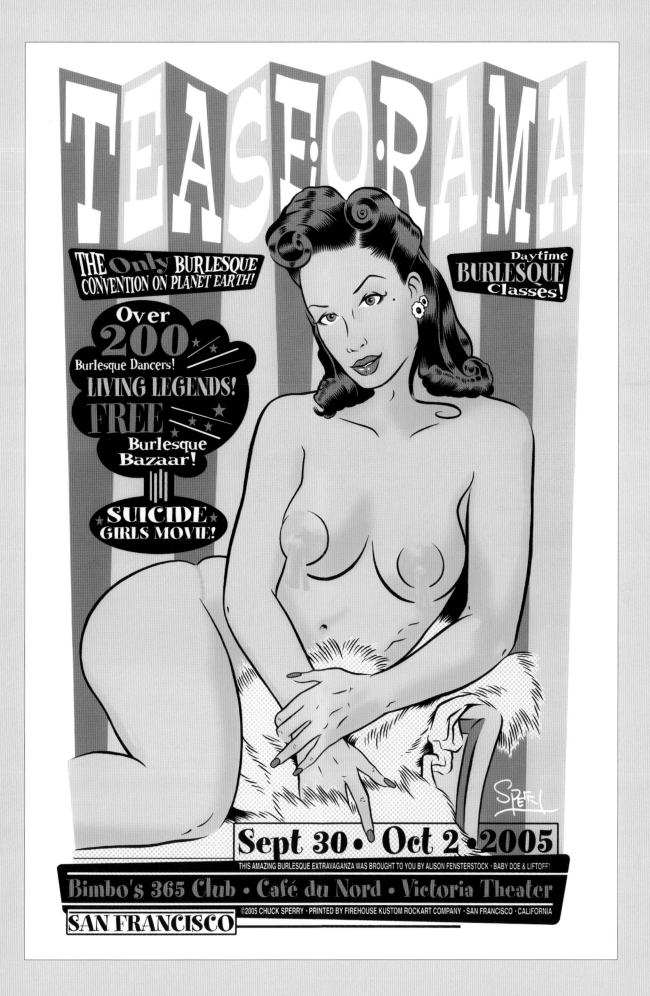

ALISON FENSTERSTOCH, BABY DOE PRODUCTIONS, AND LIFTOFF! PRESENT...

TEASE-O-RAMA
San Francisco 2005

The only Burlesque Convention on Plant Earth!

SHAG

LEFT: Poster for the
2005 Tease-O-Rama in
San Francisco, by Shag.

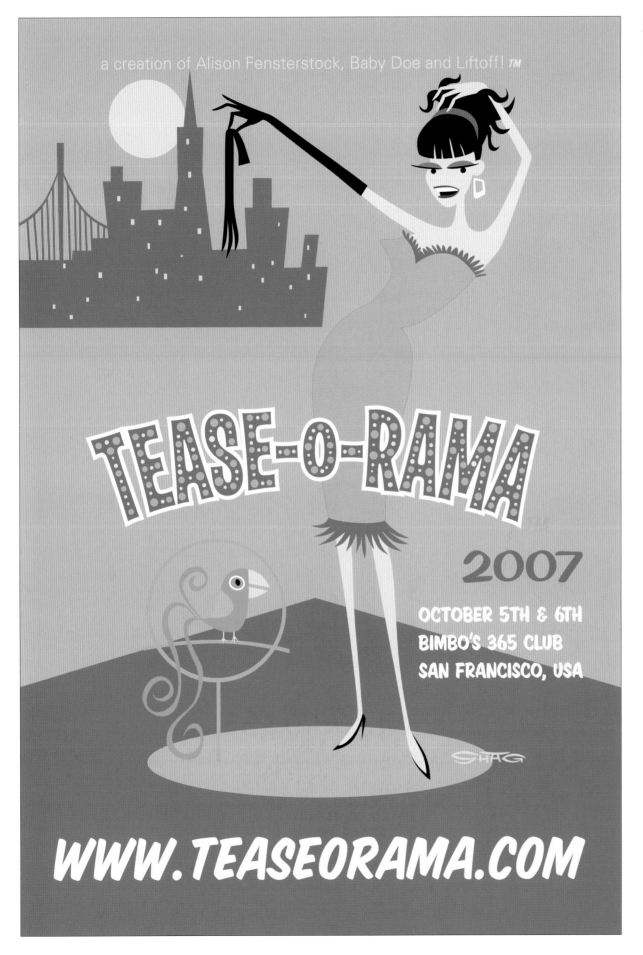

99

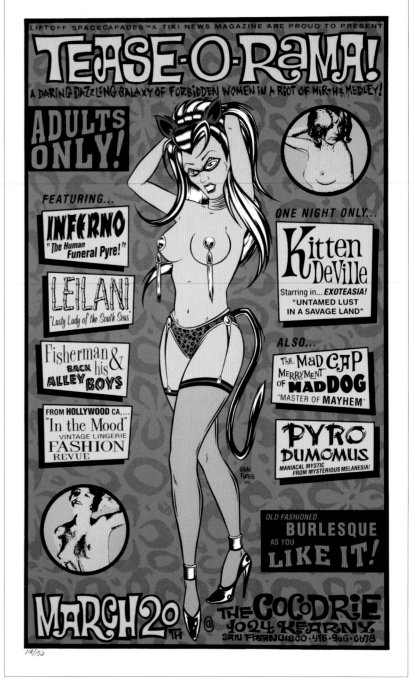

ABOVE: Rock poster artist, Alan Forbes, created this for a one-off night in San Francisco, sponsored by LiftOff! SpaceCapades and *Tiki News Magazine*.

LEFT: Poster by the renowned and prolific Scrojo.

OPPOSITE PAGE: A Tease-O-Rama movie night poster, featuring the 1964 movie, *Kitten With A Whip*. Starring Ann-Margret, the film was already retro in 1964, being filmed in black and white. Tease-O-Rama tended to connect various sub-cultures, in this case by featuring Tiki Goddess Monica as a host. Tease-O-Rama were big proponents of burlesque revival movies. This poster headlines the movies, with the burlesque acts and bands featured as part of the movie show.

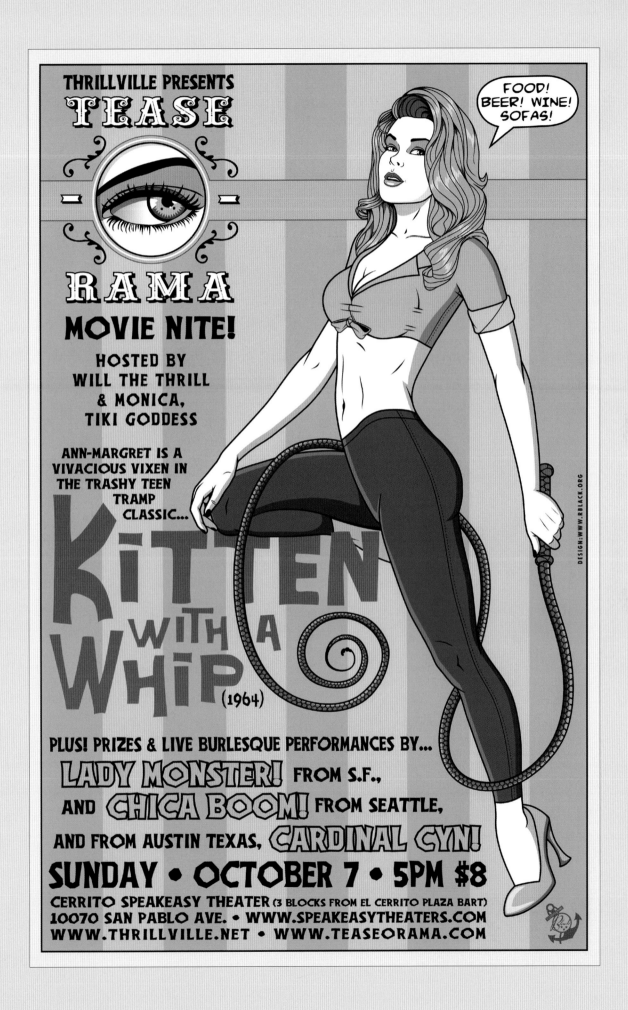

Miss Exotic World Pageant

Now a firm feature on the burlesque annual circuit, the Miss Exotic World Pageant (officially, the Miss Exotic World Pageant and Striptease Reunion) is the annual fundraiser for the Burlesque Hall of Fame, the burlesque museum in Las Vegas. Featuring burlesque performances spanning a weekend, the pageant ends with the crowning of Miss Exotic World. Now world famous, it was described by the *Daily Mirror* as "the striptease olympics".

The pageant derives its name from Exotic World, the name of the museum which was founded by exotic dancer Jennie Lee on the site of an abandoned goat farm in the Mojave Desert at Helendale, California. When Lee died in 1990, the museum was taken over by another retired burlesque star, Dixie Evans. Dixie had a great talent for publicity; she created the pageant as a way of bringing in the crowds. It worked, and in addition, many items of memorabilia were gifted from past burlesque performers and impresarios. The museum moved to Las Vegas in 2005 and reopened as The Burlesque Hall of Fame in 2007. In 2008 they teamed up, to raise awareness of breast cancer, with the Keep A Breast Foundation and The Fallout Gallery to create an exhibition of plaster moulds of the busts of legendary icons such as Tempest Storm and Tura Santana, and of recent stars, customized by artists including David LaChapelle, Mitch O'Connell and Tim Biskup.

BELOW LEFT: Miss Exotic World Poster by Josh Ellingson, 2004.

BELOW: *Dirty Martini and the Birth of the Space Program* by Josh Ellingson. Dirty Martini was Miss Exotic World 2004. In the background is featured a Mercury Atlas rocket. As part of the Zero Gravity Art Exhibit this image was exhibited aboard the International Space Station in orbit.

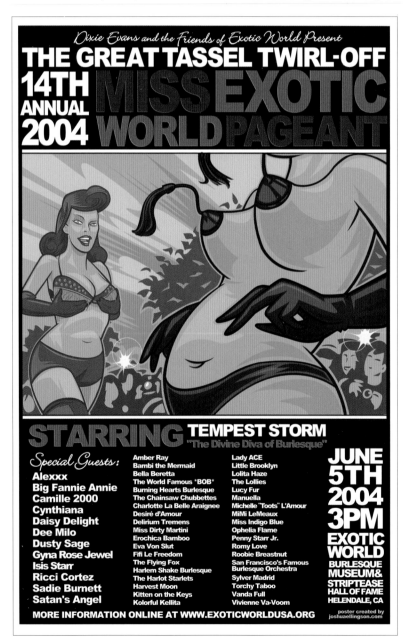

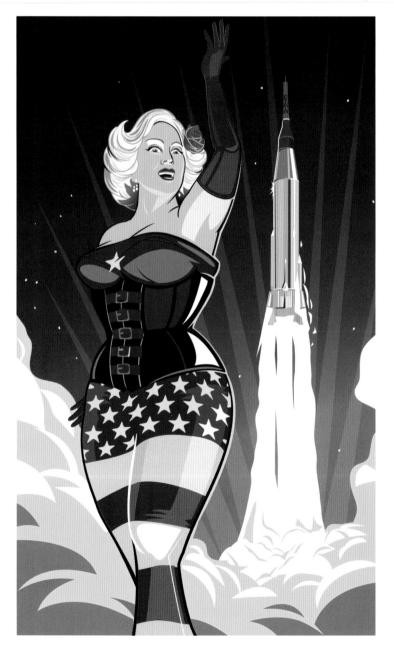

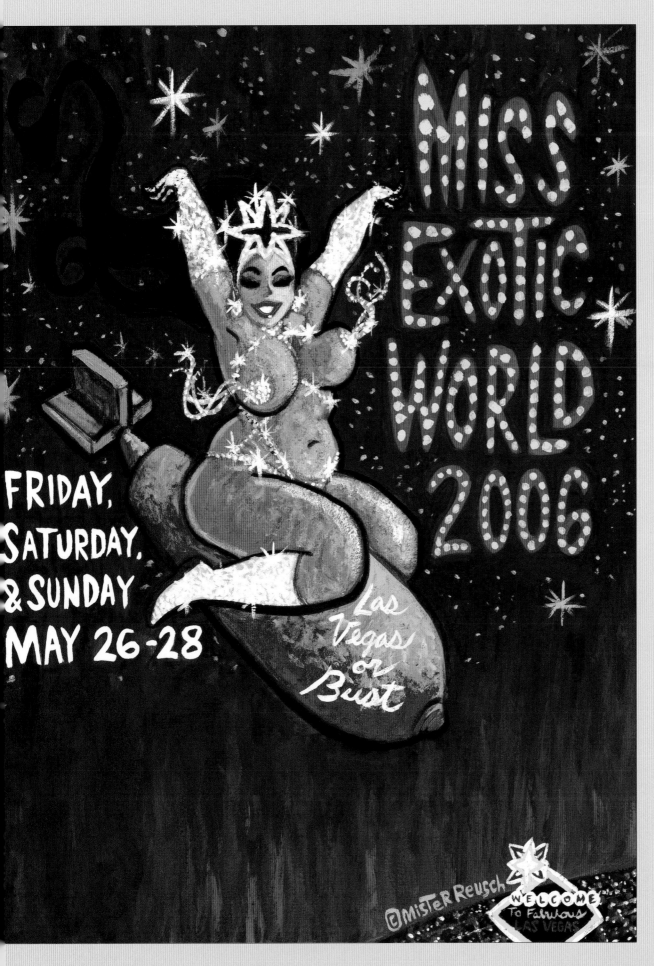

MISS EXOTIC WORLD 2006

FRIDAY, SATURDAY, & SUNDAY MAY 26-28

Las Vegas or Bust

©MISTER REUSCH

WELCOME To Fabulous LAS VEGAS

LEFT: Mr. Reusch poster design for the 2006 Exotic World Weekend. The Exotic World museum in Helendale closed in 2005, so this was the first pageant to be held in Vegas. The design suggests that Vegas has no idea it's about to be hit by the bombshell that is neo-burlesque.

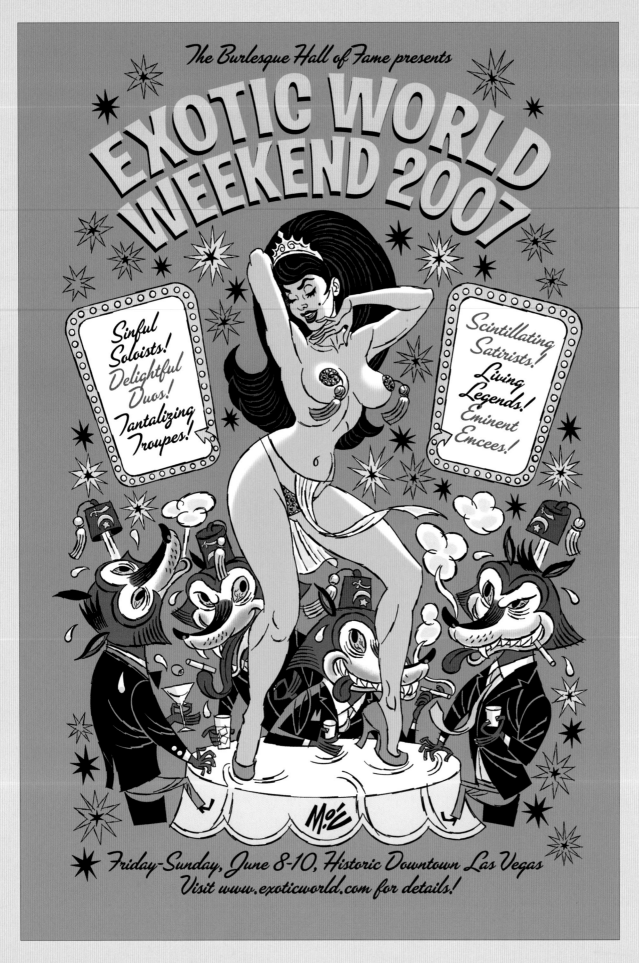

The Burlesque Hall of Fame presents

EXOTIC WORLD WEEKEND 2007

Sinful Soloists!
Delightful Duos!
Tantalizing Troupes!

Scintillating Satirists!
Living Legends!
Eminent Encees!

Friday-Sunday, June 8-10, Historic Downtown Las Vegas
Visit www.exoticworld.com for details!

LEFT: Mitch O'Connelll poster for the 2007 Exotic World Weekend.

RIGHT: Mitch O'Connell again for the 2008 event, which took place at the famous Palms Casino, reflecting the growing success of the event and neo-burlesque in general.

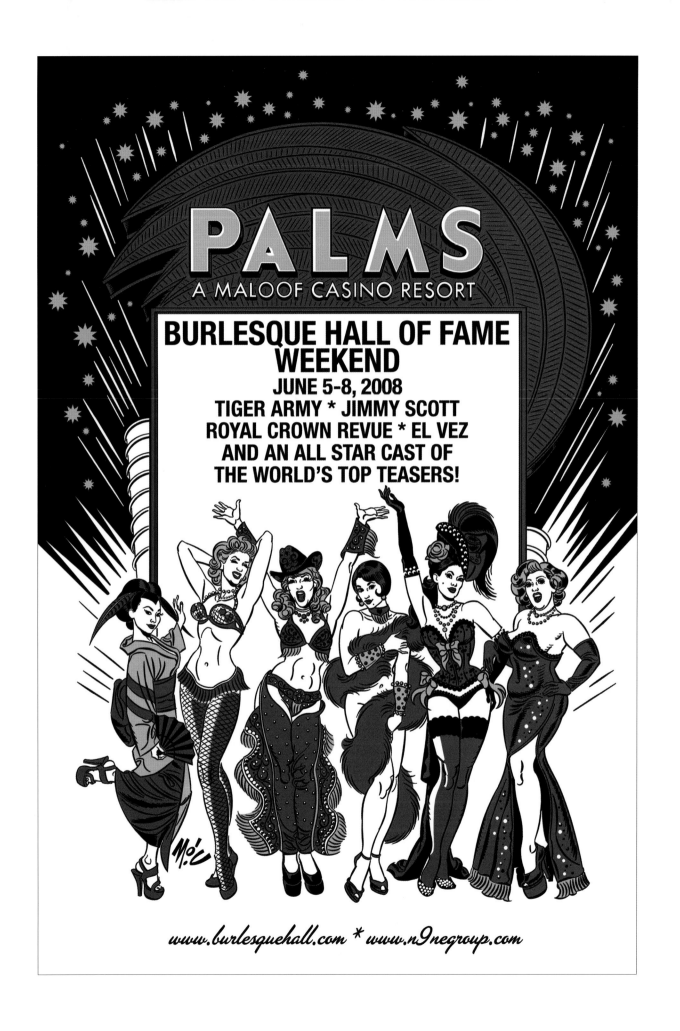

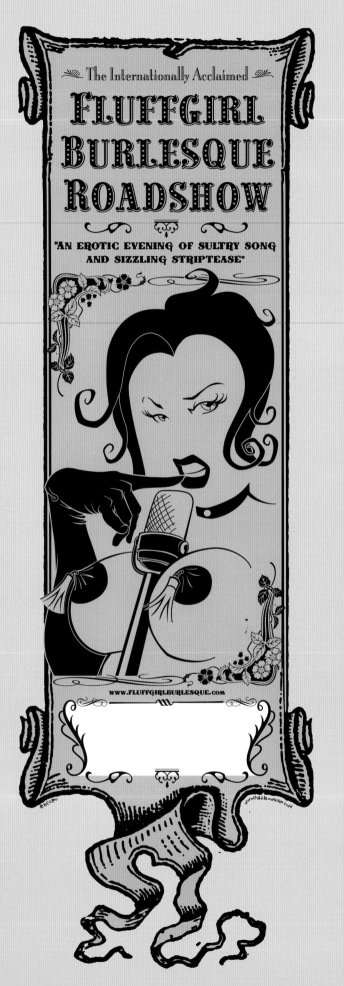

The Fluffgirl Burlesque Society

Burlesque pioneer, Cecilia Bravo, was the creator of Fluffgirl Burlesque, Canada's first and most accomplished neo-burlesque company. From their beginnings in Vancouver in the mid 1990s, The Fluffgirls catalysed a movement just emerging from the underground into a major international revival. Initially the shows were small and monthly, but soon the troupe was travelling nationally and internationally. Many dancers were inspired to take up burlesque by The Fluffgirls, and the Fluffgirls took risks in hiring and launching new talent. Their influence was great also amongst producers, Chaz Royal being a case in point. According to Bravo, the essence of a Fluffgirl show was "an environment of abandon, inspiration, glitter and magic, blended together like a perfect cocktail".

LEFT: Tour poster for The Fluffgirls by Eric Smith. Two colour, hand-pulled screenprint.

BELOW: Poster for a Chaz Royal-produced tour on Victoria Island, BC, by illustrator and animator Kevin Schmid, 2006.

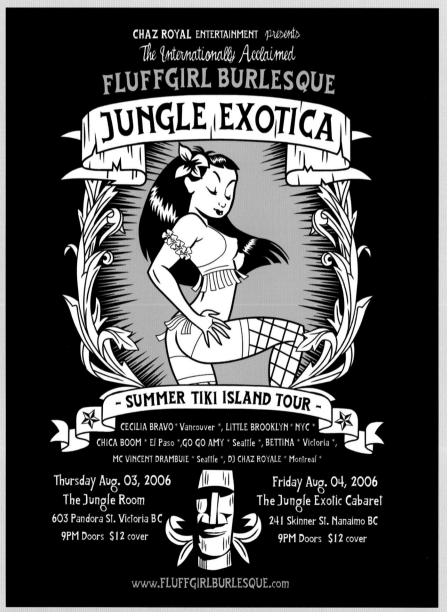

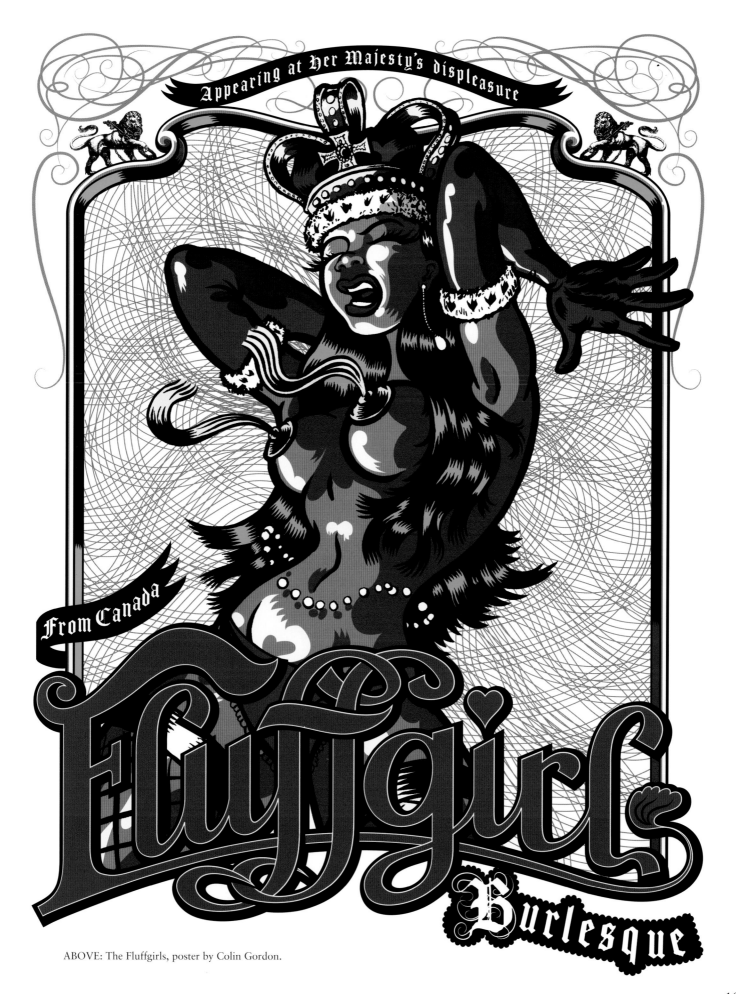

Appearing at Her Majesty's displeasure

From Canada

Fluffgirl

Burlesque

ABOVE: The Fluffgirls, poster by Colin Gordon.

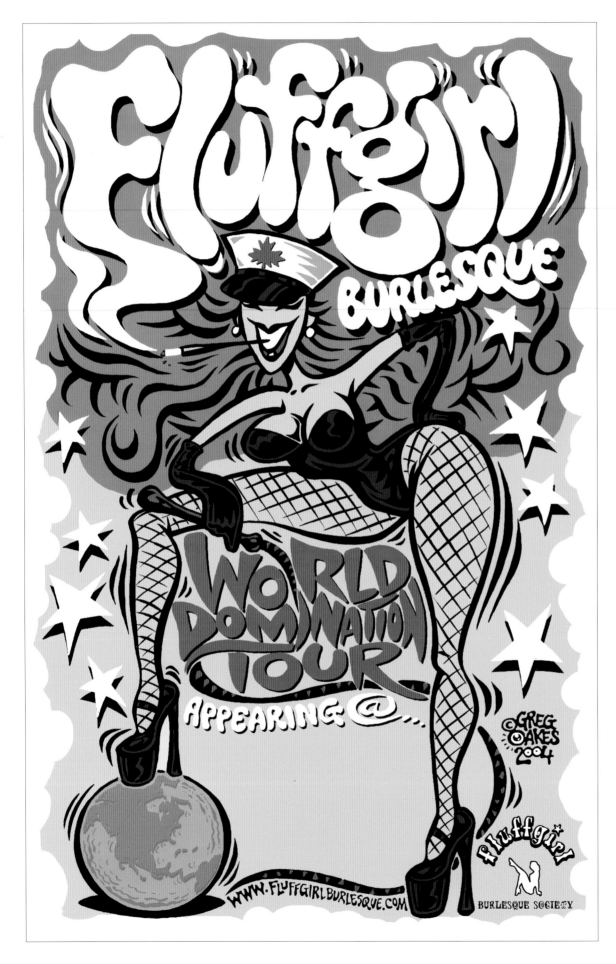

LEFT: Poster by Greg Oakes for The Fluffgirl world tour in 2004.

RIGHT: An art nouveau treatment, for the 2005 Roadshow tour, by Jason Cooper.

108

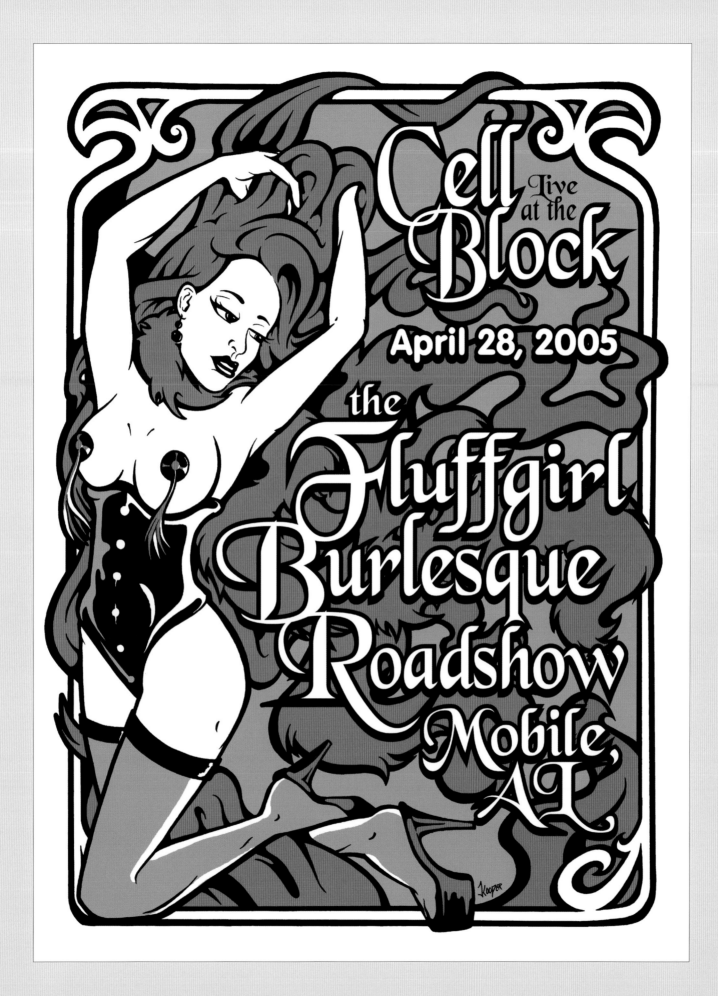

Chaz Royal

Now one of the most influential producers in neo-burlesque, Chaz was one of the pioneers when he became aware of the first signs of a scene in Vancouver in the mid-1990s. His early involvement was with Cecilia Bravo's Fluffgirl Burlesque and then he went on to create Chaz Royal's International Social Club, before forming the hugely successful London Burlesque Festival, which has got bigger every year; in 2009 it launched at the legendary Café de Paris venue and went on to have regular nights at Madame Jojo's. Truly international in scope, the festival was completely sold out and showcased over 150 burlesque, cabaret and variety performers from over a dozen countries, including the UK, Spain, France and Germany, in addition to the USA and Canada. As a result the festival has moved to a format spanning a whole week. Chaz is a classic impresario, who has produced burlesque events in over 200 cities. He is passionate about the art and its variety, promoting classic burlesque striptease, 1950s bump 'n' grind, new avant-garde interpretations of burlesque, and acts inspired by traditional vaudeville and circus side-shows.

BELOW: Poster for Chaz's Madame Jojo's shows in London, by Colin Gordon. The design makes use of classic English motifs: the Union Jack, top hat, London Underground logo and the lion and unicorn from the Royal coat of arms.

BELOW RIGHT: Colin Gordon again, this time in art nouveau / 1920s dancer vein.

FAR RIGHT: Fifth Anniversary design for Chaz's Burlesque Social Club that was used on t-shirts and flyers by JP Flexner.

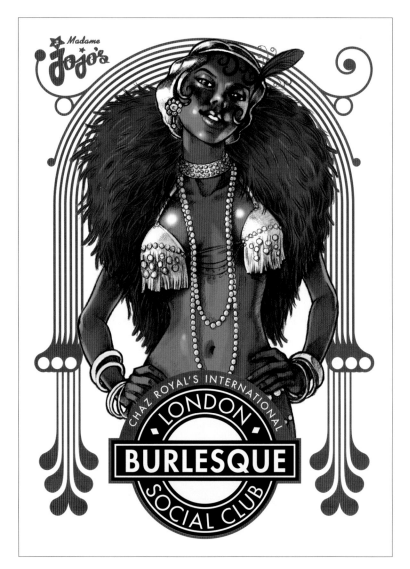

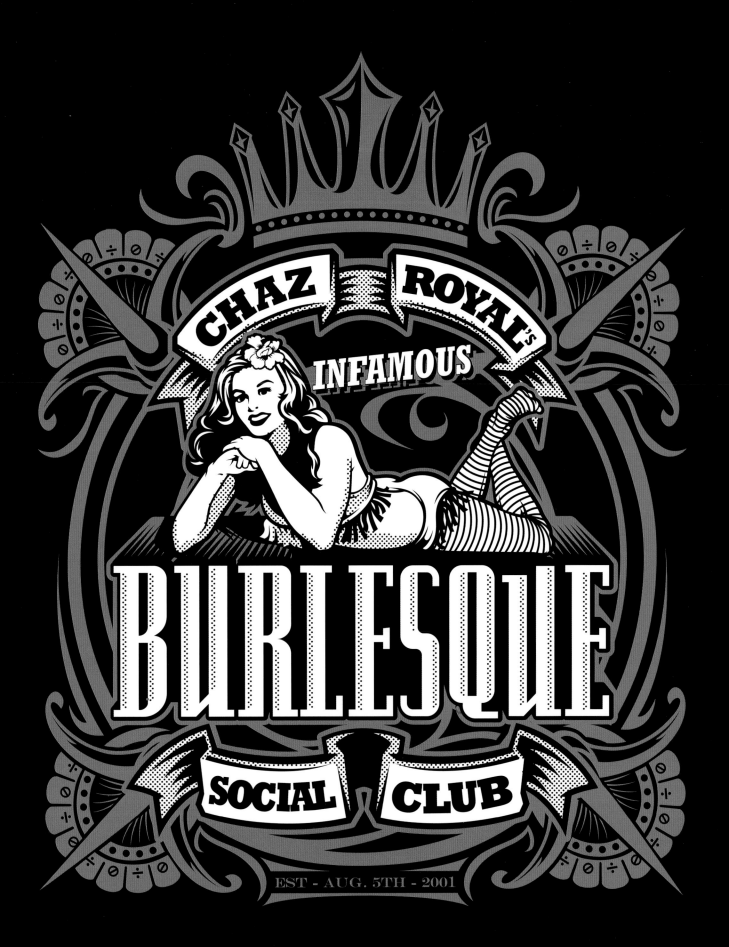

CHAZ ROYAL's INFAMOUS

BURLESQUE

SOCIAL CLUB

EST - AUG. 5TH - 2001

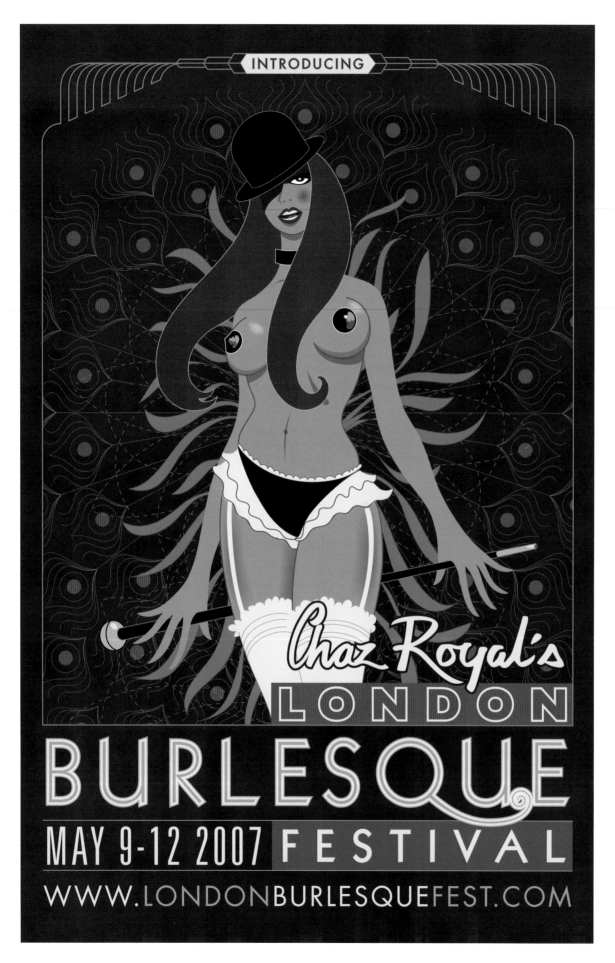

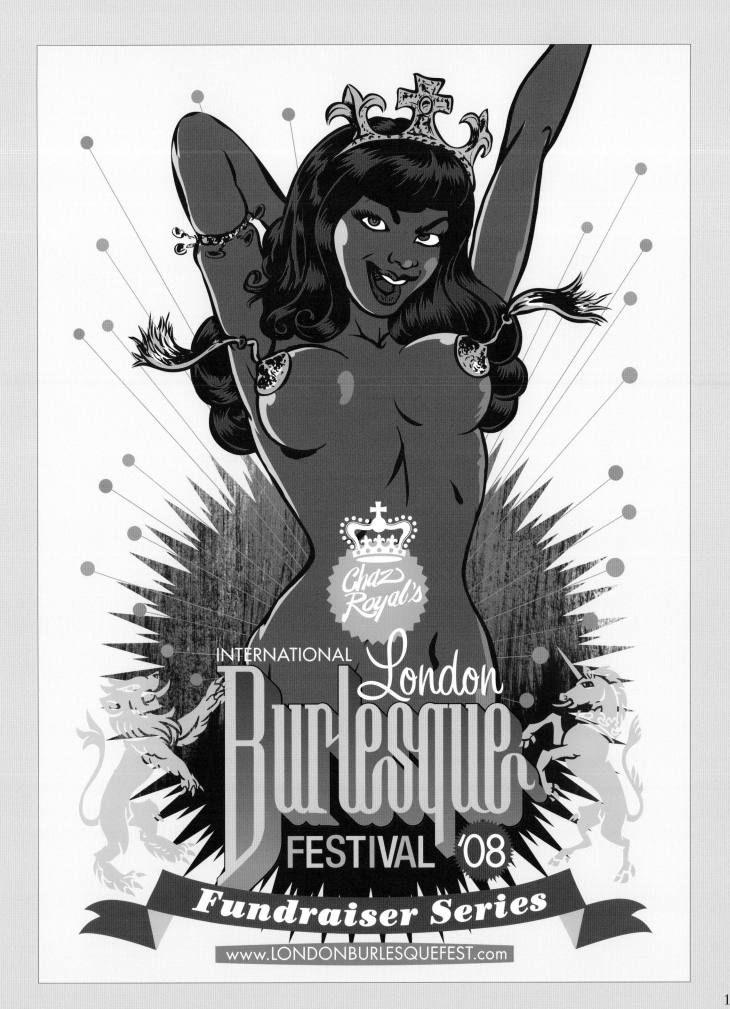

113

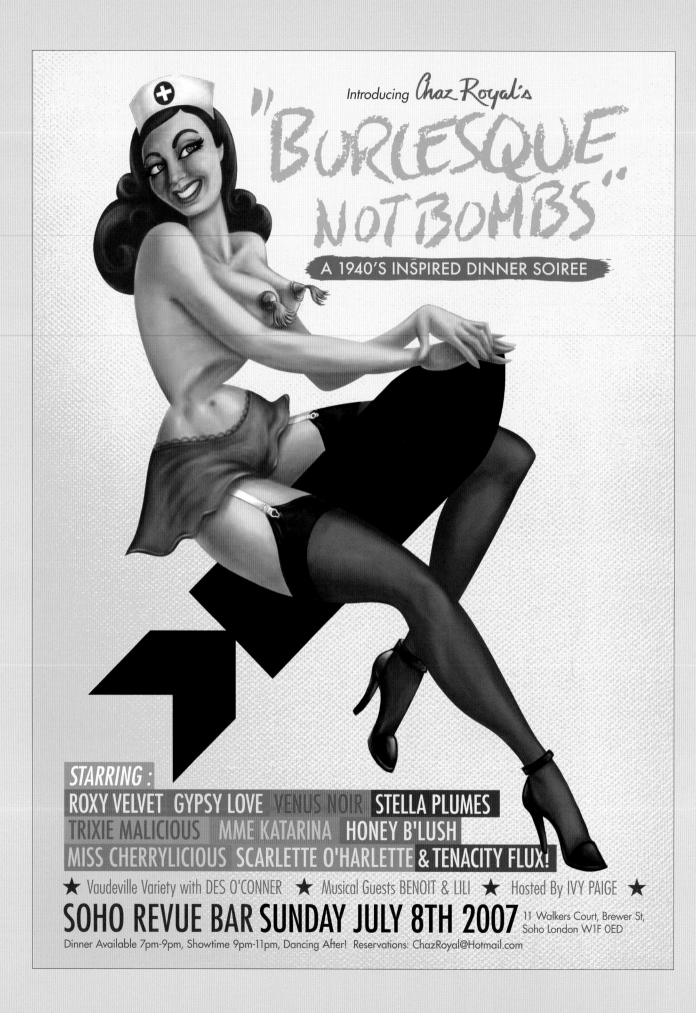

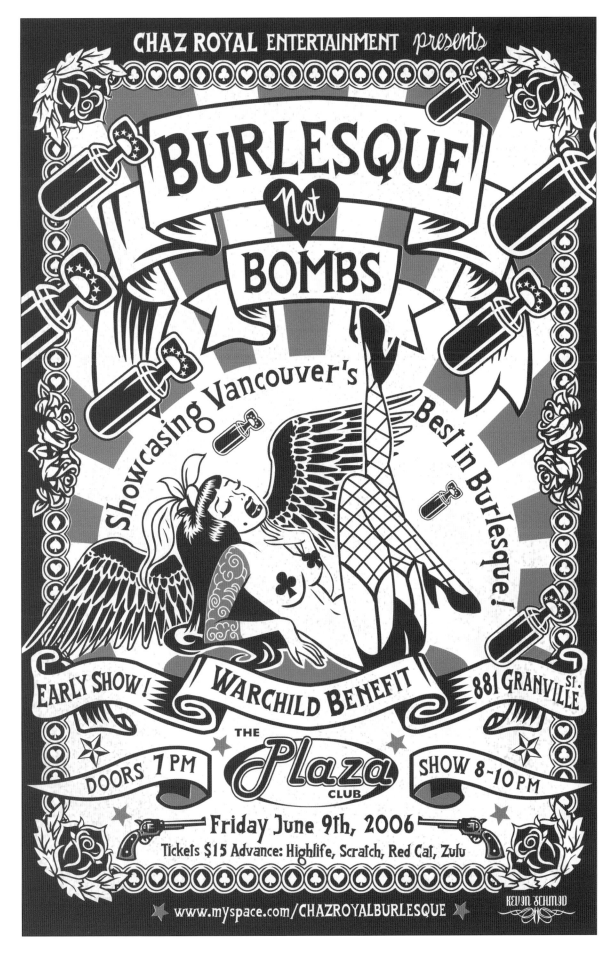

FAR LEFT: 1940s inspired design by Colin Gordon, 2007. The imagery is that of wartime London: the girl riding a bomb, the pose, the brown colourways and even the nurse's hat.

LEFT: A comic book-inspired treatment for the 2006 *Burlesque Not Bombs* show poster, by Kevin Schmid.

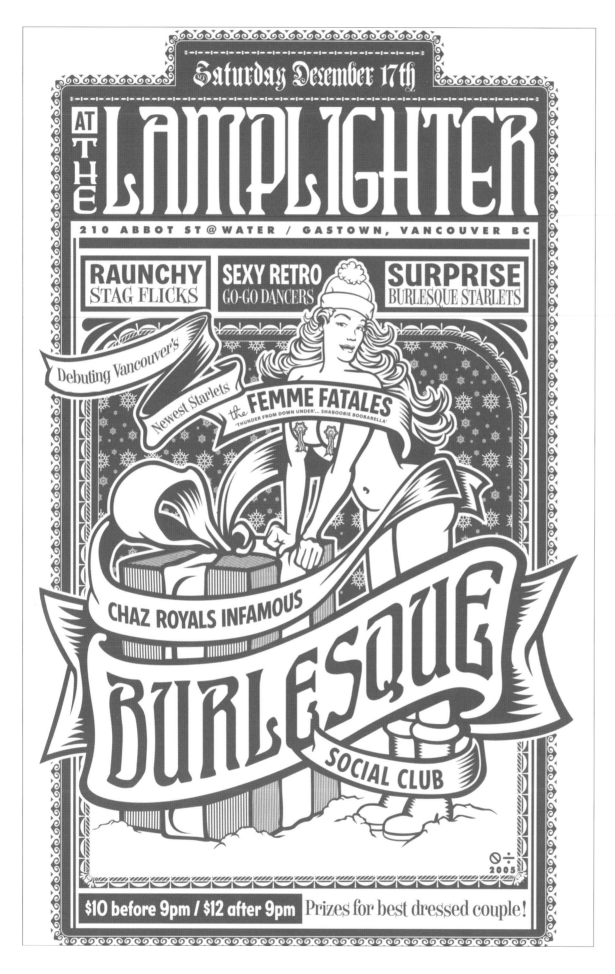

LEFT: Poster by JP Flexner for Chaz Royal's Christmas Party, 2005. A one colour offset print that was apparently pasted up all over Vancouver.

RIGHT: Poster by JP Flexner for Chaz Royal's New Year's Eve Pasties Party, 2005.

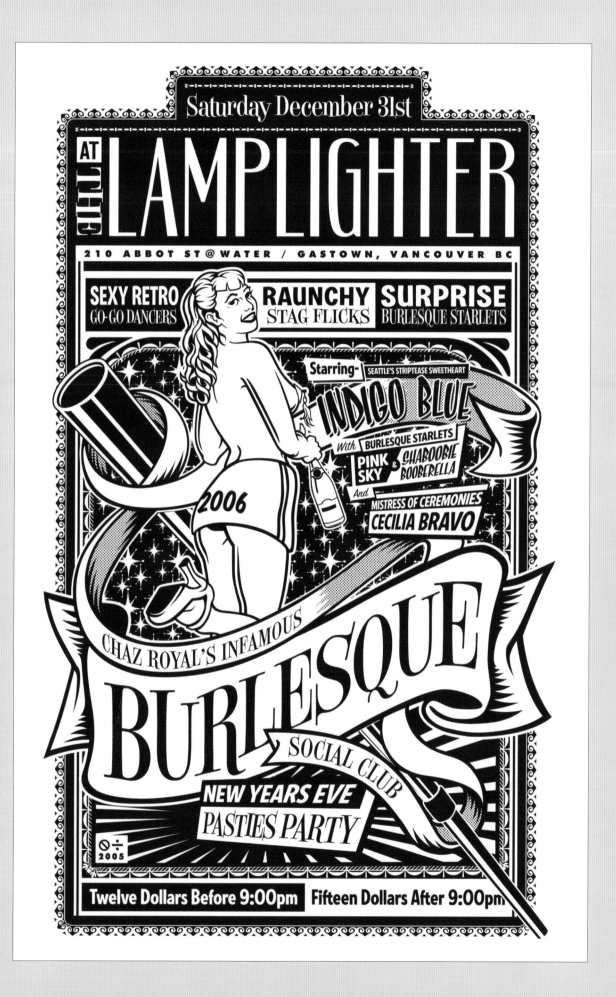

117

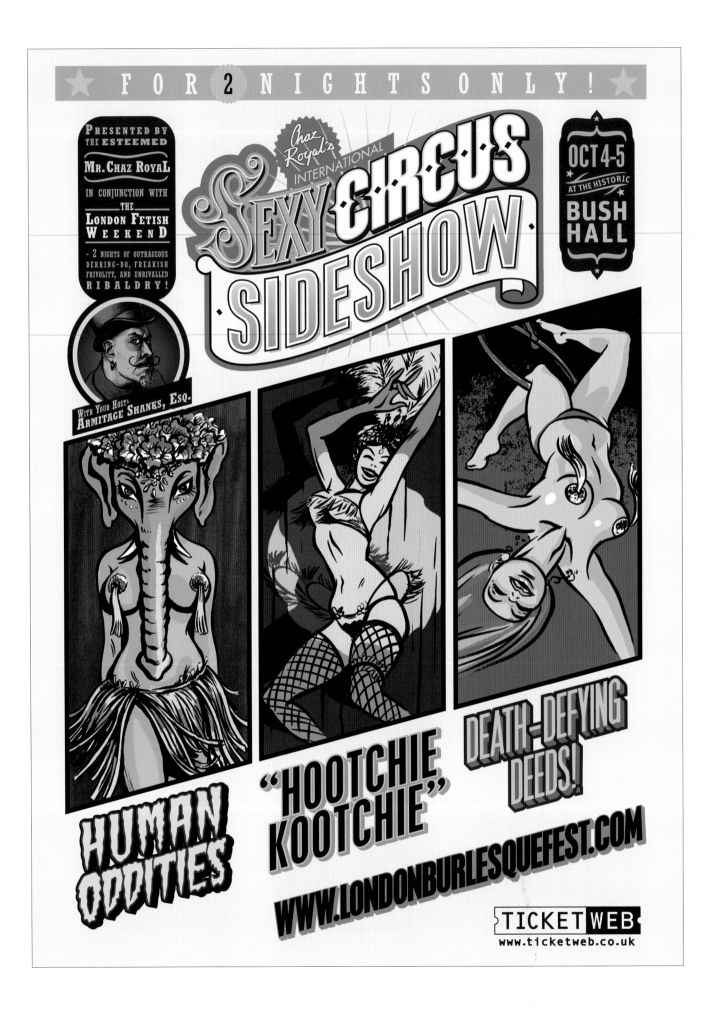

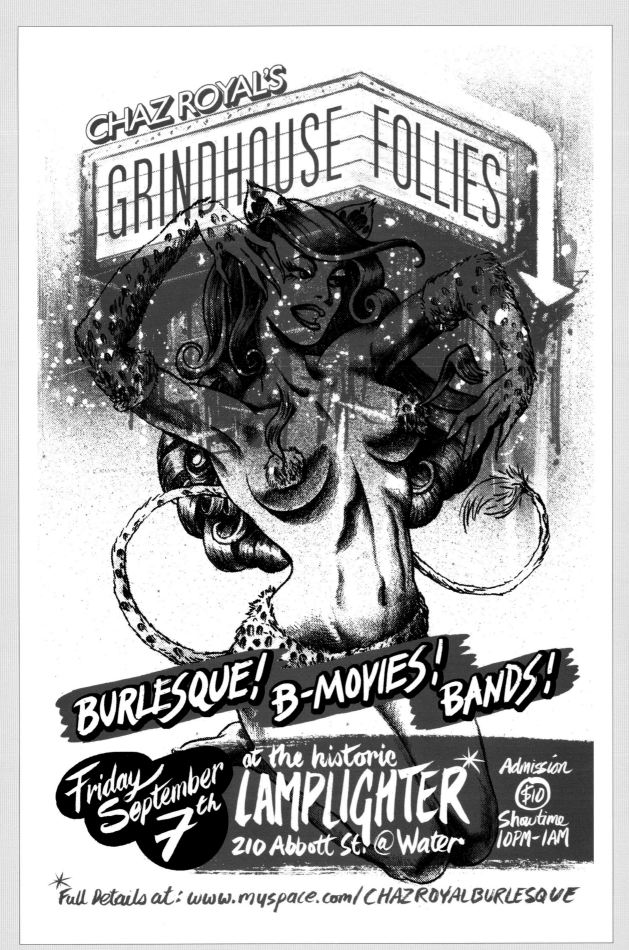

CHAZ ROYAL'S GRINDHOUSE FOLLIES

BURLESQUE! B-MOVIES! BANDS!

Friday September 7th at the historic LAMPLIGHTER 210 Abbott St. @ Water

Admission $10 Showtime 10PM-1AM

* Full Details at: www.myspace.com/CHAZROYALBURLESQUE

LEFT: A Colin Gordon design, inspired by circus and cabaret. This show took place at London's Bush Hall, originally an Edwardian dance hall called The Carlton.

RIGHT: B-movie styled poster by Colin Gordon.

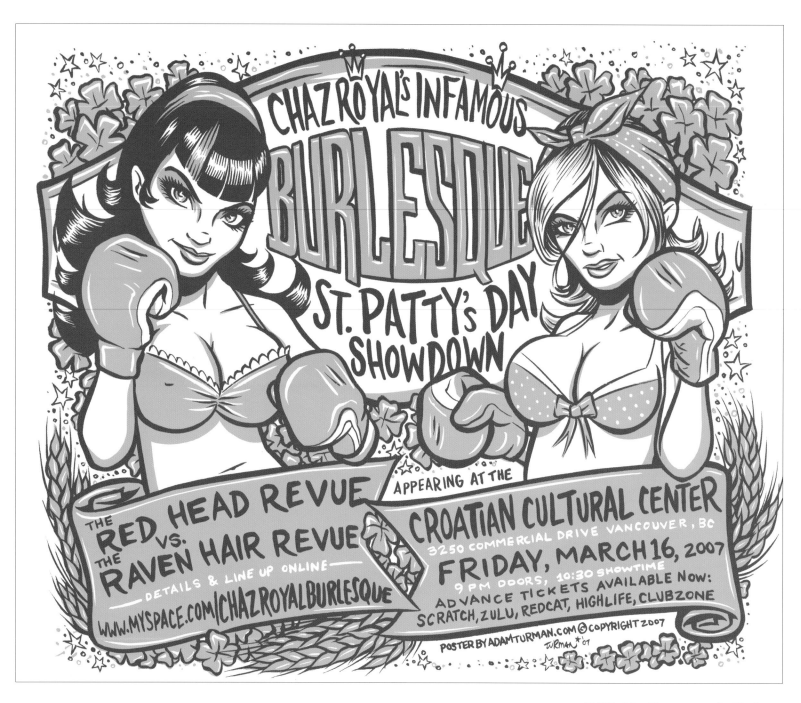

ABOVE: Adam Turman poster, for Chaz's *St. Patty's Day Showdown*, 2007.

RIGHT: Another pure grindhouse-inspired poster, this time by Nate Duval.

Chaz Royal's Infamous ★ ★ ★ ★ ★ ★ ★ ★ ★

BURLESQUE
SOCIAL CLUB

SATURDAY
AUG 5
DOORS: 9PM
SHOW: 11PM
$15 COVER

Little Brooklyn
Direct from NYC

The Royal Court Revue:

GO-GO AMY ★ CHICA BOOM
CECILIA BRAVO ★ BETTINA
FARRAH MOANS ★ MISS VIA ROSE

5 YEAR ANNIVERSARY
-Voted N. America's Best Burlesque-
Playboy.com

Appearing at:

⤷ The Historic **LAMPLIGHTER** ESTABLISHED IN 1899
210 ABBOTT ST. GASTOWN, VANCOUVER B.C. WWW.MYSPACE.COM/CHAZROYALBURLESQUE

MUSIC PROVIDED BY: DJ CHAZ 'ROYALE' ★ COMEDY BY: VINCENT DRANBUIE ★ HOSTED BY: SWANK HIPSTER T-PAUL

Lucha VaVoom

Lowbrow reaches new heights with the *sexo y violencia* that is Lucha VaVoom, in which buxom beauties and masked Mexican marauders join forces in a freewheeling, adrenaline-fueled carnival of kitsch, that draws sellout crowds and rave reviews for every one of their themed nights. The event was founded in 2002 by Mexican wrestling fan (and ex-manager of metal band GWAR) Liz Fairbairn and dancer Rita D'Albert of Michelle Carr's Velvet Hammer Burlesque. The breakthrough idea behind the show was to speed up Mexican wrestling by limiting matches to one fall, adding seductive burlesque shows between matches and featuring politically-incorrect comedians doing a running commentary during the event. The result is electric, an insane but perfect marriage of two great popular culture traditions, American burlesque and Lucha Libre. As Rita D'Albert says "Rock 'n' Roll isn't dangerous any more; we make sure our show is".

RIGHT: Poster by Mark Berry.

FAR RIGHT TOP: Poster for Valentine's Massacre show, 2003.

FAR RIGHT BOTTOM: Lucha VaVoom posters for shows at the Mayan Theater, June and October, 2005 respectively.

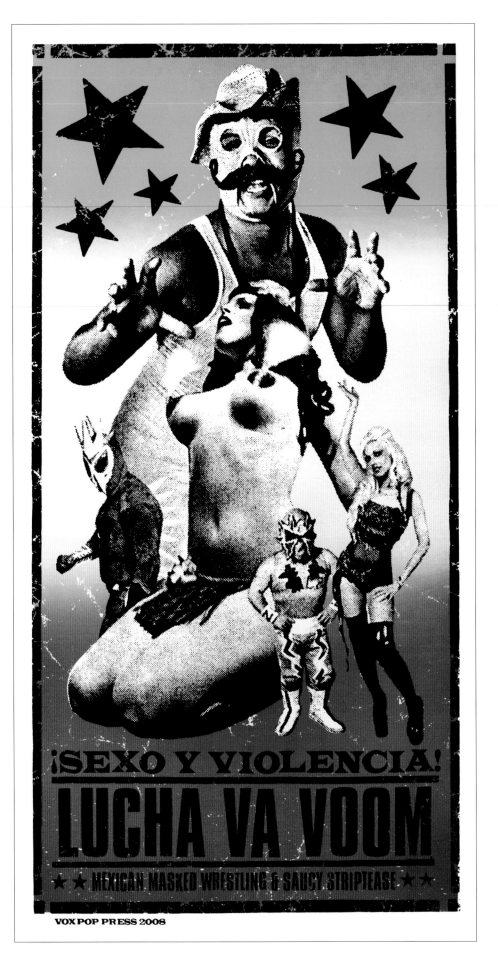

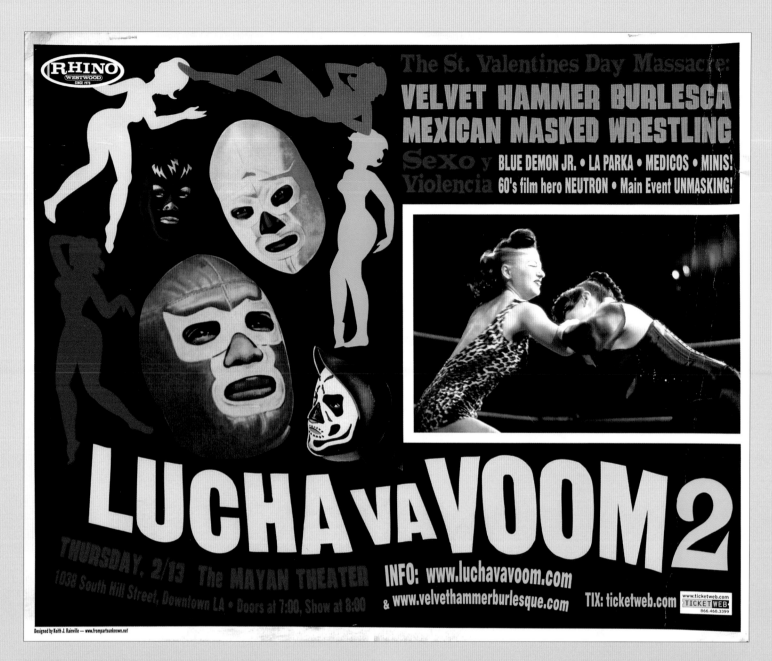

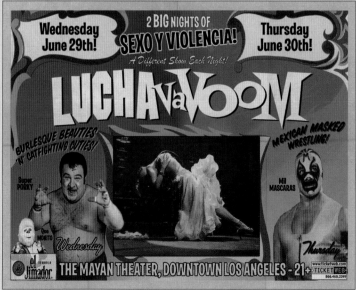

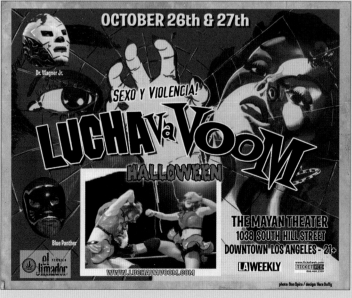

123

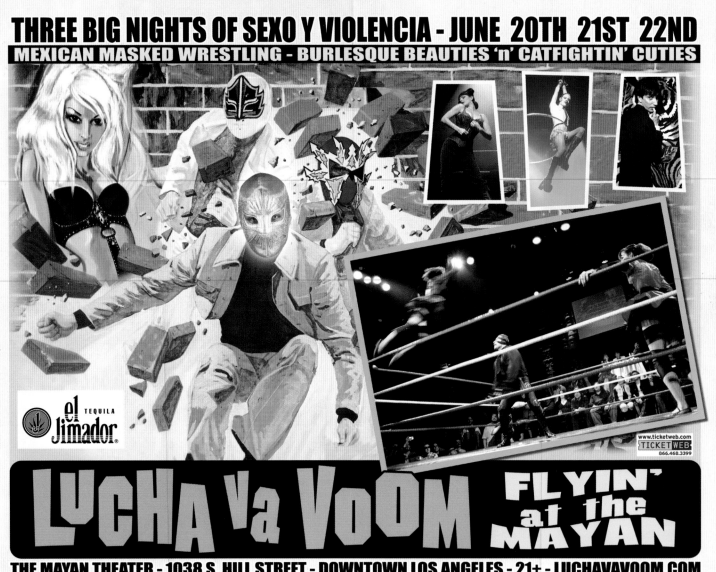

124

ABOVE: Lucha VaVoom poster for Mayan Theater Halloween show.

LEFT: Lucha VaVoom poster for fifth anniversary show, 2005.

OPPOSITE PAGE TOP: Poster for *Flyin' at the Mayan* show, June 2006.

OPPOSITE PAGE BOTTOM LEFT: Mad Mexi Monster show, October 2006.

OPPOSITE PAGE BOTTOM RIGHT: Valentines Sextacular, February 2007.

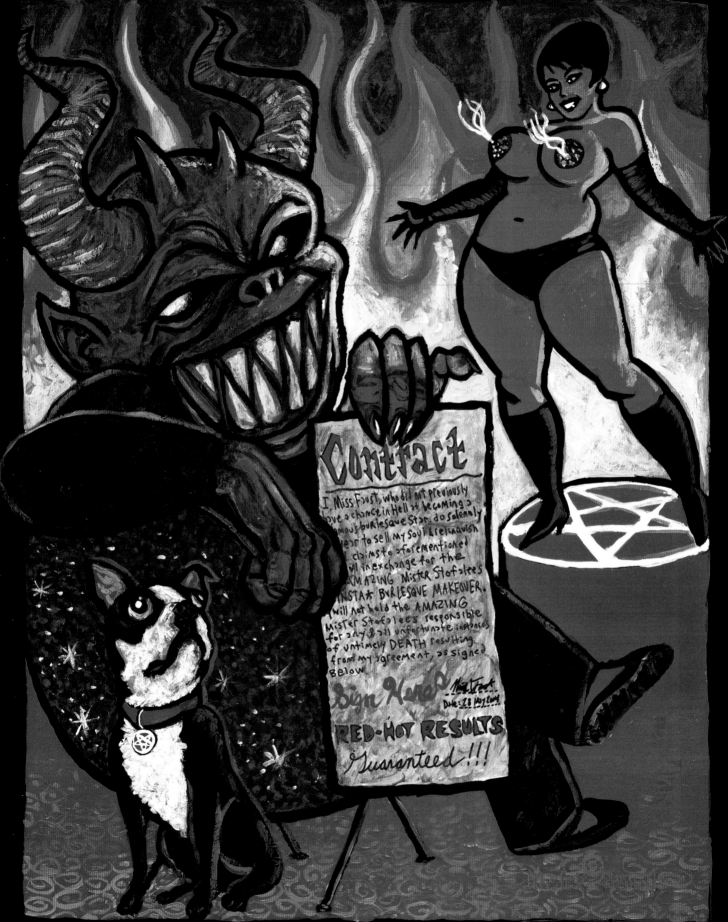

Black Cat Burlesque and Mister Reusch

A self-confessed addict of Halloween, ghost stories and scary monster movies ("I love them so much my teeth have turned into candycorn"), Mr Reusch is an illustrator who also teaches at the Massachusetts College of Art. In 2003 he co-founded Boston-based Black Cat Burlesque, with his "Evil Hootchie Dancer" partner, Devilicia, with the aim of blending "striptease thrills and spookshow chills, to push the boundaries of the art form". B-movies, the witch-soaked history of nearby Salem and monsters are major influences.

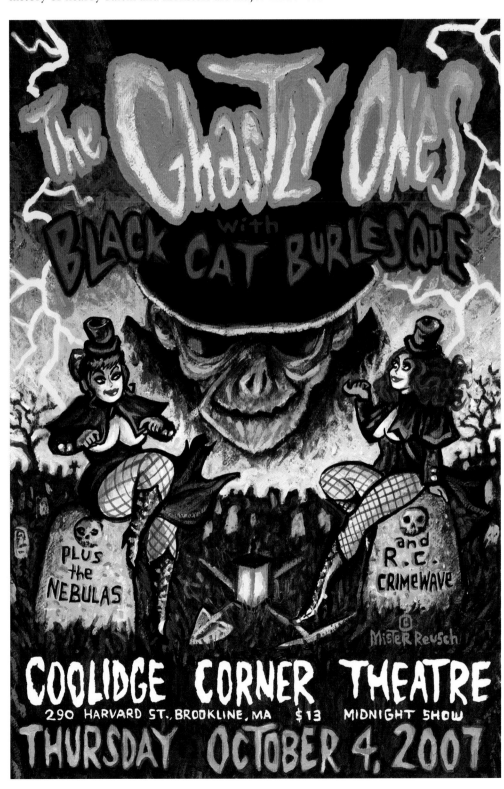

FAR LEFT: A painting of Mark Reusch as Mephistopheles, holding the contract signed by Miss Firecracker, granting him her soul. Transformed, according to Reusch, "from her earlier dumpiness, Miss Firecracker now twirls tassels eternally on a pentagram go-go box". Mark Reusch's Boston Terrier, Frankenstein, sits in the foreground with a pentagram on his collar to complete "this family portrait".

LEFT: 2007 poster, created by Mr. Reusch for the show featuring Black Cat Burlesque and the spooky So-Cal surf trio, The Ghastly Ones. The poster shows Black Cat Burlesque's Devilicia and Mary Widow (wearing matching vintage "Risque Resurrectionist" outfits) beneath the leering eye sockets of the Ghastly One's cadaverous, grave-robbing mascot. Painted in acrylic and fluorescent poster paints on watercolour paper.

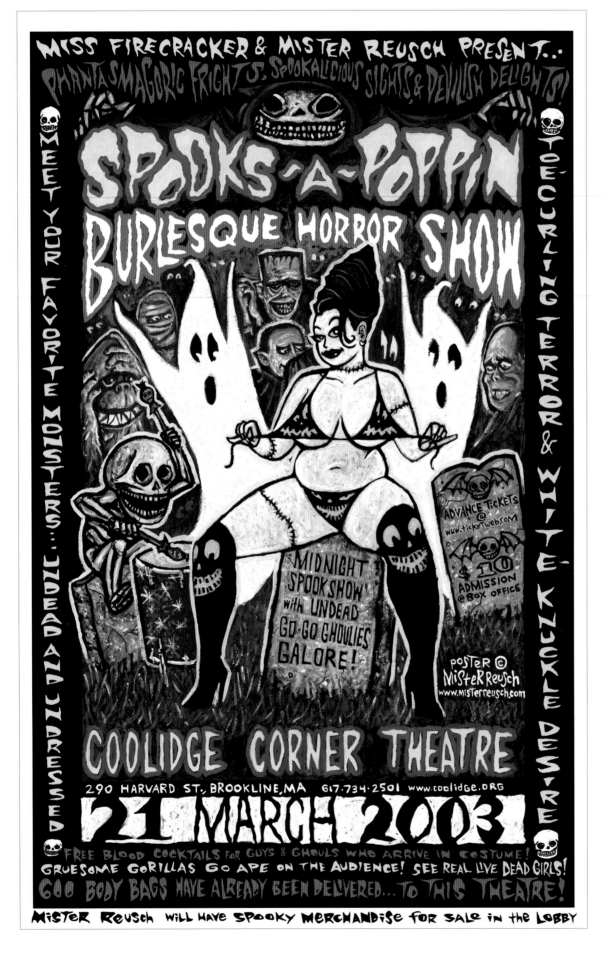

LEFT: An early 2003 Mark Reusch poster for *Spooks-a-Poppin*. The poster was hand-painted with ink, acrylic and gouache on 2-ply Bristol, then scanned into Photoshop. According to Reusch: "the inspiration was Miss Firecracker's spooky stage persona and big curves, and our mutual life-long obsession with Halloween and all things spooky. Something Weird Videos' *Monsters Crash The Pajama Party* compilation and Ed Wood's *Orgy of the Dead* film, where dead women rise to strip in a cemetery, were also influential."

RIGHT: "Flirting With Death" was one of the earliest Black Cat Burlesque acts. Here Reusch created a comic adaptation of the act, showing Mark Reusch performing with Miss Firecracker. It ran full-page in the *Boston Phoenix* newspaper as a teaser to their performance at the Coolidge Corner Theater's 2004 Halloween Horror Movie Marathon.

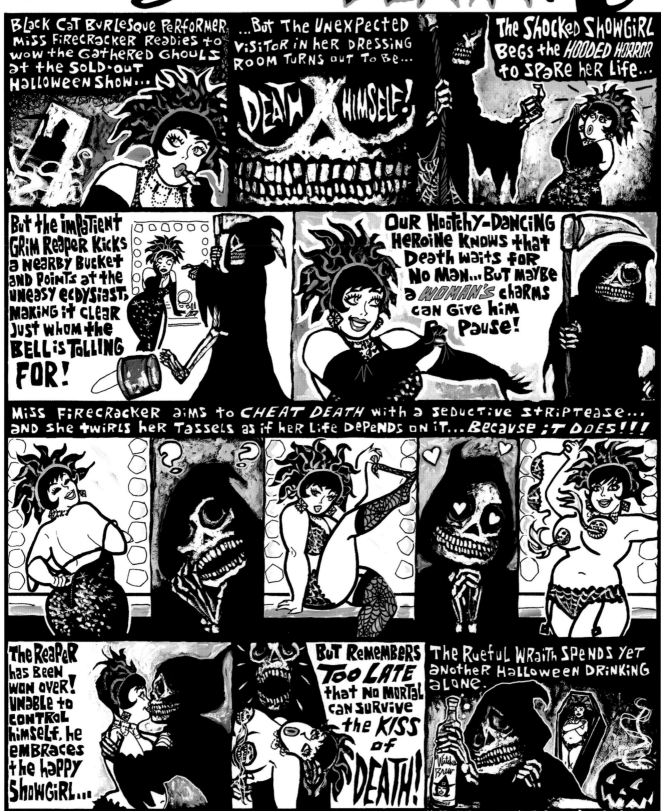

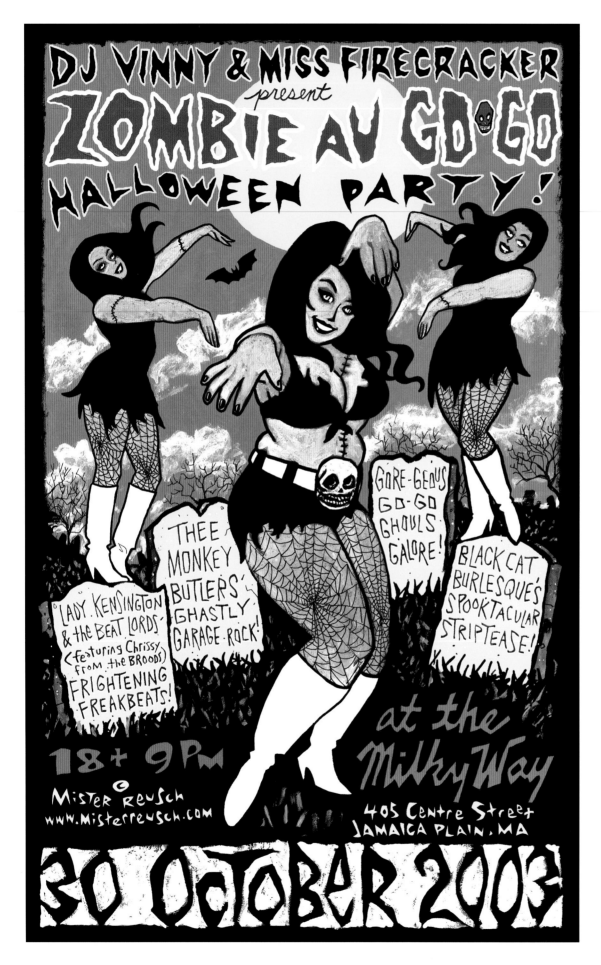

LEFT: An early, 2003, poster by Reusch for the Halloween version of the September 11, 2003 Russ Meyer Tribute Show. The original poster featured go-go girls, transformed here into zombies in a graveyard. Reusch created the poster with acrylic and gouache paints on 2-ply Bristol, finished in Photoshop.

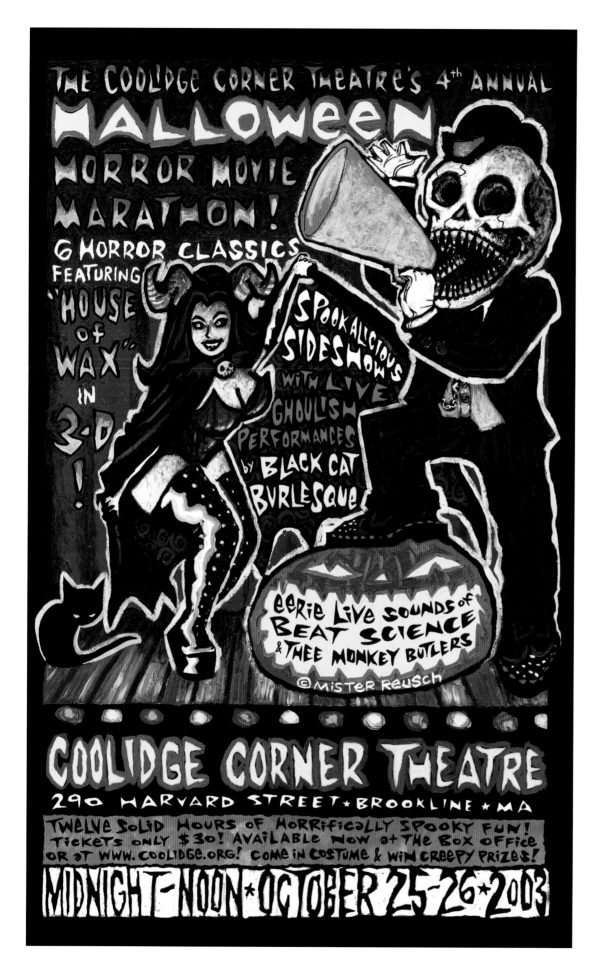

LEFT: Poster by Reusch for the 2003 Black Cat Burlesque 12-hour show. It was their biggest to date, featuring horror-themed acts between horror movies, including a creepy clown act and live circus music by Beat Science. Reusch used his acrylic and gouche techniques here as before, finishing in Photoshop.

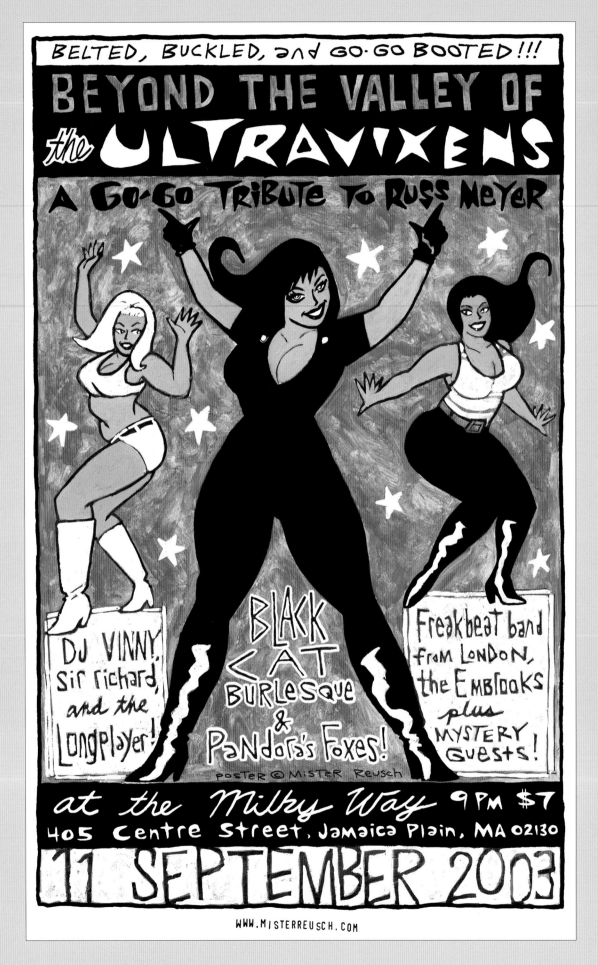

LEFT: Poster for the September 11, 2003 Russ Meyer Tribute Show, *Beyond the Valley of the Ultravixens* at the Milky Way in Jamaica Plain, MA. Reusch explains: "We combined the titles of Meyer films *Beyond the Valley of the Dolls* and *Beneath the Valley of the Ultra-Vixens* so as not to infringe on our hero's movies". At the show Miss Firecracker recreated the infamous "fish dance" from the film *Vixen* by twirling tassels with a real mackerel wedged between her breasts, before engaging in a go-go dance-off with Mary Widow while dressed as Varla from the film *Faster, Pussycat – Kill! Kill!*. The dance-off erupted into a knock down, drag-out (staged) catfight throughout the club. The poster was hand-painted with acrylic, ink, and gouache on 2-ply Bristol.

132

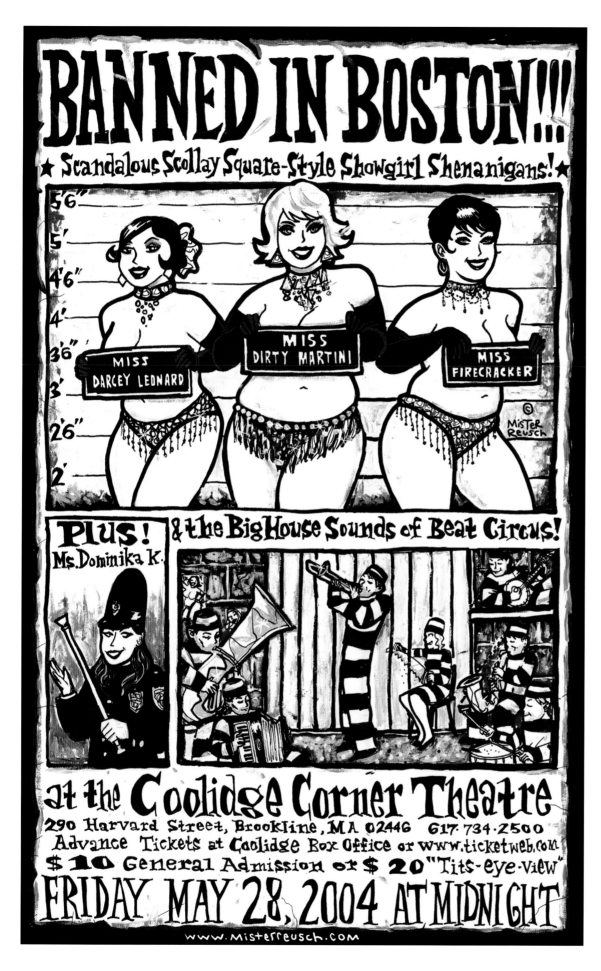

LEFT: 2004 Reusch poster for the show arranged by Darcey Leonard, bi-coastal burlesque dancer, at the Coolidge Corner Theater. Former Miss Exotic World winner, NYC's voluptuous Dirty Martini, performed and Darcey stripped down twice to the live music of Beat Circus.

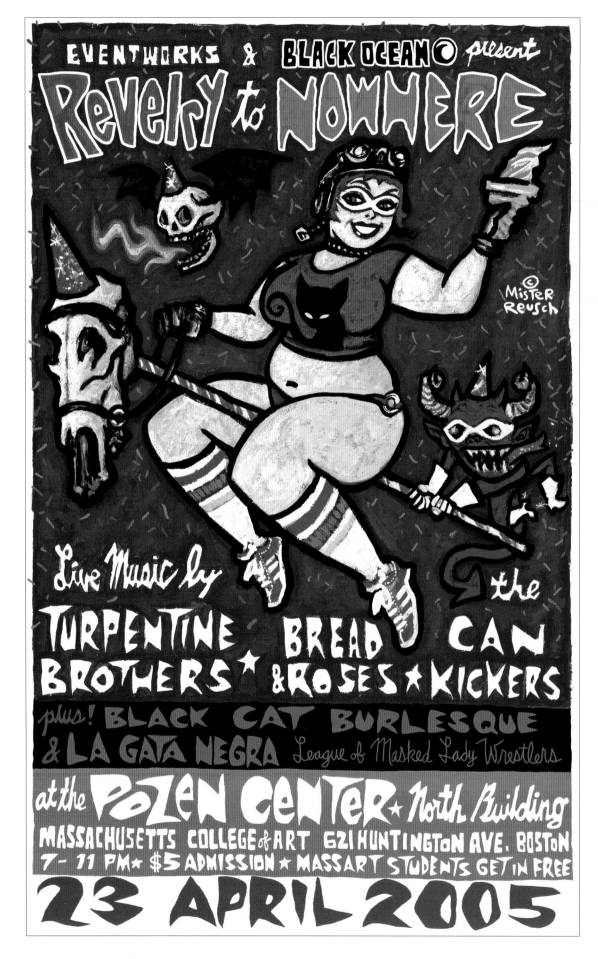

LEFT: Reusch 2005 poster for the Black Ocean and Eventworks produced show at Massachusetts College of Art. The show featured two gory acts from Black Cat Burlesque, music by three bands on two stages, and two matches by La Gata Negra League of Masked Lady Wrestlers. Earlier that night Reusch held a solo show, featuring the 110 posters he painted between 1994 and 2005, and where he wore a homemade Frankenstein monster mask and passed out Swedish fish to the crowd.

RIGHT: Mark Reusch painted this poster of Mary Widow and Miss Firecracker with reds, pinks, and violets to try to capture authentic nightclub lighting. Originally the poster included different text to promote a residency Black Cat Burlesque held at the Lizard Lounge in Cambridge, MA with the Electrolux combo. Miss Firecracker added the title and Mark Reusch added skeletons digitally for use as Black Cat Burlesque's promo poster for the 2004 New York Burlesque Festival. Created with acrylic and fluorescent paint on 2-ply Bristol, and Photoshop.

134

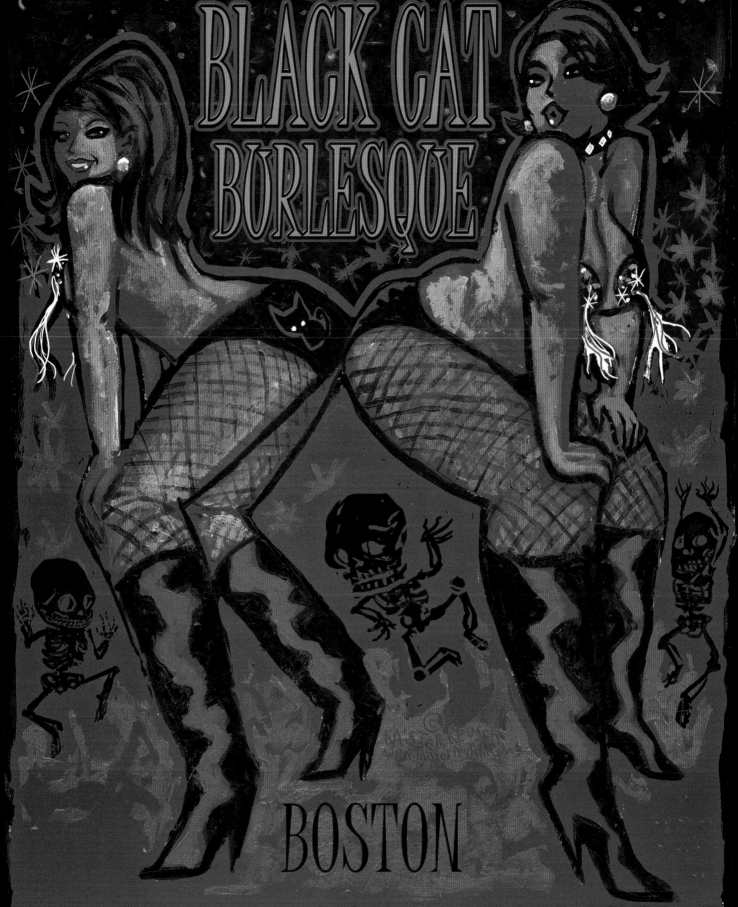

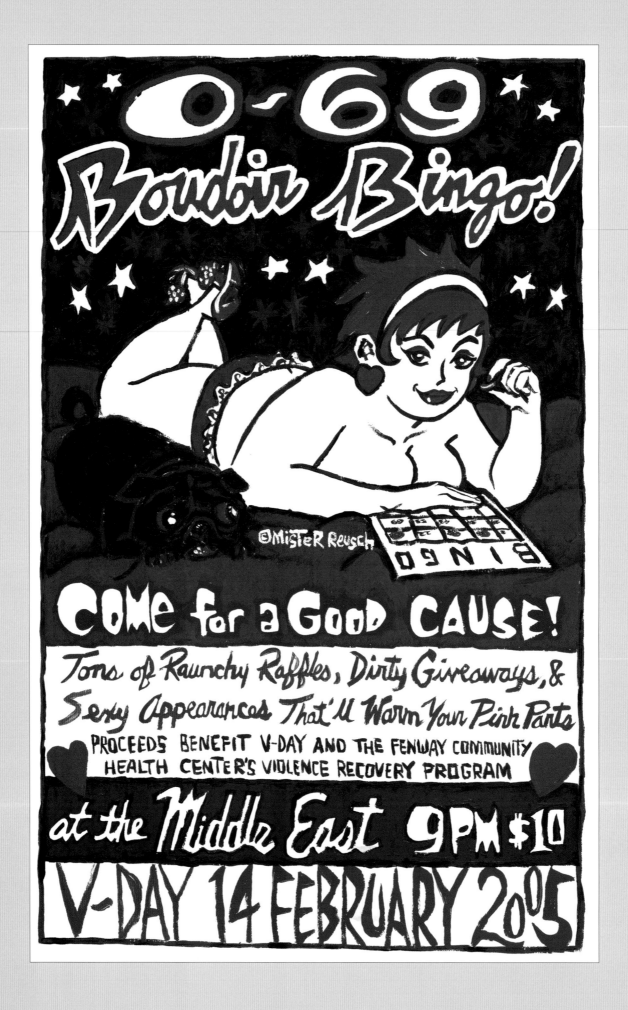

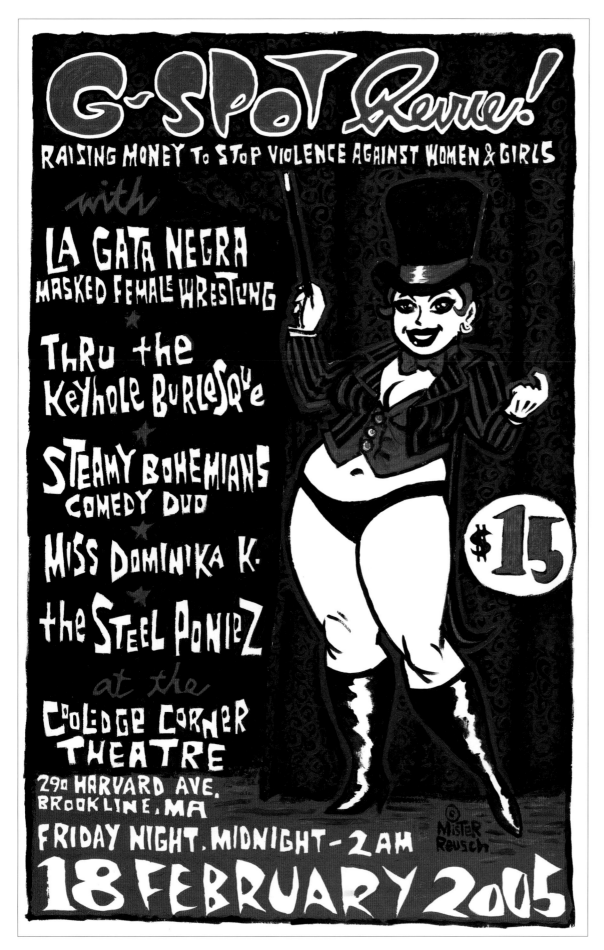

FAR LEFT AND LEFT: Reusch donated these two 10" x 16" event posters, painting them both in one weekend. The designs and colour scheme were inspired by the 'Good & Plenty' candy boxes. The shows featured Miss Firecracker's all-masked, all-female wrestling league, La Gata Negra. In her own words: "Who better to help raise money to stop violence against women than some very violent women?".

Hubba Hubba Review & R. Black

Started in 2006 in San Francisco by some Bay Area nightlife veterans, Hubba Hubba quickly established itself as the most elaborate variety show in the area. The shows are irreverent in spirit, and mix vaudeville comedy, classic striptease, circus and variety acts, and some great bands, including Lurid Bliss and The Minks. They happen weekly at the Uptown Club in Oakland and monthly at the DNA lounge in San Francisco. Performers have included Ariyanna Le Fay, Dottie Lux, Kiss me Kate and the Twilight Vixen Review.

San Diego-based R. Black, the renowned, and highly collectable, rock poster artist amongst other things, has been behind Hubba Hubba's poster designs. Black's work is recognised for its elegant line, razor-sharp design, and dark pulp motifs; his is a world of leggy sirens, gleaming bikes, spiked heels, and leather-clad devils. Black's voluminous catalogue of work includes striking images for Bauhaus, Elvis Costello, The Misfits, GWAR, and Ministry.

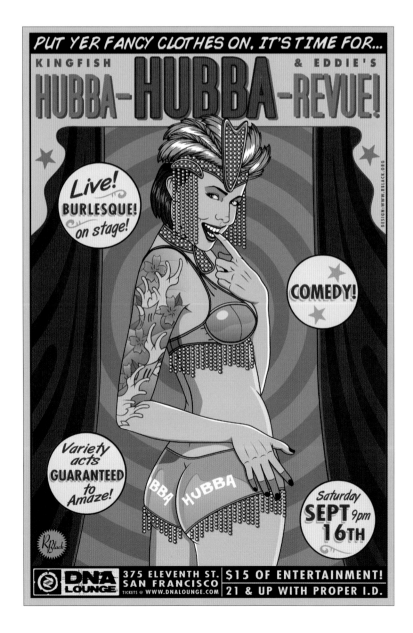

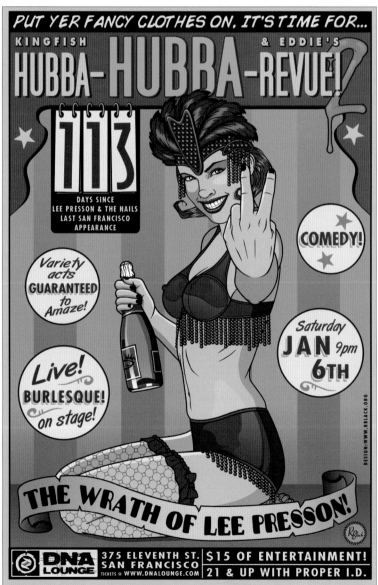

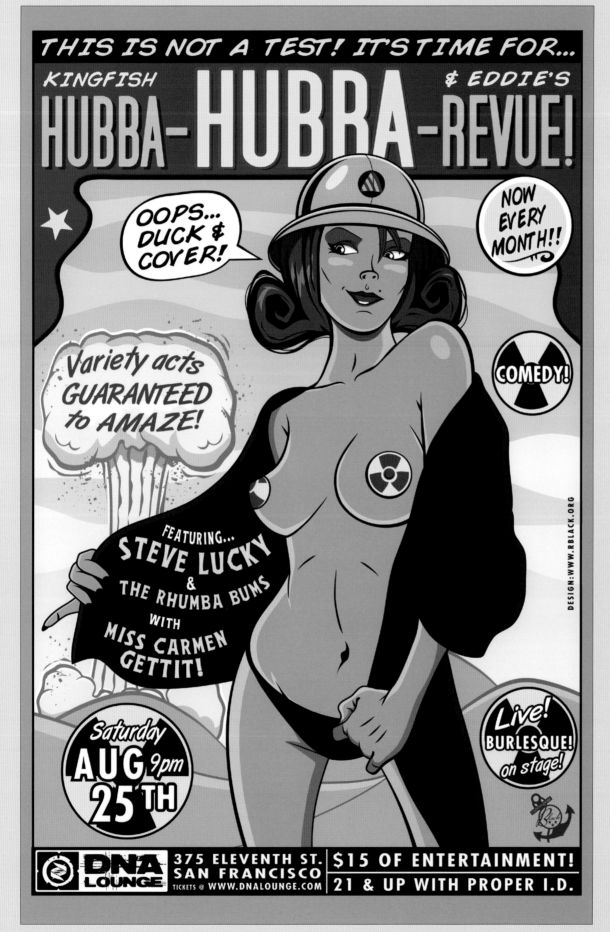

FAR LEFT: Poster for the first Hubba Hubba Revue featuring burlesque beauties, eye-poping entertainment and those Kings of Sinister Swing, Lee Presson and the Nails, September 2006 by R. Black.

MIDDLE: The second Hubba Hubba Revue: *The Wrath of Lee Presson.*

LEFT: Hubba Hubba Revue: *Duck and Cover,* August 2007 by R. Black.

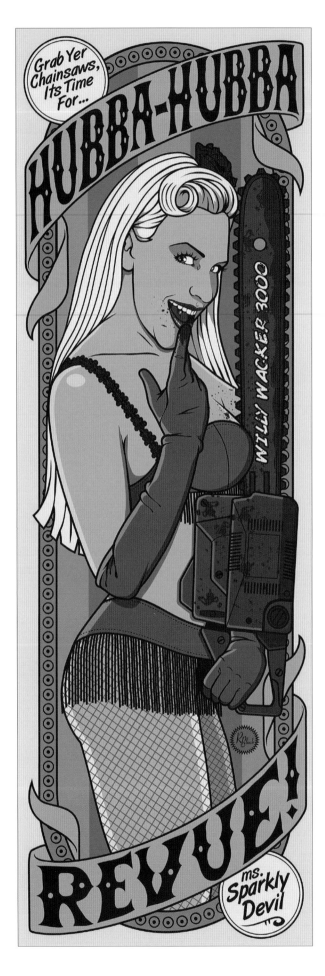

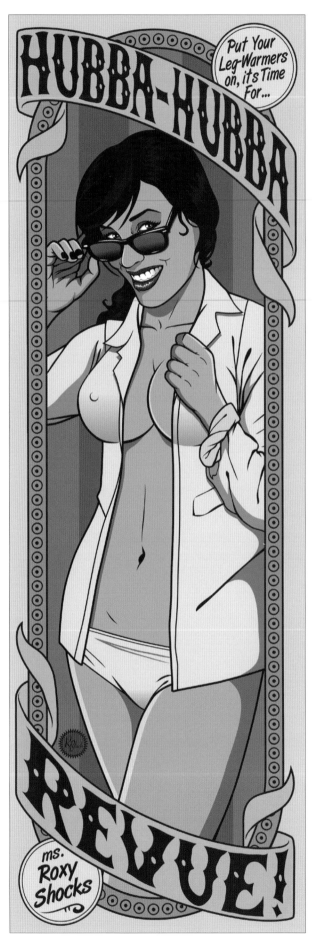

FAR LEFT: *Creepshow Peepshow*, January 2008 by R. Black.

LEFT: *Totally '80s*, February 2008 by R. Black.

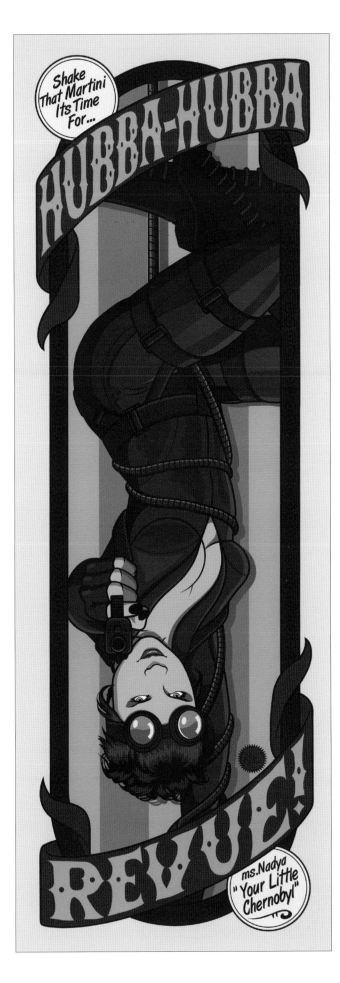

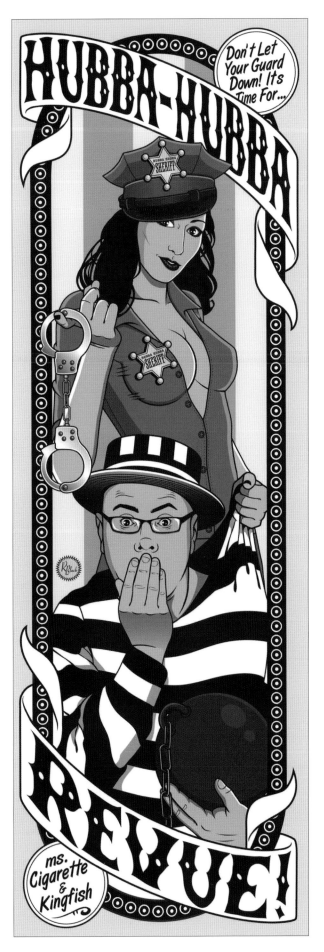

FAR LEFT: *Top Secret*, March 2008, by R. Black.

LEFT: *Cell Block Double-D*, April 2008, by R. Black.

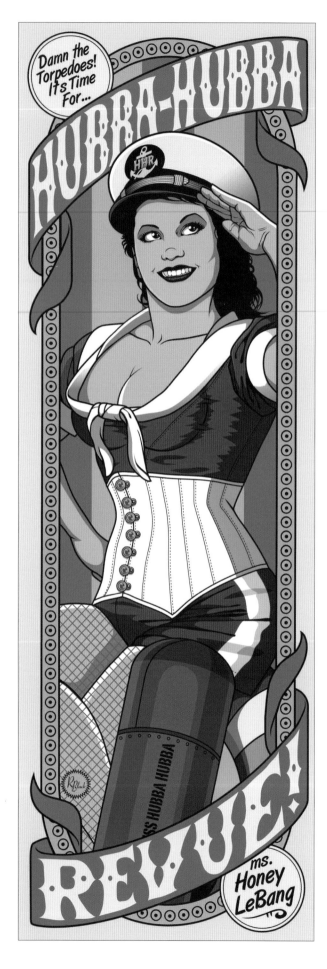

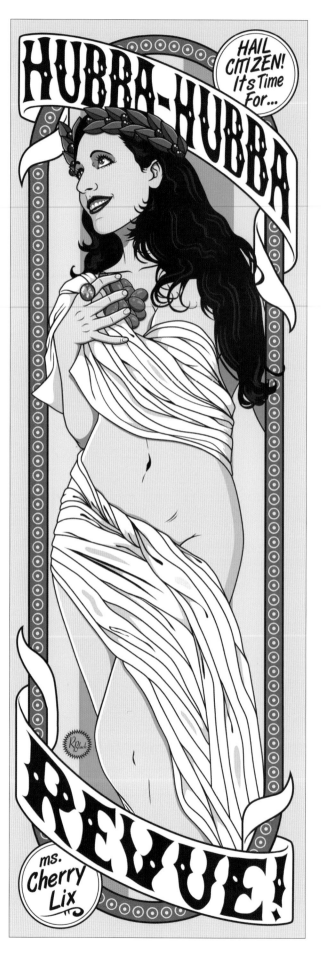

FAR LEFT: *Anchors Aweigh*, May 2008, by R. Black.

LEFT: *Rome*, June 2008, by R. Black.

142

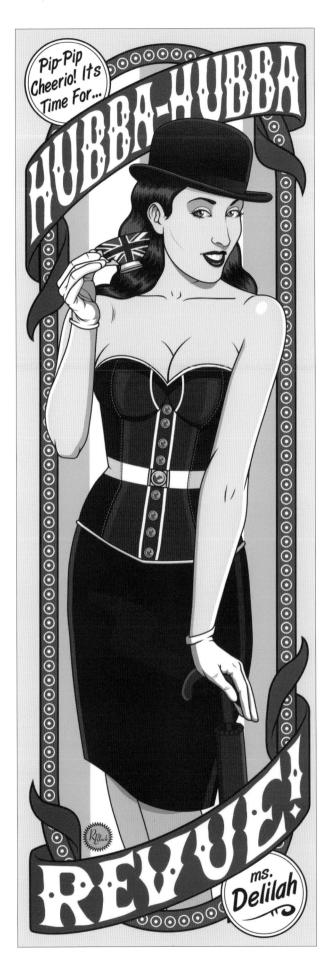

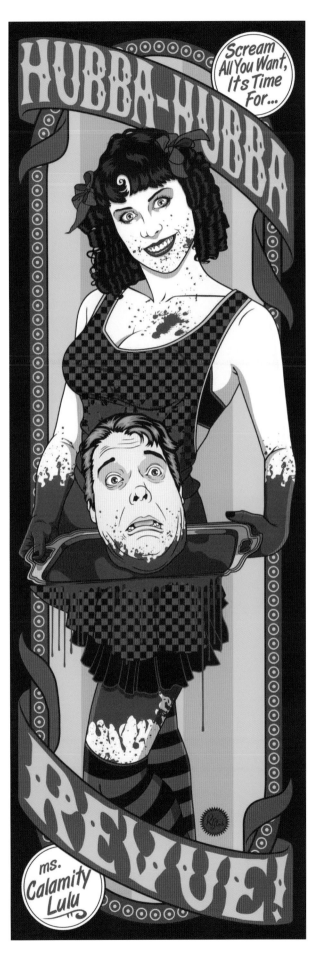

FAR LEFT: *Jolly Olde England*, July 2008, by R. Black.

LEFT: *Creepshow Peepshow*, August 2008, by R. Black.

143

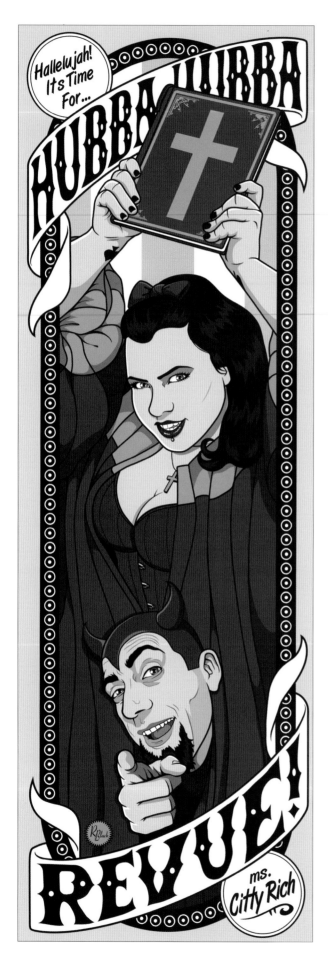

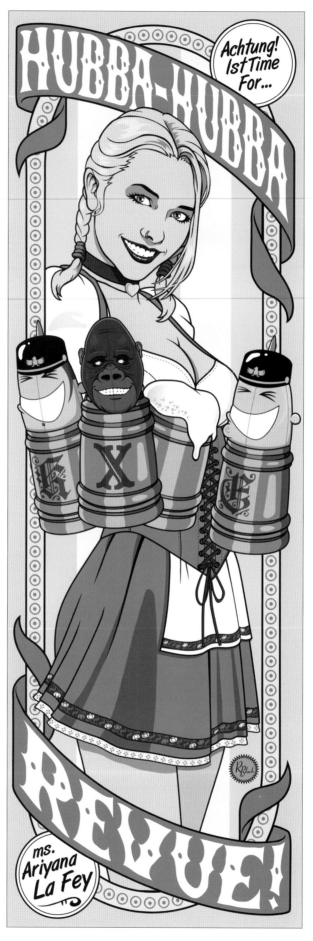

FAR LEFT: *That Olde Time Religion*, September 2008, by R. Black.

LEFT: *Oktoberfest*, October 2008, by R. Black.

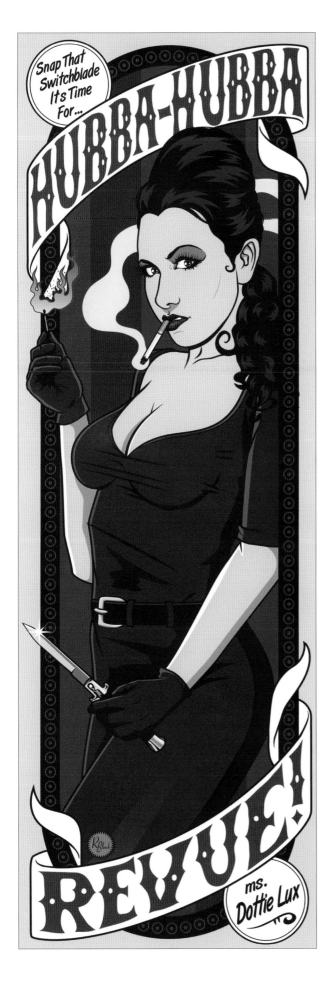

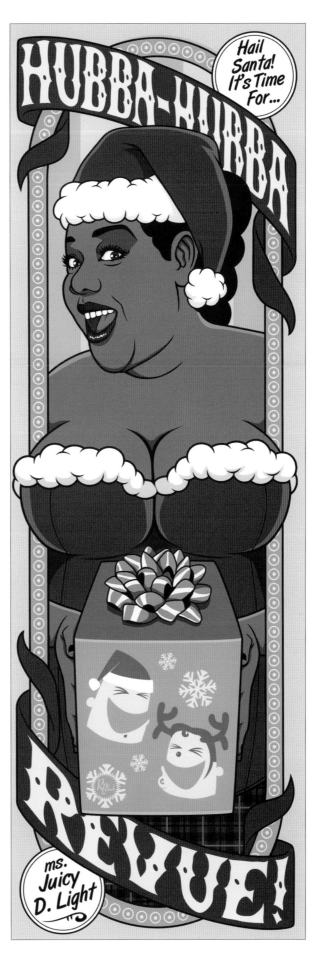

FAR LEFT: *Girl Gang!*, November 2008, by R. Black.

LEFT: *Christmas Special!*, December 2008, by R. Black.

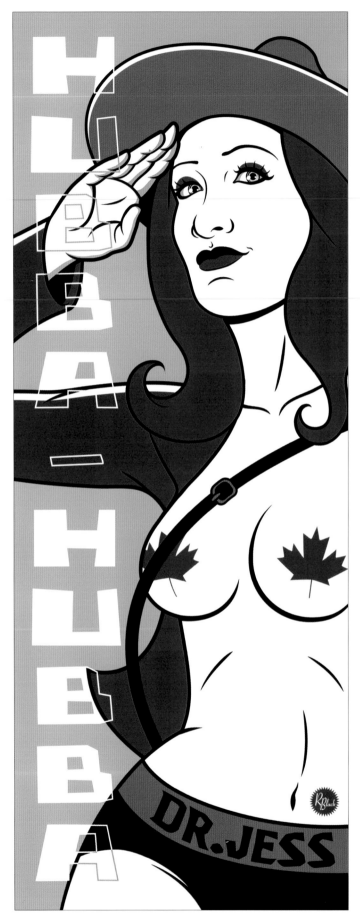

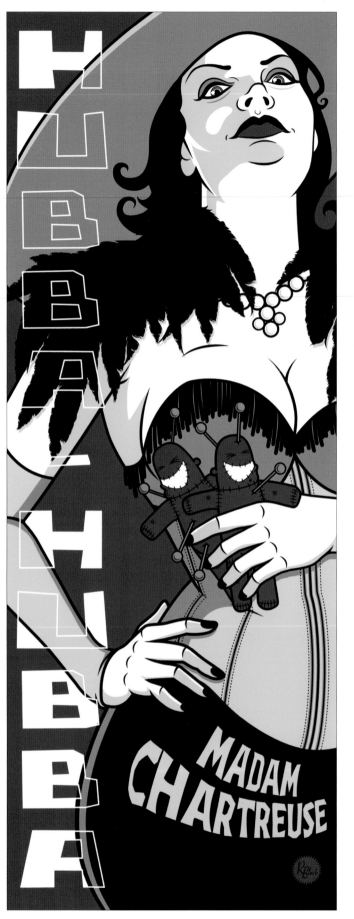

Above: *O Canada!*, January 2009, by R. Black.

Above: *Mardi Gras!*, February 2009, by R. Black.

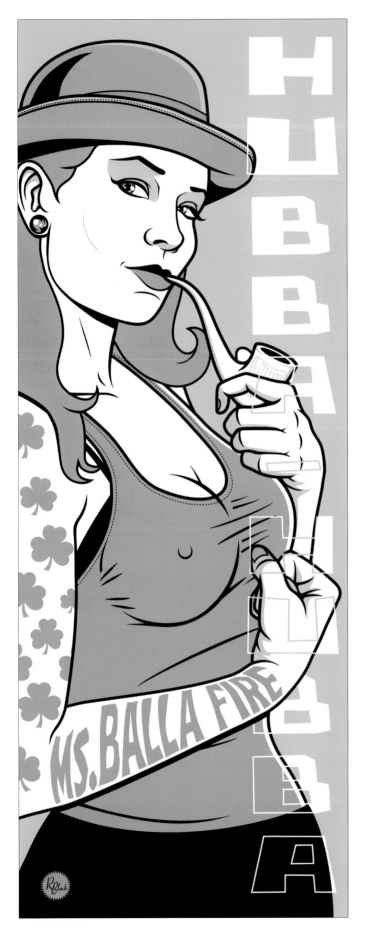

Above: *Emerald Isle!*, March 2009, by R. Black.

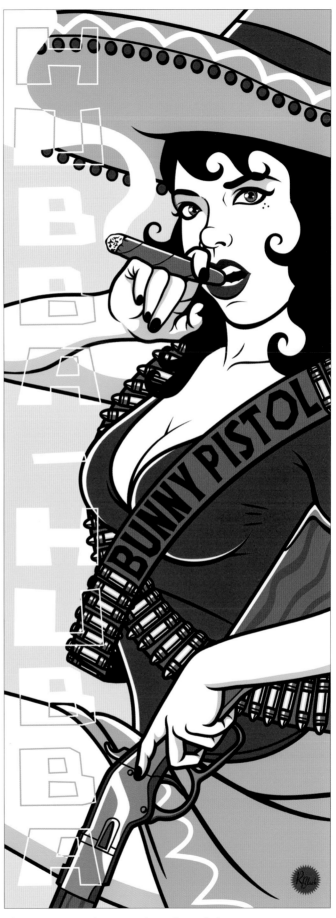

Above: *Viva La Revolucion!*, April 2009, by R. Black.

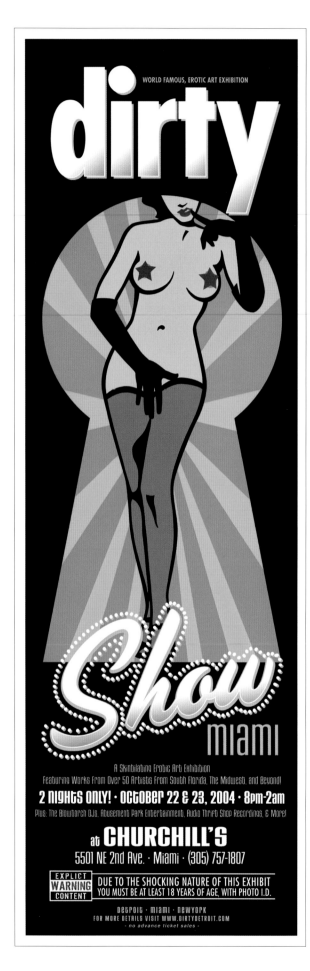

The Dirty Show

Created in 2000 by Jerry Vile, The Dirty Show has a precise mission: to promote, publish and propagate erotic art in all its forms. Vile was soon joined by Jeremy Harvey and Glenn Barr. The first show was on Valentine Day's weekend, at *Orbit Magazine's* offices, featuring 40 artists and a performance by Lady Pain and her slave. An instant hit, the show outgrew the space and in 2002 moved into the Bankle Building in Detroit. In 2003, the annual Valetine's event was held in the Museum of New Art, and was the largest attended event in the history of the museum. Performances included Spag and Hell's Belles and the Gorilla Girl.

Burlesque has always been critical to the show. The iconic keyhole logo of the show is a homage to it. "There are those who don't see the art in burlesque – fuck 'em" says Vile; "flesh was the original canvas – the ultimate aesthetic pleasure". The show rescued the once great tradition of burlesque in Detroit. Says Vile, "At the time there hadn't been a live burlesque show in decades. By the time we were legal the great burlesque houses had fallen, decaying away in the bleakest neighborhoods. Now the art lives in Detroit, thanks to Spag Burlesque and Hell's Belles, who not only resuscitated the art, but with a host of others like the Fat Bottom Girls and Causing a Scene, took it to whole new levels". The show continues to grow, now featuring over 250 artists from over 20 countries, and that's after an intense selection process. "Burlesque is as elemental now to the Dirty Show as what hangs on the walls", says Vile.

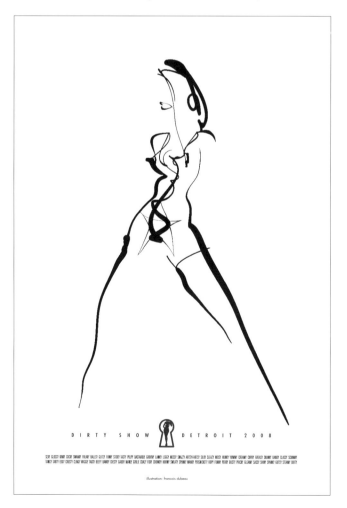

illustration: francois dubeau

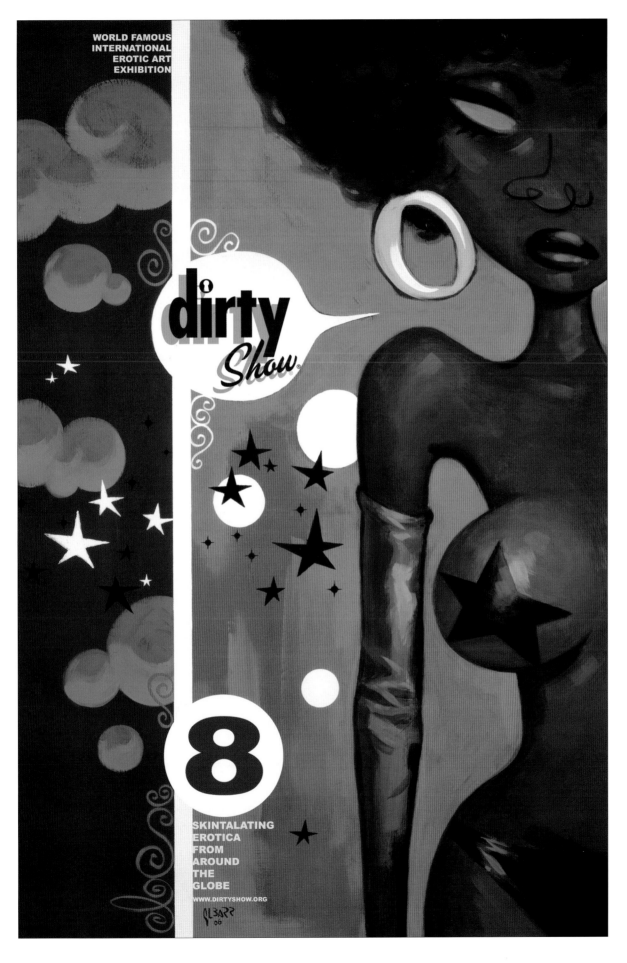

FAR LEFT: Gary Arnett poster using The Dirty Show's iconic keyhole logo, 2004.Vile: "This is a propaganda poster from our one-off Miami show we did in the Fall of 2004". The venue was an English Punk Rock bar in Miami's Little Haiti (of all weird places).

MIDDLE: Dirty Show 9 Poster, 2008. Illustration by François Dubeau; Art Direction by Gary Arnett; Screen Printing by Eclipse Printing.

LEFT: Poster by Glenn Barr, 2004. Barr is one of Detroit's most celebrated and successful lowbrow artists.

The Devil-ettes

Founded in 1999, San Francisco-based, and describing themselves as "sassy, sultry and utterly all-American", the 18-member Devilettes are part of the revival of 1960s historical go-go dancing. Founder Baby Doe, whose husband Otto von Stroheim also created the tiki afficionado magazine *Tiki News*, says "all of us grew up in the punk rock era, when you had to be super-cool...we got sick of that; we wanted to go to shows, have some fun, smile and be goofy...so at Radio Valencia's annual Christmas talent show in 1999, we tried synchronized dancing. It was a smash." They never looked back. Their acts include revivals of the hully gully, the Jamaican ska, the frug and the watusi. Troupe members are The Hellcat, The Starlet, The Assassin, The Teacher's Pet, The Smarty Pants, The Vixen, The Cherry Bomb, The Preacher's Daughter, The Glamazon, The Hip Shaker, The Rocket Girl, The Sugar Snap, The Knockout, The Spitfire, The Saucy One, The Habanera, The Rebel, and MC Juan Rapido...you get the vibe, or as *The San Francisco Bay Guardian* put it "a cornuccopia of non-stop American kitsch". For Doe it's been a hell of a ride: "I think in some ways my lack of training is why The Devil-Ettes are so unique. I have always approached the troupe as a community of women working together, rather than as a formal dance group...we try to have as much fun off-stage as we do on stage".

RIGHT: Poster by Chuck Sperry of Firehouse Kustom Rockart Company, 2004.

FAR RIGHT: "Ready, Set, Go Go"; poster by R. Black.

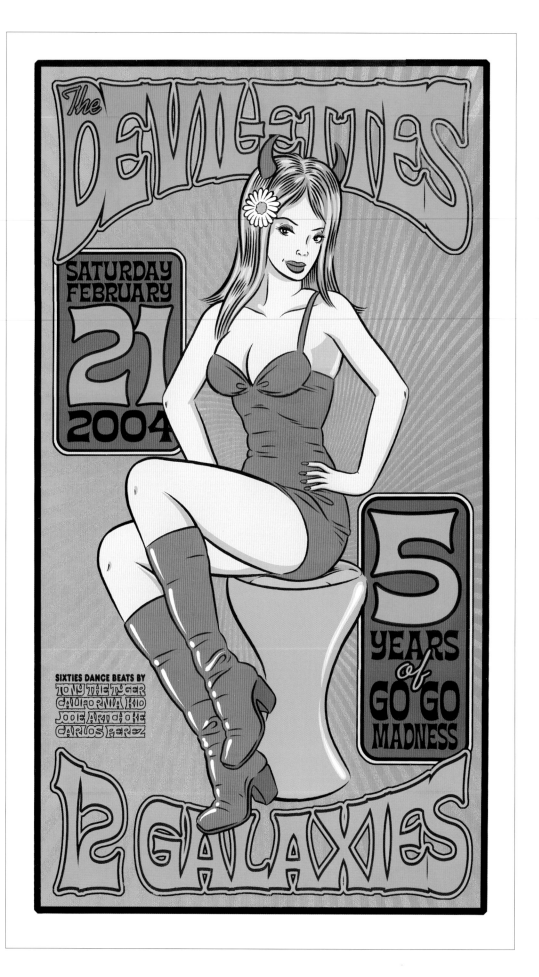

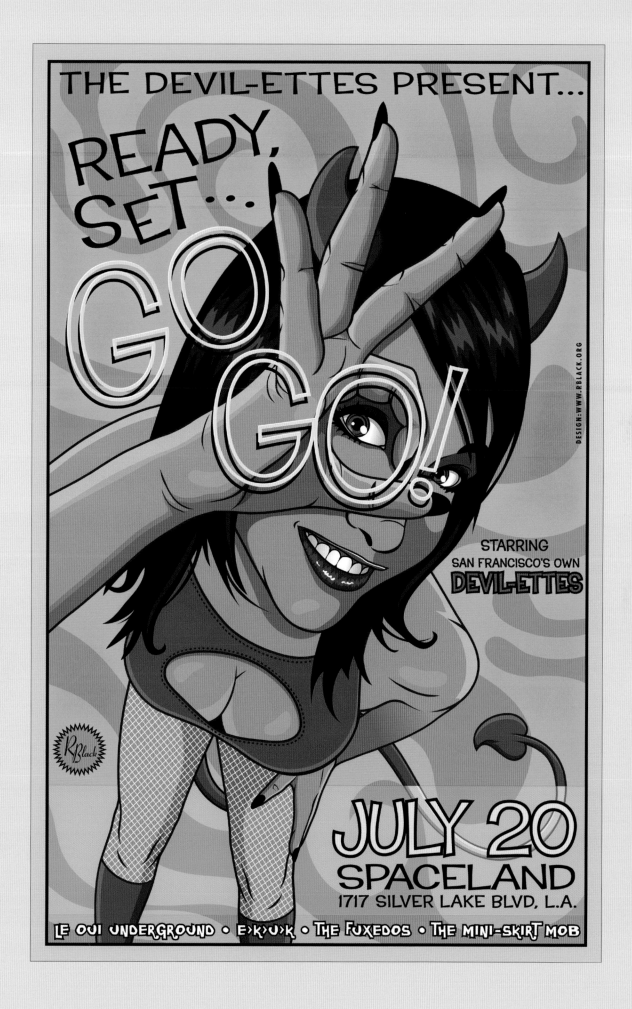

151

Wasabassco Burlesque

Unique amongst burlesque troupes for being named after a hot sauce, Brooklyn-based Doc Wasabassco heads up his team of "luscious lovelies": GiGi La Femme, Anita Cookie and Nasty Canasta, and features Johnny Porkpie "the burlesque mayor of New York". The shows are regularly seen at venues such as Bell House, Living Room Lounge, Public Assembly, Southpaw, Sputnik, and Union Hall. They stage a monthly show at the Palace of Wonders in Washington D.C..

Wasabassco also has two travelling shows: the Wasabassco Medicine Show, Wasabassco's Girls! Girls! Girls! ("a ladylicious cabaret"), and their Travelling Burlesque Revue. The latter was described by the *New York Press* as "offers up a substantial helping of coquetry, comedy and camp, along with other pinker, softer words beginning with the letter 'c' ". Their more recent Wasabassco Burlesque Hellfire Club night adds fire breathing, sword swallowing, acrobatics and go-go dancers to the "sinful striptease".

FAR LEFT: Show poster design by Matt Siren.

MIDDLE: Show poster design by Matt Siren, 2007.

RIGHT: Promotional poster, by Matt Siren.

Dr. Sketchy's Anti-Art School

Dr. Sketchy's – "what happens when cabaret meets art school" – was founded by the brilliant illustrator Molly Crabapple as a cabaret life-drawing class, which now has 57 branches around the world. Brooklyn-based Molly has a huge list of credits, including Marvel Comics, *Playgirl*, *The New York Times* and *Wall Street Journal*. Her first Boston Dr. Sketchy's was organized by tireless promoter Aliza Shapiro. Mark Reusch did the posters for the event, which featured Devilicia of Black Cat Burlesque. In her artiste's statement Molly declares of her work "the subject most dear to my heart is artifice…my time a burlesque dancer showed me plain women emerging from the club's dressing room as goddesses. In the two time periods I draw the most from in my work - Victorian England and Rococco France – people tried to make their entire public lives as artificial as a burlesque dancer's face."

ABOVE: Mark Reusch poster, for the Boston premiere of Dr. Sketchy's Anti-Art School Cabaret Life-Drawing Class, 2007. Created using ink and fluorescent paint (says Reusch: "I figured fluorescent pink was as anti-art school as you can get"), in a large sketchbook, scanned into Photoshop to show the wire ring-binding.

FAR RIGHT: Mark Reusch poster, for the November 2007 Boston show.

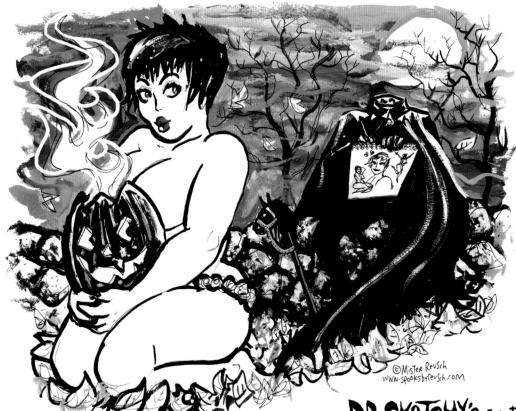

Truth Serum presents

Dr. Sketchy's Anti-Art School
cabaret Life Drawing class

©Mister Reusch
www.spooksbyreusch.com

with DEVILICIA & MISTER REUSCH
of BLACK CAT BURLESQUE modeling

DR. SKETCHY's creator
MOLLY CRABAPPLE
will be present with
2008 calendars for sale!

@GREAT SCOTT 1222 Commonwealth Ave in Allston
(CORNER of HARVARD & COMMONWEALTH)

SUNDAY 11 NOVEMBER 2007
2:30PM +18 $7

★★★ truthserum.org ★★★ drsketchy.com ★★★

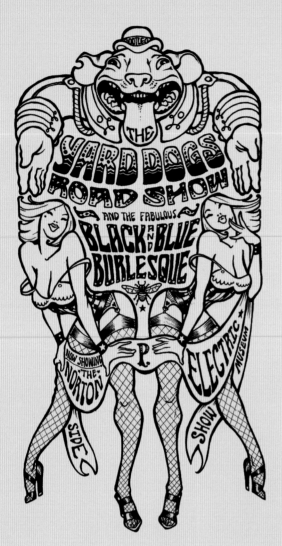

Yard Dogs Road Show

A thirteen-member traveling cabaret, The Yard Dogs Show "was born from the saloon vaudeville that toured the Wild West in the late 1800s, and then slammed into the underworld that is modern American road culture". Their performances include vaudeville, burlesque, stage magic, sideshow oddities, and beatnik "hobo poetry." Originally from San Francisco, their first national tour was in 2005, playing 25 shows in 35 days.

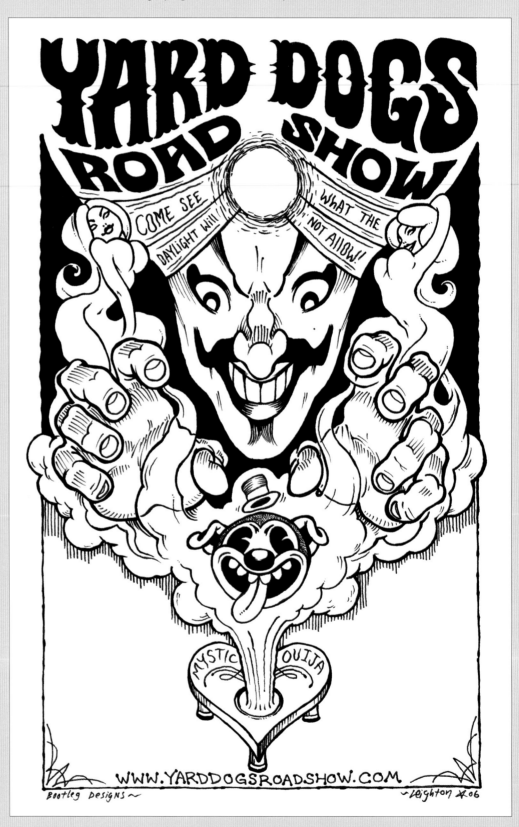

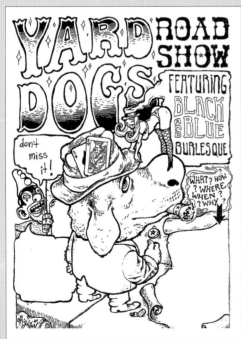

TOP: Artwork design by Leighton.

ABOVE: Handbill artwork by Leighton.

RIGHT: Poster artwork by Leighton, 2006.

156

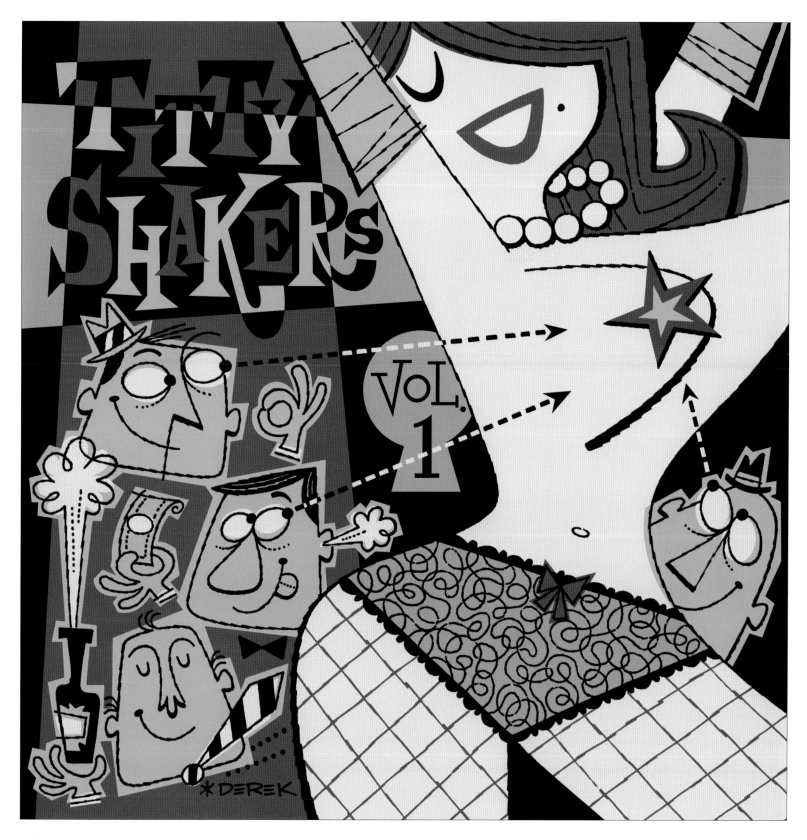

ABOVE: Print by Derek Yaniger, from artwork he originally designed for Jazzman Records' *Tittyshakers Vol. 1*, 2009.

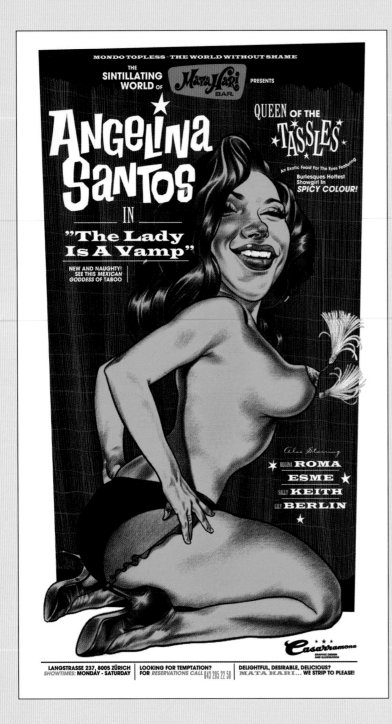

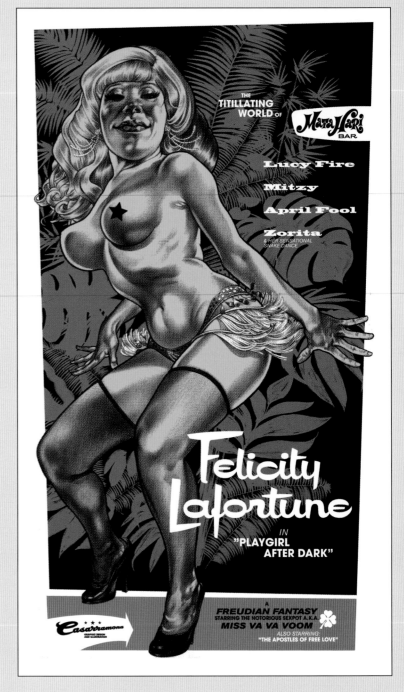

Three posters by Michel Casarromona for the Mati Hari Bar in Zurich, Switzerland, 2005; LEFT: Angelina Santos ; ABOVE: Felicity Lafortune; RIGHT: Katyusha Marx.

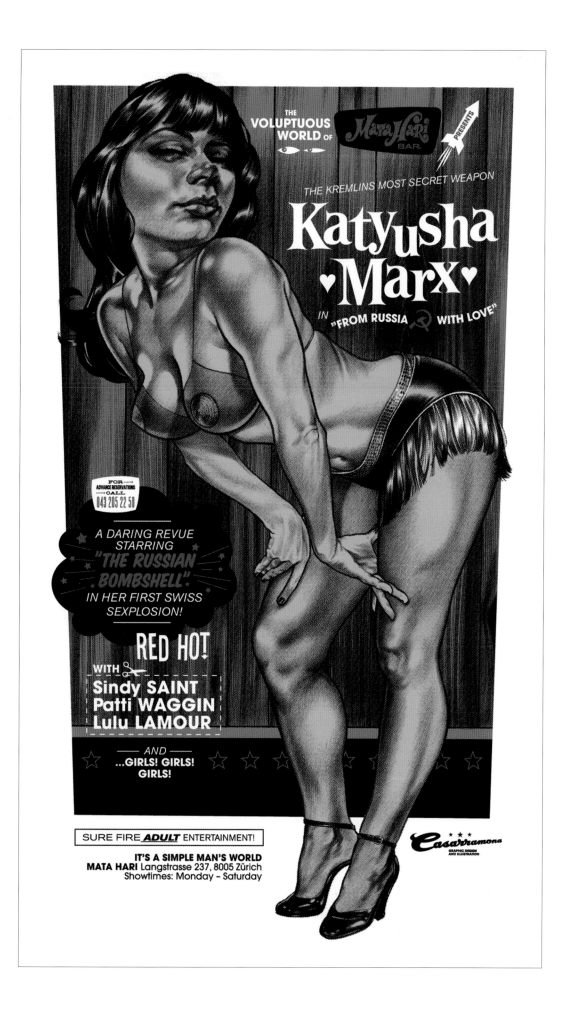

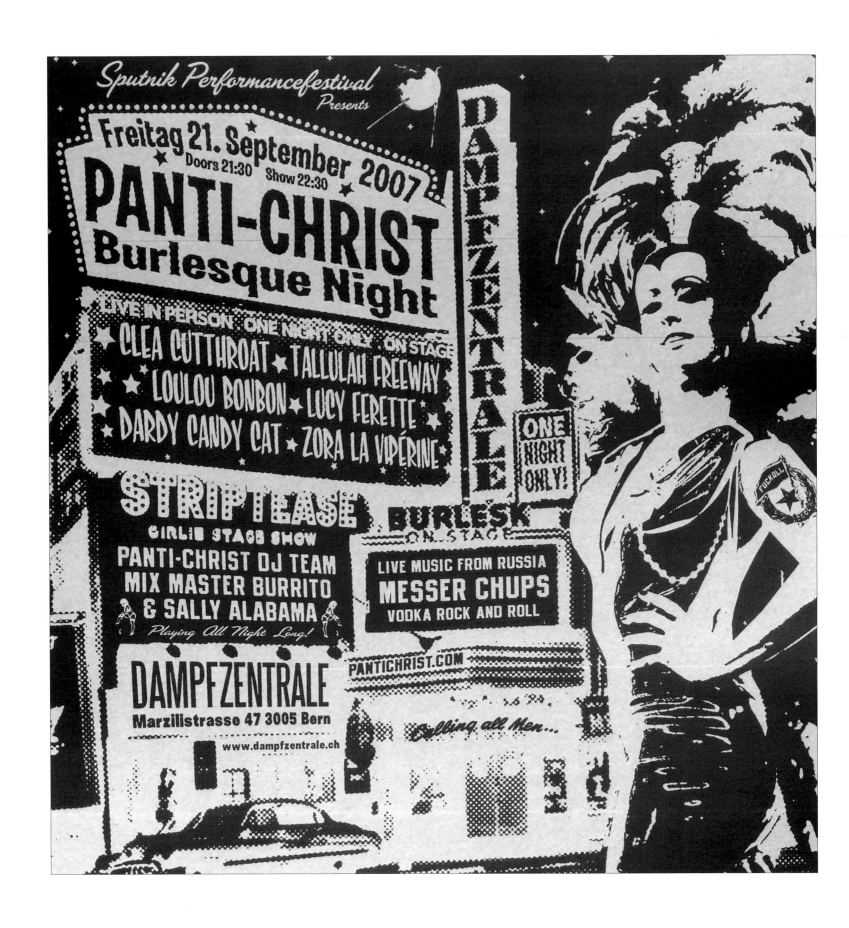

ABOVE: Poster artwork, 2007, by Panti-Christ from Switzerland.

RIGHT: Poster artwork, 2008, by Panti-Christ.

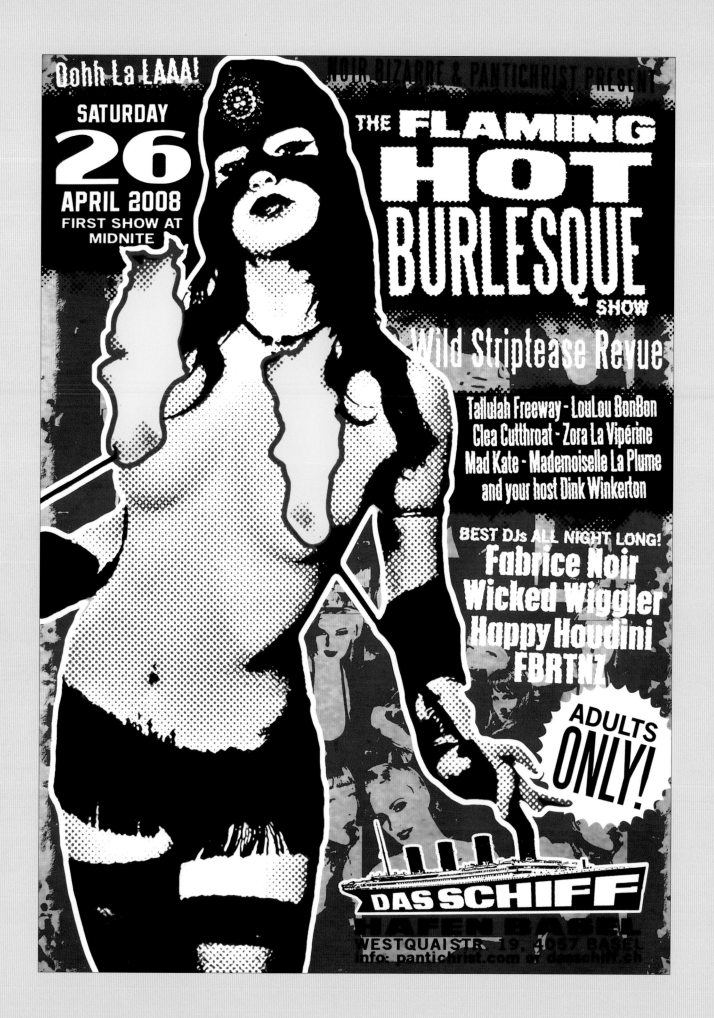

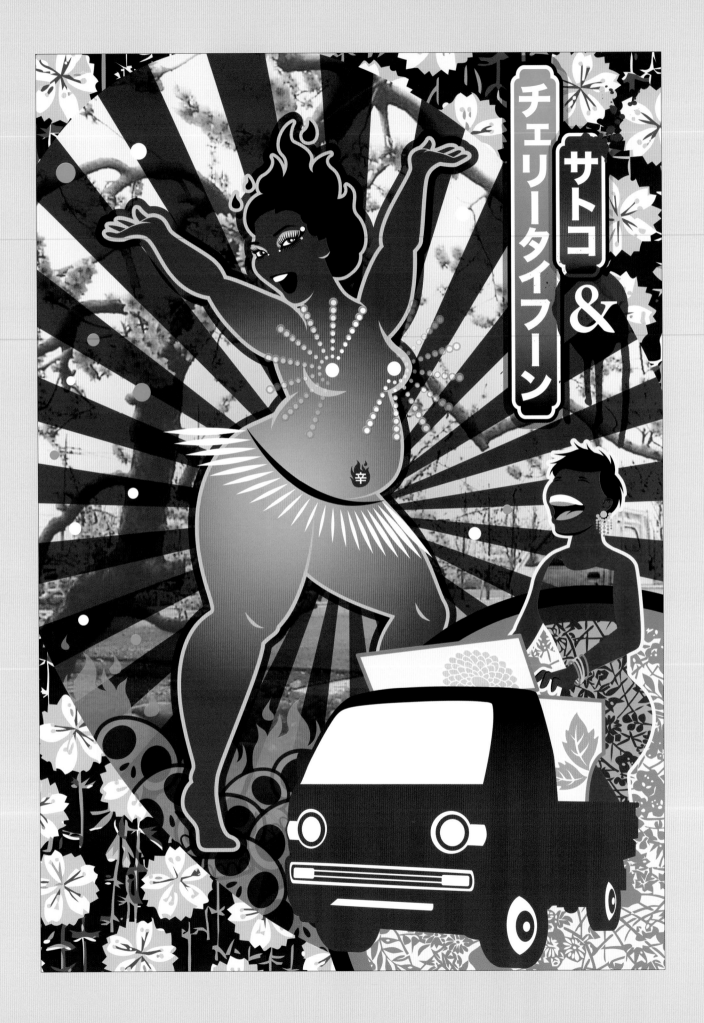

LEFT: Josh McKible poster for
Japanese burlesque duo, Satako
Nakamura and Cherry Typhoon. The
poster is inspired by the early work
of Japanese painter and illustrator,
Tadanori Yokoo. Satako and Cherry
blend aspects of both Japanese and
burlesque performance traditions
with humour and sexuality. Satako
belts out the tunes and commands the
organ (as well as a variety of drums,
whistles, and other percussion), while
Cherry mesmerizes the crowd with
her ample figure and outsized stage
persona.

RIGHT: *Kaboom's Fiery Hot Box*
is a fast-paced variety production
produced by SideshowThrills.com
featuring sword swallowers, acrobats,
magicians, fire-eating daredevils, and
burlesque queens. Poster by Adam
Turman, 2007.

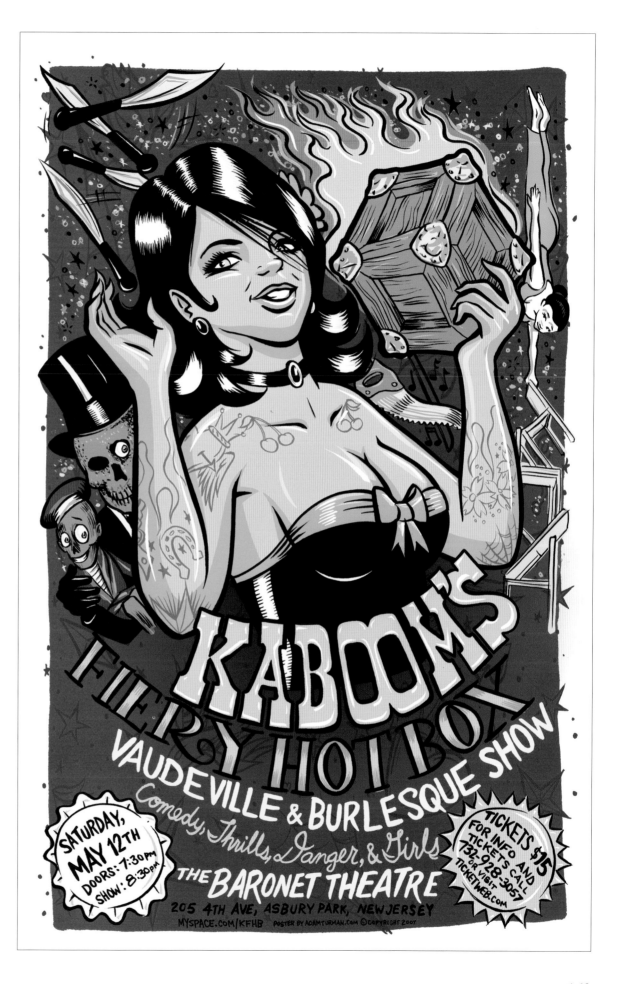

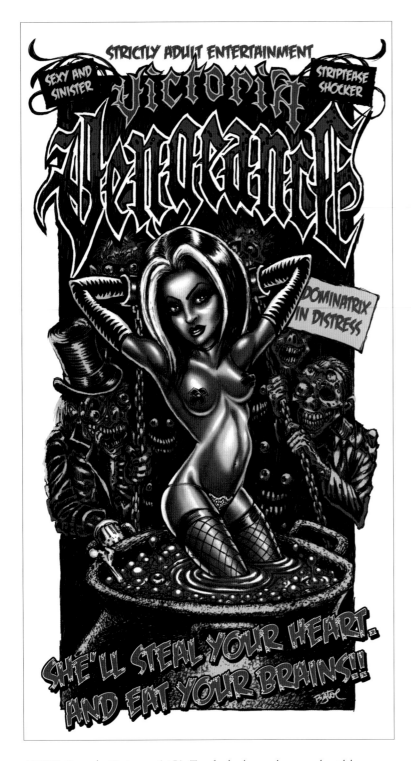

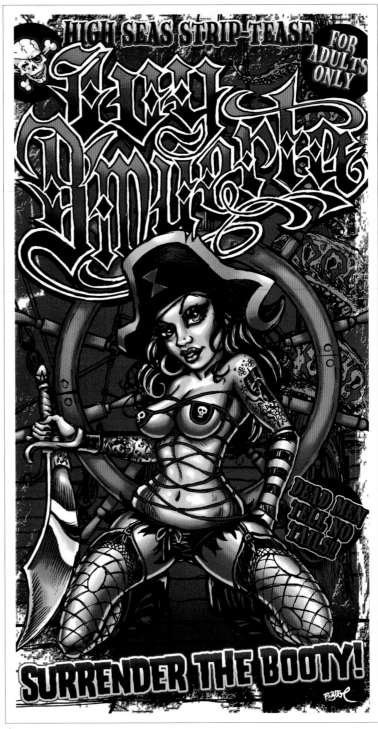

ABOVE: Poster by Kustom artist Big Toe, for burlesque dancer and model Victoria Vengeance, 2009.

ABOVE: Poster by Big Toe, for burlesque dancer and model Ivy D'Muerta, 2009.

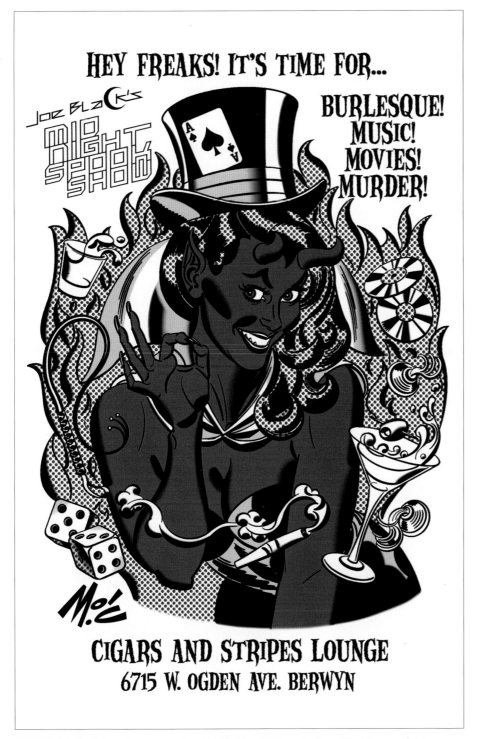

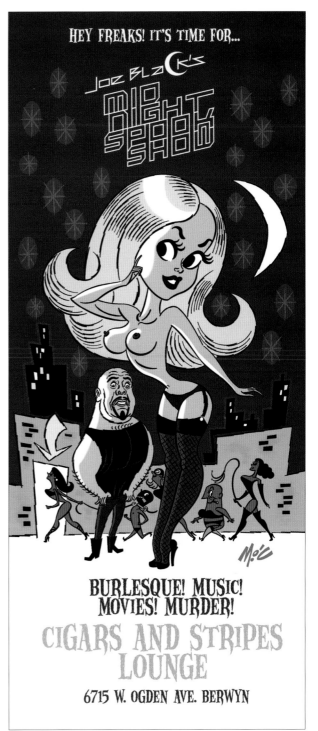

ABOVE: Mitch O'Connell poster for *Joe Black's Midnight Spook Show*. The Cigars and Stripes Lounge is on Ogden Avenue, part of the historic Route 66 through Berwyn, a suburb of Chicago.

ABOVE: Mitch O'Connell poster for the *Midnight Spook Show*.

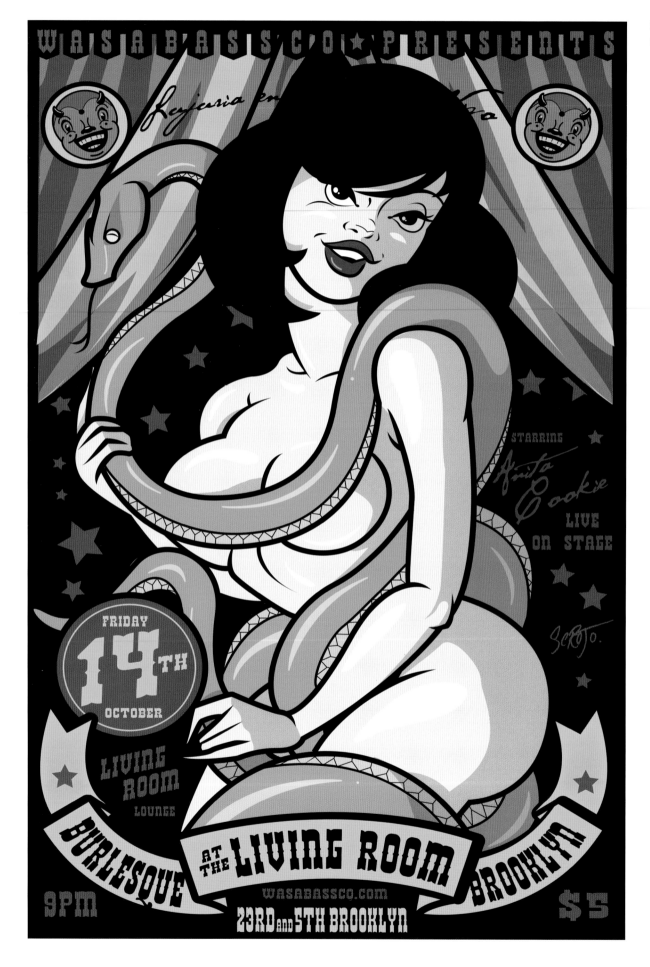

166

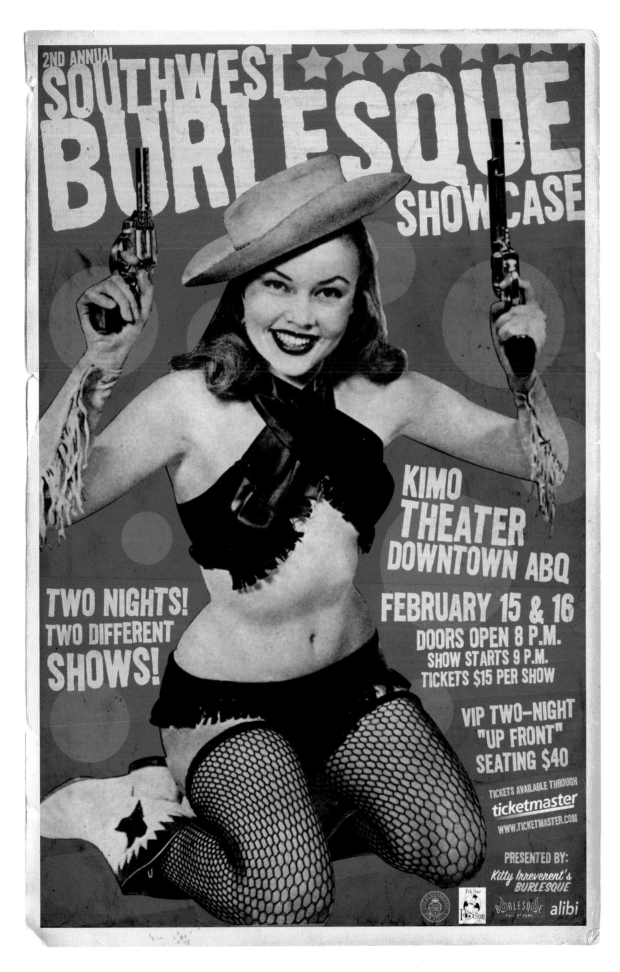

LEFT: Vintage-influenced poster, designed by Jeff Drew, for the 2nd Annual Southwest Burlesque Showcase, 2008. The show takes place in February at the historic KiMo Theater in Downtown Albuquerque, New Mexico, and features performers from across the Southwest.

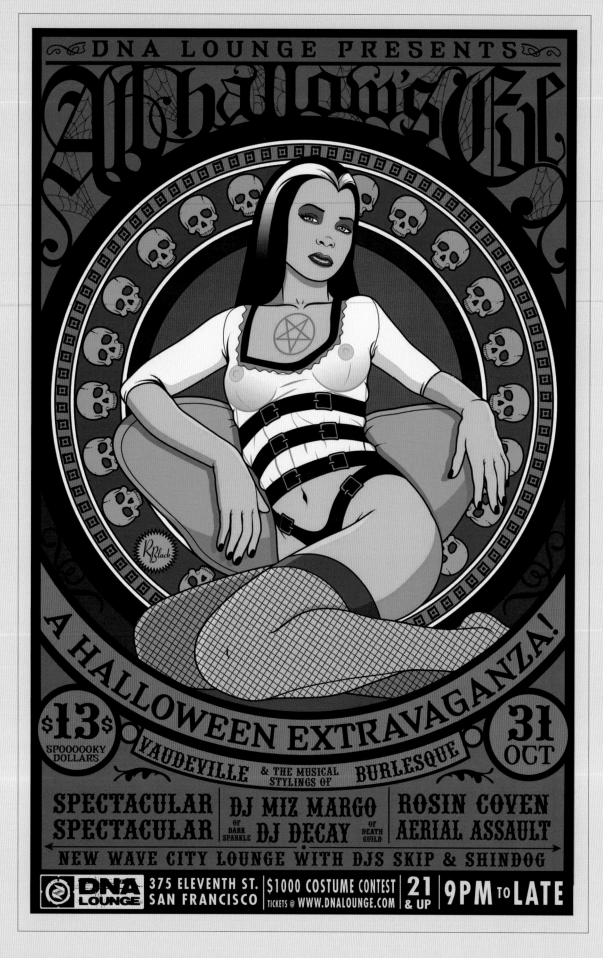

LEFT: R. Black poster for San Francisco's DNA Lounge Halloween Extravaganza, 2004.

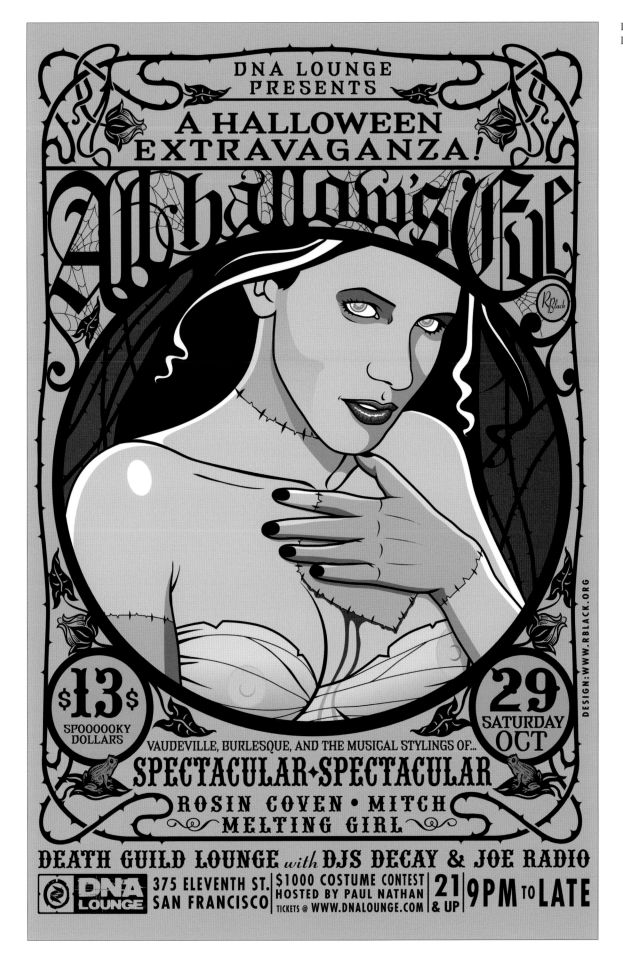

LEFT: R. Black poster for The DNA Lounge Halloween Extravaganza, 2005.

LEFT: Poster artwork by R. Black, for the *Creepshow Peepshow* at the DNA Lounge, San Franciso, 2006.

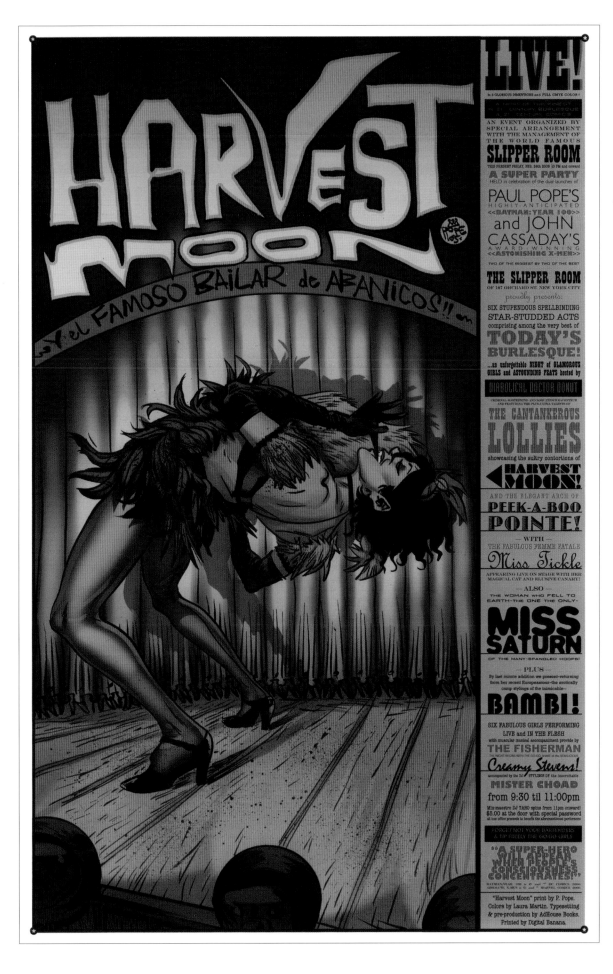

LEFT: Poster by comic book artist Paul Hope, for the Batman: Year 100 release party at The Slipper Room, NYC. The show featured Harvest Moon, also known as "The Sultry Siren of Burlesque" performing a fan dance, 2006.

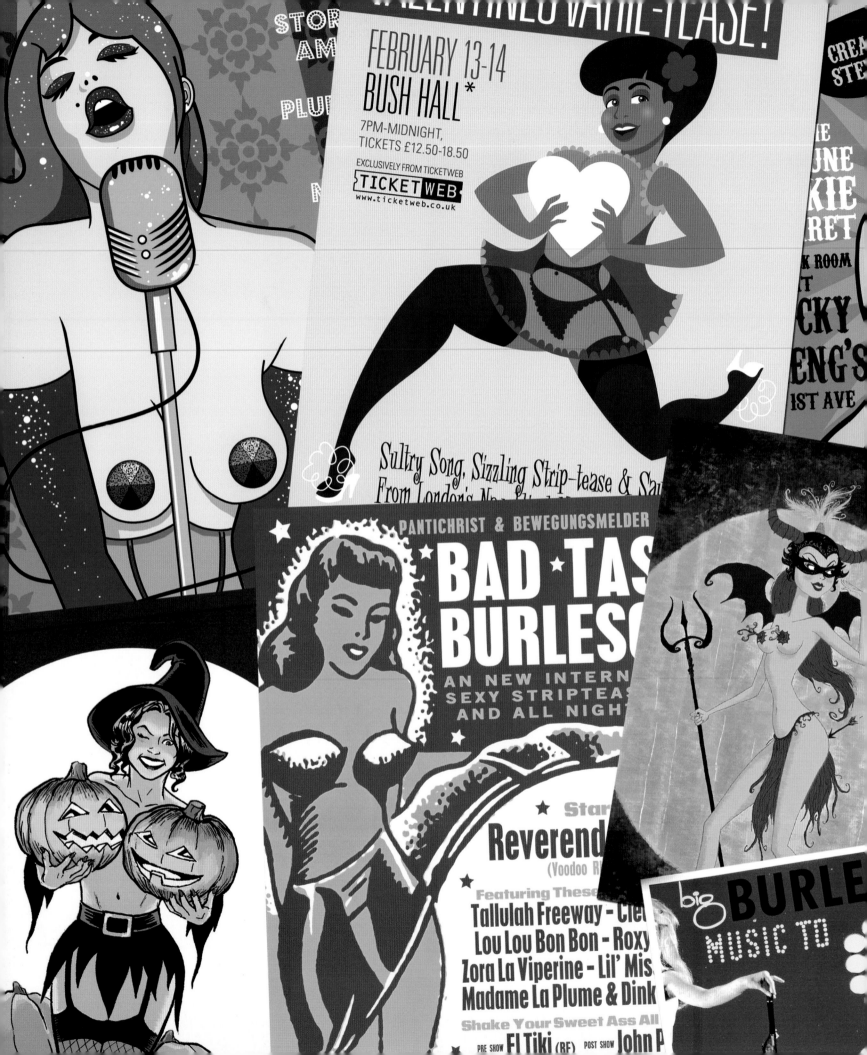

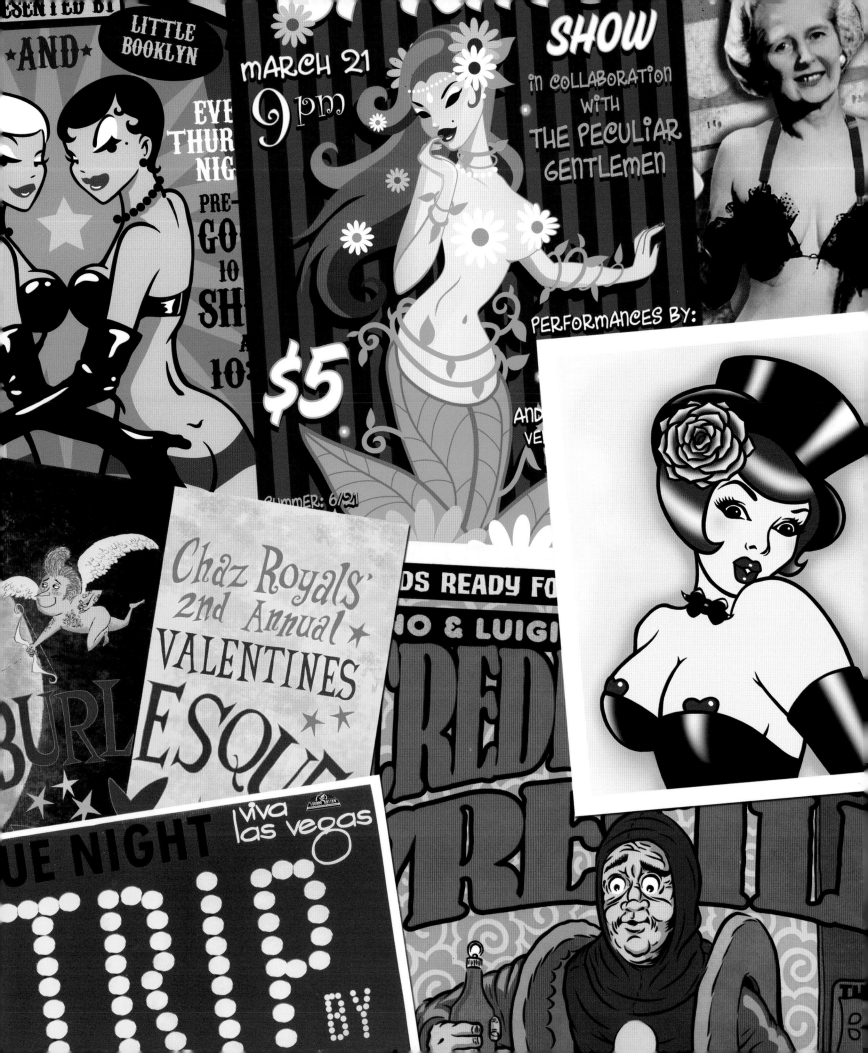

ACKNOWLEDGEMENTS

A special thank you from Korero Books
to all those who made this book possible.

Chaz Royal www.londonburlesquefest.com
Satan's Angel www.satansangel.com
Gary Arnett www.dirtyshow.org
Mark Berry www.hot-cherry.co.uk
Immodesty Blaize www.immodestyblaize.com
Michelle Carr www.velvethammerburlesque.com
Molly Crabapple www.mollycrabapple.com
David Drumond Pleasures of Past Times, London
Lurker Grand www.klangundkleid.ch
Flash Monkey www.theflashmonkey.biz
Segan Friend Lucha VaVoom
Hubba Hubba Revue www.hubbahubbarevue.com
Kittie Klaw www.ministryofburlesque.com
Luke Littell www.burlesquehall.com
Club Noir www.clubnoir.co.uk
Alan Parowski www.teaseorama.com
Don Spiro www.donspiro.com
Zebu Recchia www.yarddogsroadshow.com
Dan Wald www.burlesqueposters.com
The Whoopee Club www.thewhoopeeclub.com

Maurice Poole, **Cecilia Bravo**, **Mark Berger**,
Juicy Jenn, **James Petter**, **Devin O'Leary**, **Dean Mietch**,
Emily Frye, **Clair Whitefield**, **Catherine Johnson-Roehr**
and **Andrzej Michalski**.

ARTISTS

Glen Barr www.glbarr.com
R. Black www.rblack.org
Casarramona www.casarramona.ch
Joshua Ellingson www.joshuaellingson.com
Alan Forbes www.secretserpentsstore.com
Steven R. Gilmore www.srgdesign.com
Colin Gordon www.colingordon.net
Claudia Hek www.claudiahek.net
Josh McKible www.mckibillo.com
Joanna Mulder www. joannarchy.com
Mitch O'Connell www.mitchoconnell.com
The Pizz www.thepizz.com
Paul Pope www.paulpope.com
Vince Ray www.vinceray.com
Mister Reusch www.misterreusch.com
Panti-Christ www.pantichrist.com
Shag www.shag.com
Scrojo www.scrojo.com
Matt Siren www.mattsiren.com
Big Toe www.bigtoeart.com
Jemma Treweek www.jemmatreweek.co.uk
Adam Turman www.adamturman.com
Kirk Von DaDa www.vondada.com
Derek Yaniger www.derekart.com

Picture library credits
Pages 12, 13, 15, 16, 18, 19, 21, Getty Images Ltd
Pages 10, 14, 31, Rex Features Ltd
Page 17, Daily Mirror

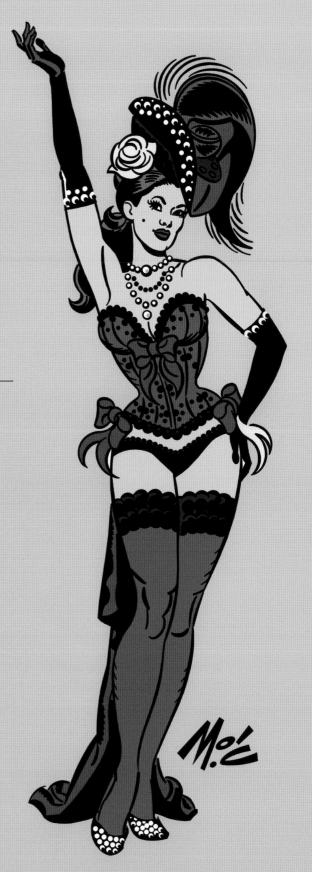

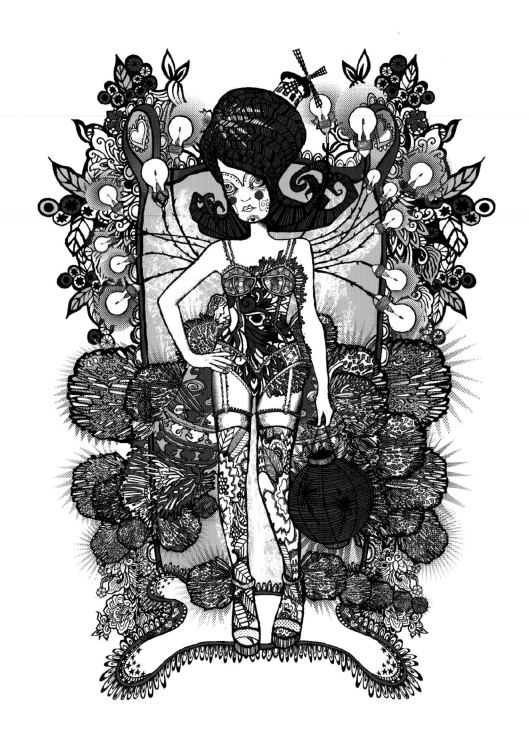